Ceramics in the Pacific Northwest

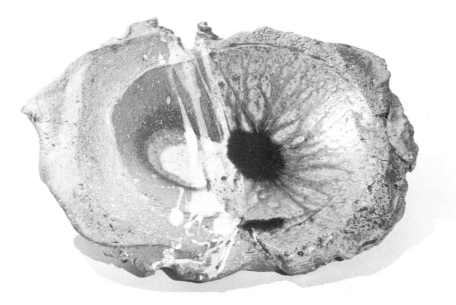

David Shaner (b. Pottstown, Pa., 1934). Garden Slab,
*1966, stoneware, hand-built, wood ash, white slip, and
burn flashings from Osage orange tree, H. 4 × W. 14.
Everson Museum of Art, Syracuse, N.Y.*

Paul Nelsen. Ceramic Construction, 1959, stoneware,
hand-built, iron slip decoration, 22½ × 11 × 10⅛.
Henry Art Gallery, Univ. of Wash., Seattle.

Opposite: Robert Sperry (b. Bushnell, Ill., 1927). Plat-
ter, ca. 1975, stoneware, wheelthrown, white glaze,
chrome, iron, and cobalt oxides, gold luster, Dia. ca.
20. Coll. of John and Anne Hauberg, Seattle.

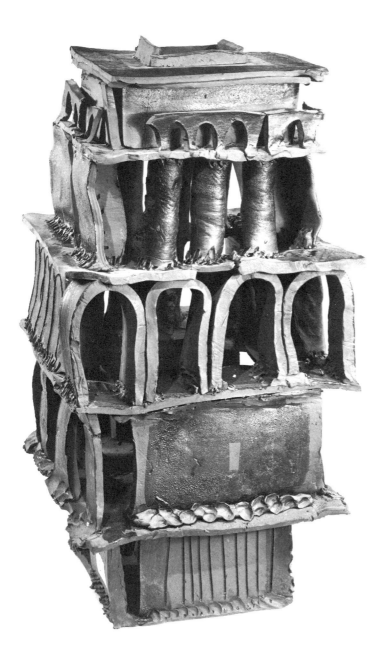

Ceramics
in the
Pacific
Northwest

A HISTORY by LaMar Harrington

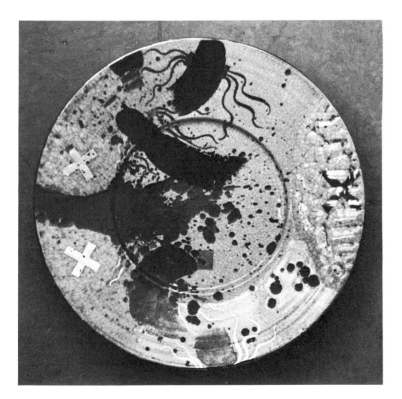

Published for the Henry Art Gallery
by the University of Washington Press
Seattle and London

INDEX OF ART IN THE PACIFIC NORTHWEST

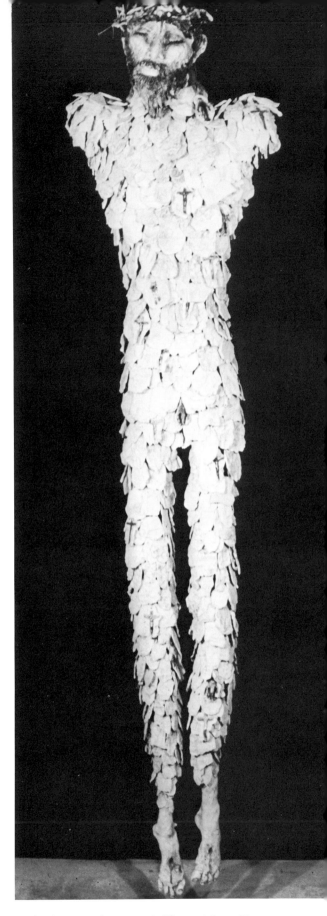

Ceramics in the Pacific Northwest: A History was published in connection with exhibitions shown at the Seattle Art Museum, 22 March–6 May 1979 and at the Henry Art Gallery, April–May 1979.

Copyright © 1979 by the University of Washington Press
Printed in the United States of America
Designed by Audrey Meyer

This project is supported by a grant from the National Endowment for the Arts in Washington, D.C., a Federal agency.

Library of Congress Cataloging in Publication Data

Harrington, LaMar, 1917–
 Ceramics in the Pacific Northwest.

 (Index of art in the Pacific Northwest ; no. 10)
 Bibliography: p.
 Includes index.
 1. Pottery, American—Northwest, Pacific.
2. Pottery—Northwest, Pacific. 3. Ceramic sculpture—Northwest, Pacific. I. Henry Art Gallery. II. Title. III. Series.
NK4018.A1H37 738'.09795 78–4369
ISBN 0–295–95623–2

Michael Lucero (b. Tracy, Calif., 1953). Jesus Figure, *1977, earthenware, hand-formed clay "petals" over wire armature, underglaze in pink, blue, and white.*

Preface

Activity and experimentation in the field of ceramics has been intensive in the Northwest states—Idaho, Montana, Oregon, and Washington—since the late 1930s. This volume surveys Northwest ceramics development from its beginning and identifies the various locations within the region that from time to time have served as centers for the evolving art medium. It is also meant to mark the sustained energy and forceful expression evident among the artists working throughout the region. Beginning with a discussion of early influences on Northwest ceramics from the eastern United States and Europe, the text explores the major trends and style changes in functional and sculptural objects in the Northwest over the past forty-five years and names individual ceramicists and institutions whose influence has been felt both regionally and nationally. Although some discussion of early, manufactured objects of clay (bricks, flower pots, and bird feeders) is included, the concern is predominately with the individual studio artist making one- or few-of-a-kind functional or sculptural works of artistic interest. Included are reproductions and descriptions of many outstanding ceramic pieces made by these artists as well as a minimal amount of technical data. Extensively discussed are those artists who have devoted themselves to working in the medium of clay and whose impact from a historical, technical, or aesthetic standpoint has been considerable on a regional or national basis. Others who may only have worked in clay for a short time have also been included when their contribution has been notable. Many of the artists discussed are native Northwesterners, while others have come from other areas to live permanently. Many graduate students have come from out of state to attend a university, made notable contributions while residing in the region, and then returned to a home state. The term "Northwest artist" is used to refer to artists who have lived and worked in the Northwest; the objects included are usually, but not always, limited to those works produced while the artist was in residence in the Northwest region. Although many artists are producing fine work, not all of them, especially in the area of functional wares, could possibly be discussed in this broad survey.

Traditionally, the medium of clay has been categorized as a "minor" art medium, not worthy for use in a "major" art form—objects in clay have been excluded and considered distinct from such "major" art forms as painting and sculpture. Underlined in this text is the now prevalent view that clay is as appropriate a vehicle for "major" art forms as oil or acrylic paints, bronze, marble, collaged mulberry paper, or any other medium. Objects of clay, even functional objects, most notably, Greek vases, have withstood the historical test of time as objects of fine art. The quality of expression evident in an object is the critical factor in determining whether it is "major" or "minor." The creative sensibility, not the medium, is here the major subject of consideration.

In letters and conversations with the artists, it has became clear that clay, for many of the artists, is revered as a sensitive, expressive, living medium about which they were eager to describe their feelings. Robert James of the University of Oregon believes clay is "one of the few things you can work all the way through. You are close to where the first human was—a longing to touch bottom—that's where its appeal lies." Harold Myers, now of California, who assisted in a major way at the University of Washington in the early sixties to open up the formal options for working in clay

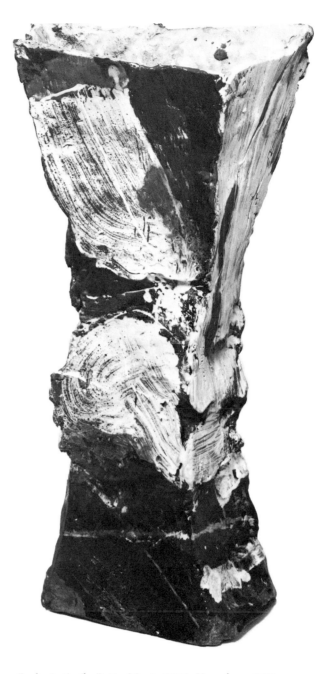

Rudy Autio (b. Butte, Mont., 1926). Vessel, ca. 1962, stoneware, slab-built, glazes, 31 × 15 × 10. Coll. of R. Joseph and Elaine Monsen, Seattle.

(from functional ware to abstract sculptural forms) and was wholly committed to clay as an art medium, sees it as "a timeless medium. The essential nature of a pot made with clay never changes." A young undergraduate currently at Boise State College, Beth Garland-Ledden, said: "When the clay is in my hands, my mind is clear and my self at peace. All else seems chaos." Kenneth Shores of Portland, Oregon speaks of his involvement with clay as "almost hypnotic, with the material becoming an extension of the human being." And, Mary Caroline Richards, in her book *Centering,* describes centering as "that act which precedes all others on the potter's wheel. The bringing of the clay into a spinning, unwobbling pivot, which will then be free to take innumerable shapes as potter and clay press against each other. The firm, tender, sensitive pressure which yields as much as it asserts. It is like a handclasp between two living hands, receiving the greeting at the very moment that they give it."

At the other extreme are artists, who, in their efforts to achieve certain aesthetic ends, feel the need to control the clay rather than to work with it, not only in their handbuilding but also in such techniques as casting. John Fassbinder, now of California and formerly of Seattle, says, "I like clay. It's pleasurable to work with, but I have never gotten into this philosophical approach of letting the clay form itself. I've always felt that what I wanted to do required bending the clay to my interest and not using the approach that the clay should look like clay, which I enjoy seeing in the work of others—they leave thumbprints and rough edges and poke holes and let it fall on the floor. It's a material that can be shaped into forms and ideas, and that's what I do with it. If it were possible to work in plastic, I probably would do that, too. I don't have any great love for clay as a material for itself."

Both approaches have resulted in the production of objects ranging from the simplest functional forms, to those with lavishly decorated surfaces, to the most profoundly expressive sculpture.

The author wishes to thank the many people both in the Northwest and throughout the United States who helped so graciously in the search for factual material and for the actual objects and the photographs of objects for this history. The work could not possibly have been completed without the patience and good will of the some two hundred artists who were contacted by the author and who enthusiastically submitted to the taped interviews from which so much insight was gained into their working philosophies and methods. It has been a delight to live among these artists for the past thirty years and observe the creative development, individual and collective, that has occurred.

Unless otherwise indicated all quoted statements by individual artists are from personal correspondence with the author or from the taped interviews conducted by the author in preparing this work. This material is available in the Harrington Collection, Archives of Northwest Art, Suzzallo Library, University of Washington.

Measurements given in the captions are in inches; unless otherwise specified, height precedes width precedes depth.

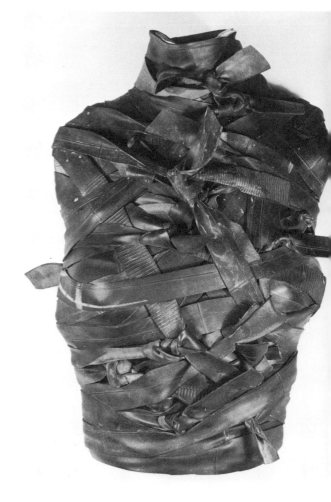

Linda Wachtmeister (b. Washington, D.C., 1950). Tarred and Tethered, 1977, stoneware, cast, fired clay figure covered with strips of tire tube, 17 × 11 × 3.

Opposite: Anne Currier (b. Louisville, Ky., 1950). Double Cup Box (with two spoons), ca. 1976, covered sculpture, white earthenware, slab and slip-cast forms, clear glaze, ca 5 × 15 × 14.

Contents

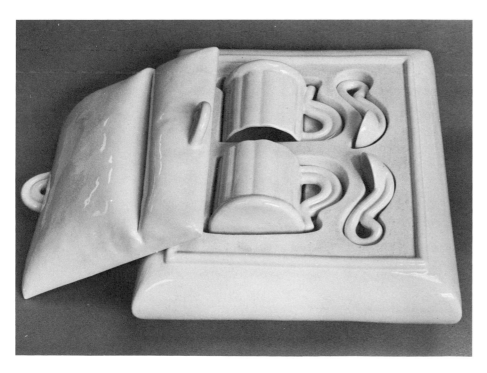

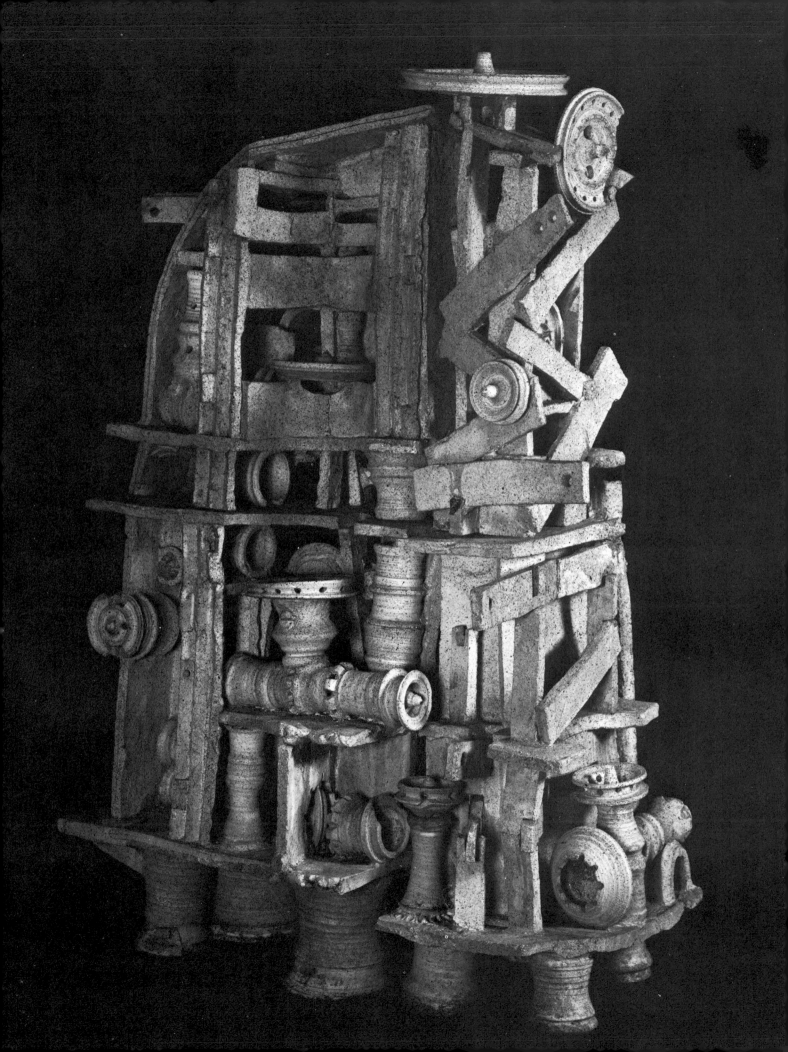

Ceramics in the Pacific Northwest

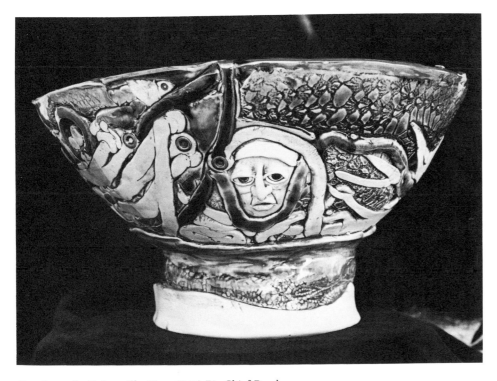

Ben Sams (b. Gainesville, Tex., 1945). Big Chief Bowl,
1973, porcelain, slabs and coils fused in a plaster con-
cave form, modeled features applied, glaze brushed
on, H. 9 × Dia. 14. Coll. of Arlene Schnitzer, Fountain
Gallery, Portland, Ore.

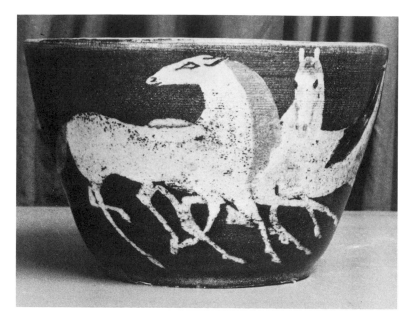

Henry Meloy (1901–51, b. Townsend, Mont.) and Peter
Meloy (b. Townsend, Mont., 1908). Bowl, 1950, stone-
ware, wheelthrown, drawing in underglaze pencil, H.
4⅝ × Dia. 7⅜. Portland Art Museum, Portland, Ore.

Early Influences in Northwest Ceramics Development

Although the northwestern United States was settled late, the area was uniquely blessed from the earliest days with a combination of attributes conducive to the broad development of ceramics. The superbly handcrafted objects produced by the Indians of the Northwest Coast before the new settlers arrived engendered progressive attitudes toward the value of the so-called decorative arts. The large Asian population brought a tradition of decorative objects of enduring beauty and refinement, and the Asians, as well as Scandinavians, Balkans, and Mexicans, brought their culturally significant folk arts in all media. Dr. Richard E. Fuller, founder and director of the Seattle Art Museum, had begun, with his mother, Mrs. Eugene Fuller, a major collection of Asian objects for the museum, which opened in 1933. Included in the wide range of objects they gathered were fine examples of early Asian and Near Eastern ceramic wares and, later, superb examples of Japanese folk ceramics.

All of these factors created among Northwesterners an awareness of and an appreciation for beautifully designed and well-crafted objects. The individuality and experimental attitudes characteristic of Westerners might have also contributed to a dynamic environment for the making of handcrafts. Rich deposits of native clays and minerals in all four Northwest states would provide a necessary source of materials for future creative studio potters.

Still an outpost in many ways before World War II, the Northwest was nonetheless exposed to and its artworks affected by aesthetic and design philosophies prevalent in the eastern United States, just as the East had earlier been affected by events in Europe. Before 1900, William Morris and John Ruskin, leaders of the Arts and Crafts Movement in England, had struggled to ward off the machine in favor of handwork—an obviously humanizing philosophy that was felt in the United States at a later date.

In 1919 in Weimar, Germany, Walter Gropius, an architect, founded the Bauhaus School, which represented as an ideal the fusion of art and industry and emphasized humanistic ideals. It stressed designing objects and architecture to conform perfectly with their functions and to make use of materials to the best advantage. It concentrated on removing the traditional Western barrier between the crafts and the fine arts and advocated close collaboration between the arts and technological mass production for the social good. Although Bauhaus objects and architecture exhibited characteristics in common (pure, machine-like geometric lines and forms, generally), the enlivening aspect was one of philosophy rather than style, and its philosophy was to influence the call for high-quality product design in the United States. Bauhaus faculties, forced to flee Europe before World War II, transferred their bases to the United States, and helped to integrate, through their design theories, the major and minor arts throughout American systems of higher education, giving more respectability to such media as fired clay.

There seems to be general agreement that several individuals in the East, including Charles Binns, Adelaide Robineau, Arthur Baggs, Charles Harder, and Henry Varnum Poor, who worked in the most important ceramics centers in the United States early in this century were responsible for the development of the "individ-

ual" ceramicist we know today. From 1900, Binns was the first director of the New York State School of Clayworking and Ceramics (Alfred University), a training ground for industrial designers in ceramics. Binns's work was influenced by the simplicity of form and surface and by the rich glazes of ancient Chinese ceramics, while Robineau's mature work, with its heavily carved surfaces, was reminiscent of the more active and ornately designed European wares, which also included the organic, curvilinear motifs of Art Nouveau. She experimented extensively with porcelain clay, a white body chemically composed to require a very high fire for fusion and durability. She also became expert at controlling crystalline patterns in the glaze in which the glaze formula, the firing, and the cooling are all critical. Although her interest in ceramics started as a hobby in the area of china painting, Robineau eventually made a significant contribution as a teacher of art at Syracuse University and as founder and editor of *Keramic Studio* (later changed to *Design*) magazine, a periodical that aimed "to help all who are struggling for higher ideals for design and technique" and that was available in many libraries in the Northwest as early as 1920. Baggs, a student of Binns, became director of ceramics at Ohio State University where the fine arts and industrial concerns were merged. Baggs was also interested in reduction firing, in which the oxygen is reduced to change the colors of the applied oxides and in which the results are seldom predictable, and in self-glazing techniques, such as the salt glaze used earlier in America (salt is thrown into the kiln to form a vitreous surface on the objects). Harder, also Binns's student, was one of the first to experiment with high temperature and stoneware bodies (producing a more vitreous, harder body than the low-fired earthenware clays) and with reduction firing. The work of both Harder and Baggs portended the American ware of the 1950s. Poor, a painter, drew or incised decorations onto his pots.

Although their styles varied, the five shared similar philosophies and were to affect the future profoundly as national communication increased. They all believed in the importance of one's work as an expression of individuality. They called for fine craftsmanship and high-quality design, stressing unity in form and surface decoration. They encouraged experimentation with bodies, forms, and glazes and, unlike the tradition in Europe where designer and technician worked separately on specific aspects of a work, they saw a need for the designer to understand and control every aspect of the ceramic process.

The Ceramic National, founded in memory of Robineau at the Everson Museum in Syracuse, New York in 1935 "to improve the ceramic art of America," was to sustain itself for four decades as a showcase for ceramics from all parts of the United States. The eminent Ukranian sculptor, Alexander Archipenko, who was later to teach at the University of Washington, entered the competition several times, beginning in 1937, thus putting the stamp of "fine art" on the image of the show. Work by Northwest ceramicists also began appearing in the exhibition in 1937 when the entry of Cheney's Nan Wiley was accepted. The catalogs, well-documented and, as early as 1948, with reproductions, were available to potters of the Northwest and served as a line of communication with the Eastern ceramics centers and with California centers in their early development. The reduction-fired objects and salt glazes, both of which require the high temperatures of the gas-fired kiln, were prevalent before World War II in these exhibitions, yet were new to most ceramicists of the Northwest, who had been limited to the lower firing and oxidation atmospheres of the electric kiln.

The Northwest
before World War I

Although the Northwest had no dinnerware factories, a number
of ceramics industries in the later nineteenth century were produc-
ing brick, sewer tiles, and flower pots. In Portland, Pacific
Stoneware, founded in 1896, was a well-equipped traditional pot-
tery, hiring Black labor from the South and manufacturing crocks,
animal feeders, milk pans, and other products similar to those that
had been made in Appalachia a century earlier. Leonard and Eliza-
beth Martin had founded a brick company in Forest Grove, Oregon,
later manufactured terra-cotta ornaments for architecture, and
eventually, in 1945, founded Martin Ceramics Supply in Auburn,
Washington, selling clays, glazes, wheels, and castings, and firing
objects for ceramicists during the 1950s and 1960s. In Seattle, Build-
ers' Brick Company was active around 1900, and Northwest Pottery,
specializing in flower pots, thrived from its beginning in 1927.
Founded in 1898, the Western Clay Manufacturing Company in
Helena, Montana began making bricks and press-molded decora-
tions for early neoclassical architecture in 1911. Later, this company,
under the direction of Archie Bray, a native Montanan with a love
for culture and a philanthropic attitude, was to become a major
force in the development of the ceramic art object in the Northwest.

Starting around 1910, when there were still no serious studio
potters in the contemporary sense, china painting on blank, factory-
made ware imported from the East was popular, but that trend
died out around World War II. Handmade functional ware from
both the San Francisco and the Los Angeles Keramics Clubs could
be seen in Seattle in 1909 in the California Building of the Alaska–
Yukon–Pacific Exposition. The catalog of that exposition shows
all work to be functional and for sale but gives little technical
information.

Early Training Centers

Between the close of World War I and 1939, all major colleges
and universities and some professional schools in the four North-
west states included ceramics in their curricula. Most of these
classes in their earliest days were headed by female educators
who had attended the various normal schools of the United States
and who, when ceramics later, after World War II, gained more
status in the curricula, were replaced in most cases by men.

Before 1945, most work was modeled or hand-built with slabs,
coil-built, press-molded or slip-cast in pre-formed or handmade
molds, sometimes formed with a jiggering device on the wheel,
and occasionally, thrown on primitive wheels. Kilns—oil, wood-
burning, or electric—were small and fired to low temperatures
accommodating small objects of porous earthenware with glossy,
glazed surfaces in brilliant colors made possible only by low firing.
The cast, functional wares were crisply formed, decorative works
with geometric designs (e.g., concentric circles). A November 1937
article titled "Modern Forms" in *Design* magazine describes these
mechanistic pieces as having a "feeling of motion, vitality, progres-
sion not found in static work of the past." It speaks of the "severe
lines of the modern school . . . straight, sharp lines, tiers, and
blocked effects contrasting with subtly straight lines inspired by

industrial machinery" (p. 48). At Montana State University in Bozeman, the discovery in the late 1940s of a kerosene-fired muffle kiln was evidence that china painting had been done there at an earlier time. Probably most universities offered this technique in the early days.

The ceramics curricula of Eastern Washington State College in Cheney and the University of Idaho in Moscow were established by Nan Wiley and Mary Kirkwood, respectively. Both were trained at the University of Oregon and in Eastern schools and in Europe and thus brought a non-Northwestern sophistication. Both Kirkwood and Wiley encouraged their students to search for their own clays and mix their own glazes, a trend that was growing throughout the country. In the '30s a kiln at Idaho was rebuilt by student Francis Newton, who later became director of the Portland Art Museum, where the philosophy was sympathetic to the clay medium. Ceramics at the University of Puget Sound in Tacoma began in 1947 under Lynn Wentworth, a graduate of the University of Washington. Glen Hogue introduced pottery into the industrial arts curriculum at Central Washington State College in Ellensburg about 1940.

In Corvallis, Oregon State University offered ceramics on a limited basis until 1964, when Marian Bowman and Ted Wiprud developed the program and studio to their present state.

Victoria Avakian, (later, Ross), an immigrant from Armenia to Los Angeles, and eulogized today as a tough teacher with a great respect for her craft, developed the curriculum at the University of Oregon starting in 1920. While maintaining tight control in her classroom, she offered much freedom to learn. One of the early studio potters on the West Coast, she left a legacy of technical knowledge, especially of glaze formulae with which she had begun experimenting during her graduate work at the University of Southern California with the distinguished and influential Midwest-trained Glen Lukens, who spent much of his career developing glazes of intense and luminous colors from native California clays and minerals. Victoria Avakian was well known for her brilliant uranium glazes and exhibited in the 1930s and 1940s in shows in the East, including the Ceramic National and at the Albright-Knox Gallery. Although Avakian attended workshops and summer sessions at such distinguished Eastern institutions as Ohio State University and Alfred University, where she saw wheel throwing, her own work was mostly limited to hand and mold construction. Possibly also inspired by Lukens and his hope to integrate ceramics with architecture, Avakian executed some of the earliest "public art" in the Northwest: two polychrome panels (twenty-four colors) each measuring 26' by 3', for the architecture building at the University of Oregon, and a panel still in place in the Lane County Courthouse in Eugene.

Lydia Herrick Hodge, a student at the University of Oregon began in 1936 to work toward the formation in Portland of the Oregon Ceramic Studio, a W.P.A. product, which was to become the most vital and productive early ceramics program in the Northwest. With strong support from the Portland Art Association, founded in 1892, the Society of Arts and Crafts, an art school founded in 1906, alumni organizations and the School of Architecture and Allied Arts at the University of Oregon, many individuals, including Victoria Avakian and the ceramicists Katharine Talbot MacNab and Margaret Murray Gordon, and a gift of property from the Portland Public School System, a building was erected in 1938 to provide an outlet for ceramic work, a center for purchasing materials and fulfilling technical services and firing needs, and gallery space for exhibiting ceramic objects. The Studio served as a liaison organization and

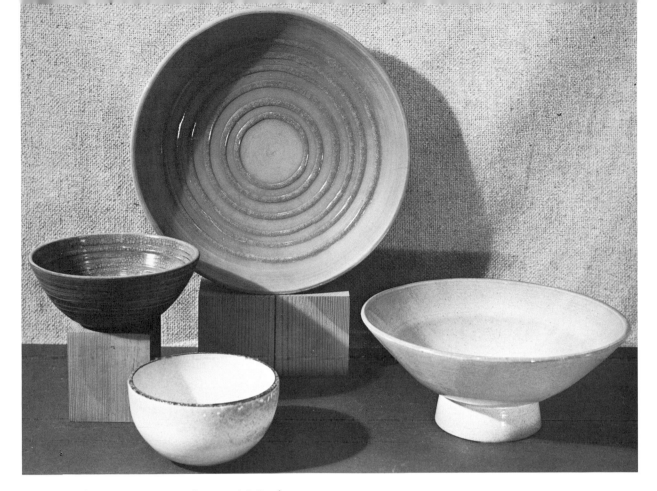

Victoria Avakian Ross (1894–1975, b. Armenia). Bowls and Plate, early 1940s, earthenware, press-molded or coiled and trimmed, low-fire glazes, trailed slip. Contemporary Crafts Gallery, Portland, Ore.

Lydia Herrick Hodge (1886–1960, b. Valparaiso, Ind.). Plate, Vessels, and Figurines, 1942, earthenware, cast and press-molded, low-fire glazes.

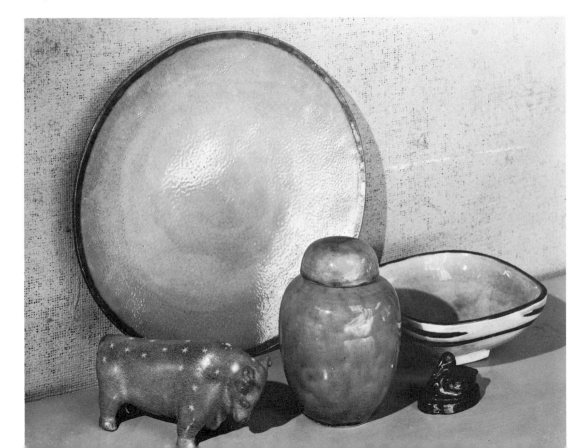

catalyst in the field of art education. Mrs. Hodge, a ceramicist, educator, and business woman, saw the possibility of using clay as an expressive medium and wanted to work both with adults and with children. This emphasis reflected a widespread ideal that art not only could, but should be understood and enjoyed by all members of society. Among the many subjects of interest to her was the ethical relationship between craftsmen and their retailers and promoters.

Burt Brown Baker was president of the Oregon Ceramic Studio from its founding day until 1950. Maurine Roberts, who served on the first board of trustees of the Studio and who was responsible for the vitally important activities committee from the beginning to 1976, has probably served in more capacities over a longer period of time than anyone associated with the Studio. She served as gallery chairman for many years, planning and mounting exhibitions, and she successfully encouraged the American Institute of Architects, Oregon chapter, to establish and develop the collection of clay objects through purchases from the annual exhibitions. John Ryder, who later, with Leta Kennedy, developed the ceramics curriculum at the Museum Art School of the Portland Art Museum was the first technician at the Studio. One of his main duties was firing the large kiln, which was continuously loaded with clay objects made by students from public schools throughout the state. In 1966 when the board decided to change the traditional emphasis from clay to all craft media, the name of the Studio was changed to the Contemporary Crafts Gallery. It is still housed in the original, but enlarged and improved building.

During the early years, a number of potters, including Margaret Murray Gordon, Katharine MacNab, and Constance Spurlock, associated with the Oregon Ceramic Studio sold pots throughout the country in a program called "The American Way of Education," inspired by Russel Wright. The philosophy of Wright, who was a nationally recognized designer and educator, was strongly national in its emphasis on building the cultural confidence of America through education.

From the beginning, the board of the Oregon Ceramic Studio, in collaboration with the Portland Art Museum, planned their exhibitions with great sensitivity to the needs of the Oregon public, and to the national scene, bringing high-quality traditional and innovative objects by recognized American ceramicists. This lively scene occurred in Oregon unmatched in other areas of the Northwest for at least a dozen years.

Margaret Murray Gordon (b. Watertown, N.Y., 1911). Three Bowls, 1940, earthenware, plaster mold made from coiled form, slip poured for multiple production, mustard gold glossy glaze, small bowls: H. 3½ × Dia. 6; large bowl: ca. H.6 × Dia. 10.

Two important exhibitions during the Studio's first years were from California—one in 1938 at the Portland Art Museum, and the other in 1939 at the Oregon Ceramic Studio—and showed the work of that state's noted ceramicists. These exhibits were followed in 1940 by a group of works from the Seventh Annual Ceramic National at Syracuse (1938), which was shown in transit at the Golden Gate International Exposition in San Francisco and the Seattle Art Museum in 1939. In this exhibition viewers saw the work of Laura Andreson, Edgar Littlefield, Henry Varnum Poor, Herbert Saunders, Arthur Baggs (his famous, salt-glazed cookie jar), Glen Lukens, and Paul Bogatay. This was followed by a show of the work of Frans and Marguerite Wildenhain, the latter a Bauhaus-trained ceramicist who, at Pond Farm in California, was one of the first potters in the United States to establish a studio.

A significant event at the Portland Art Museum was the appearance of Arthur Baggs of Ohio State University in the 1942 summer institute funded by the Carnegie Corporation and sponsored by the Oregon Ceramic Studio, Portland Art Museum, Portland Public Schools, and the University of Oregon. A fine designer and craftsman and a selfless teacher, Baggs helped Lydia Hodge realize her dream of raising the standards of design. He was a profound inspiration to the workshop participants. Among the twenty-nine attendants were Margaret Murray Gordon, Vivian Pesola, Tom Hardy, and Olive Roberts, as well as many teachers who later established ceramics programs in their schools throughout Oregon. The Carnegie Corporation included funding for long-term research into clays for high-temperature firing.

Running concurrently with the 1942 institute was an exhibition that included the work of ceramicists Edgar Littlefield, Margaret Fitzer, Paul Bogatay, Mary A. Giles, Maija Grotell, Otto and Gertrud Natzler, and Glen Lukens. The high quality of exhibitions continued throughout the years with exhibitions of the work of Bernard Leach and the potters of St. Ives (1951), Peter Voulkos, John Mason, Rex Mason, Henry Takemoto, Win Ng, Toshiko Takaezu, and other nationally recognized artists including many who live and work in the Northwest.

At the University of Washington, ceramics classes were established as early as World War I with the use of firing facilities in the School of Mines. Annette Edens taught pottery design as early as 1920. About the same time, Eugenie Worman, a painter, taught ceramic pottery and sculpture. The early School of Art philosophy, according to a pamphlet published in 1932 by Lambda Rho (founded in 1917), bridged "the gap between design and painting." The pamphlet goes on to state in the "Practical Objects" section that "metal, jewelry, and pottery develops an appreciation of the influence of materials on art." The "Public Schools Methods" section states that "the ultimate effect of art on life is the chief concern." Reproduced in the pamphlet are fine examples of low-fired, press-molded or slip-cast, functional objects with clean, geometric forms and decoration and glossy surfaces, all familiar aesthetic qualities of the machine-inspired Art Deco of the day. Others were decorated with underglaze figurative drawings (colors applied to the surface for one firing and transparent glossy glaze for another). Lambda Rho, still an important developmental arm of the University of Washington's School of Art, established rapport between the university and the community in the early 1930s by forming an art studio in the Seattle Arcade Building, where classes in art, including ceramics, were taught.

Ebba Rapp, sculptor and painter, taught ceramics in the 1930s at the Cornish Institute of Allied Arts, a professional school considered by many to have nurtured at that time some of this century's most creative activity.

1. DORIS HUNTSMAN
2. STELLA LOWRY
3. ON YUEN WONG

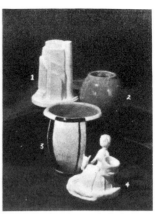

1. ANNETTE PYE
2. MARJORIE BEEUWKES
3. AYLSWORTH KLEIHAUER
4. DORIS HUNTER

1. OSCAR KLEINBIN
2. JESSE WILKINSON
3. MARION DIEHL
4. BERYL ADAIR
5. GERALDINE BAKER
6. BETTY KUNST
7. KATHERINE NORMAN
8. LOUISE TREEN
9. SYDNEY CARLSON
10. DORIS HUNTER
11. VIRGINIA KING

POTTERY

Page from Lambda Rho pamphlet about the Department of Painting, Sculpture, and Design in the School of Art, University of Washington, 1932.

Sculptors, Painters, and Clay

A number of artists trained in the East or in the universities of the Northwest states produced, as early as the 1920s, sculptural objects of terra cotta, a red earthenware body strengthened with the addition of grog (ground, fired clay) and used traditionally for sculpture. These works were often of human or animal imagery done in variations of Cubism, Art Nouveau, or the active forms of Futurism or other types of "technological art." Although the plasticity of clay lends itself well to the creation of such forms, this medium may have been used in the 1930s and 1940s because the economic limitations of the Depression and the following years discouraged the use of bronze and other more costly materials. Listings of sculpture in terra cotta can be found in exhibition catalogs as late as the mid–1960s. Sculpture was also made in stoneware, especially after gas kilns were installed in the Northwest. Among those artists working in clay were Tom Hardy, George Tsutakawa, Everett DuPen, and Lynn Wentworth.

Immediately after World War II, Betty Feves, an artist from eastern Oregon who was trained at Columbia University and at Washington State University, Pullman, began working in sculpture and hand-built pots in clay, firing them at stoneware temperatures. Woking alone in remote eastern Oregon during the thirty intervening years, her impact has been felt in exhibitions throughout the United States and Europe. Her dynamic semiabstract sculptures with natural surfaces are powerful expressions of nature and are, as she stated in a recent letter to the author, "direct responses to the clay and the firing. The process of working very much shapes my thinking about forms and ways of handling the materials." Basically cubistic, the shapes and images recall the work of Jacques Lipchitz and Henry Moore but are uniquely Feves's. Making no real distinction between pots and sculpture ("the same process is at work"), she says her interest has always been "in the direction of getting back to basics—using native Oregon materials in bodies and glazes as much as possible in a straight forward manner." Clyfford Still, her teacher at Washington State College, did not influence her style, but did affect her attitudes and enthusiasm about art. Her association with Still could well explain her dedication to working out her own problems and making a unique statement. Later, she spent two summers working under Alexander Archipenko, one in 1937 at the University of Washington. "We worked in terra cotta and (although) we . . . didn't handle clay and firing and construction from a ceramic point of view . . . it was, for me, . . . the beginning of a direction." In the light of her individualistic approach to her work over the years, it is interesting today to reread her words in the transcript of "Design and Ceramics," a panel discussion at the First Annual Conference of American Craftsmen at Asilomar in June 1957: "On this problem of design and tradition, . . . I feel that tradition, principles, and, I guess, rules, are guideposts. I would hate to see them set up as a set of laws that we find we must adhere to. I don't believe that we can find a timeless value. . . . The materials we use like pottery clay and the techniques of firing and so on have changed very little, but, . . . the content, the expression, the meaning it has for us, not the way we work with it, but the meaning that the object can convey changes, . . . our society changes and our values change." Having worked some in Raku, Feves's greatest enthusiasm is for primitively fired pots, which she does in the summer as Oregon weather permits.

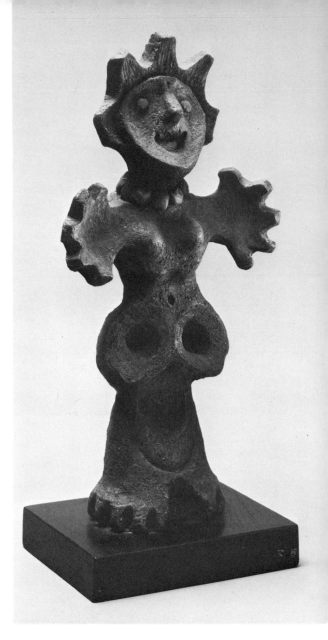

George Tsutakawa (b. Seattle, Wash., 1910). Extrovert, *1959, stoneware, hand-built, H.13. Coll. of Cornelius and Gloria Peck, Seattle.*

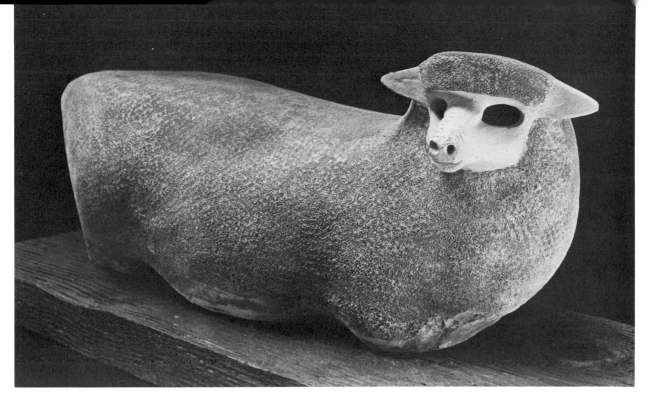

Tom Hardy (b. Redmond, Ore., 1921). Ram, 1951,
earthenware, slab-built, brush textured, 9 × 28 × 8.
Coll. of Alexander Pierce, Portland, Ore.

Lynn Wentworth (1905–74, b. Monroe, Wash.). The
Flowering, 1957, three bottles, earthenware, coil con-
struction, white low-fired matte glaze, H. 17¼ ×
Dia. 4. Coll. of Peggy Mayes, Tacoma, Wash.

Everett DuPen (b. San Francisco, Calif., 1912). Destia,
1953, terra cotta, modeled directly and hollowed out,
waxed while hot from firing, 12½ (including
base) × 7 × 7¾.

About the same time that Feves started working in Oregon, Margaret Tomkins, a painter, and her husband James FitzGerald, a sculptor, active artists in the "Tobey circle" in Seattle, turned their attention briefly to making functional clay objects of stoneware and porcelain. This pair manufactured their own equipment and mixed their own glazes, producing among others, white crackle and reduced copper surfaces. Painted decorations were sometimes applied under hand-dipped glazes. The pots were mostly functional: bowls and vases of classical forms, thrown and "tooled" to achieve the thinnest of walls. They also combined ceramics or enamels and wood in decorative functional objects such as table lamps. An early exhibition of this work by the FitzGerald's was shown at the Seattle Art Museum in late 1948.

Universities Awaken

Immediately after World War II, in 1946, a new dimension was added to the ceramics division at the University of Washington with the arrival of Paul A. Bonifas, a highly recognized Swiss artist and ceramicist, for the purpose of building a top-quality ceramics facility in the School of Art. He had been established in his studio in the French province of Ferney-Voltaire from 1922 to 1940, practicing in the traditional European system under which the artist conceived the work and technically prepared assistants executed it. He required strict discipline and long training periods of his students. His emphasis on the importance of technical skills may have been underlined in his own mind by the fact that in the United States, without his technicians, he, himself, was without part of the knowledge necessary to operate as a complete designer-craftsman. Some of his students who were developing an avid interest in clay as an expressive medium, found the technical aspects boring. Ironically, today, John Fassbinder, who now produces functional wares full-time, looks back with favor on, among others, Bonifas' assignment to design forms to fill a certain kiln area as a way of conserving costs. At the time, such ideas seemed far too restrictive. Bonifas' approach to the making of pottery and sculpture was highly intellectual. An ardent philosopher, he believed that art is an expression of life and spoke of his dedication to the development both of the individual and of the individual in relationship to society and to the environment. His views and his personal charisma were boundlessly inspiring to a coterie of students and members of the community in the late 1940s and 1950s.

Bonifas' forms were primarily vessels, some of them executed in bronze in the late 1930s in France and many of them in clay or bronze, produced in editions of three or more. Some were designed for particular architectural settings, a reflection of his interdisciplinary interest. His ceramic work was sometimes hand-built, sometimes molded in plaster casts, and, on occasion, thrown free or in a mold on the wheel. The ceramic vessels of the late 1940s and early 1950s were classically simple forms, occasionally with carved sections or press-molded decorations and with handles, spouts, and other appendages cast and added before firing. Simone Bonifas, his wife, prepared and applied glazes and assisted in the production in many other ways. Bonifas was much involved in trying to duplicate through experimentation the elegant glazes of the earlier European ware, especially the satiny black, and the celadon and crackle, which were directly influenced by ancient Chinese wares. The rudimentary equipment in the School of Art

Betty Feves. (b. Lacrosse, Wash., 1918). Structure, ca. 1962, stoneware, slab-constructed, red slip, ash glaze, 35 × 18 × 9¼. Coll. of Robert Hale Ellis, Jr., Portland, Ore.

(in portable buildings) was improved when Bonifas and the students moved into the new building where gas kilns were available that accommodated larger works, still in the earthenware temperature range. The high-temperature kilns were installed later during Bonifas' tenure and were never a major part of his repertoire.

If, as Walter F. Isaacs stated in his 1947 article in *Design,*[*] Paul Bonifas had come to the United States because he liked a practical approach to problems and the spirit of industrial life, he was abundantly aware by 1954 of a growing desire in the United States "for a new kind of production bearing the imprint of the individual's sensitivity."[†] After his sabbatical leave in Europe that year, he reported that the old forms of workshops and their static traditions were dying out and that the same drive toward individualism among artists was operating in Europe. He called for a harmonious evaluation of the seemingly irreconcilable differences between the individual and industry with creativeness and responsibility as leveling factors.

One may assume that Bonifas' personal frustrations were intense, leaving as he did, past middle age the security of his homeland and arriving in the western United States at a time when all the traditions connected with his medium were about to be abandoned in the revolution within ceramics. From 1955 until his retirement in 1959, he was involved in producing sculptural objects in terra cotta, including a series of stylized figures and masks, the titles of which were biting satirical social commentaries. Many of these were formed of various chemically composed, unglazed clays of different colors, so carefully analyzed and mixed that they could be fired at the same temperature. Bonifas' work was shown in solo exhibitions at the Seattle Art Museum as well as in other galleries in the Northwest and in Utah. He died in 1967.

[*] "Paul Bonifas, Potter from Switzerland," *Design* 48–49 (September 1947):24.
[†] From Bonifas' report of 28 September 1954 to the School of Art, Univ. of Wash., on his sabbatical leave.

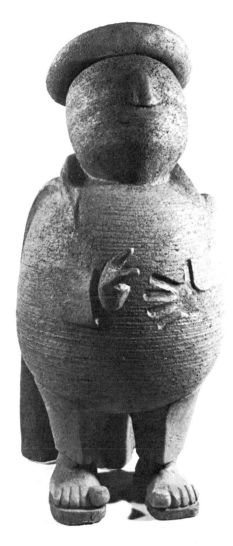

Paul A. Bonifas (b. Geneva, Switz., 1893). Sancho Panza, *ca. 1959–60, terra cotta, wheelthrown with modeled parts attached, unglazed (work from this period was often polished with a stone), 25¼ × 10½ × 12. Henry Art Gallery, Univ. of Wash., Seattle. Gift of John and Anne Hauberg.*

Betty Feves. Harmonica Player, *1955, red stoneware, slab- and coil-built, matte glaze, H. 12.*

At Montana State University, another artist, printmaker Frances Senska, was switching to pottery. Trained in ceramics under Marguerite Wildenhain, Hal Riegger, and Edith Heath of California and Maija Grotell at the Cranbrook Academy, she accepted a bid in 1946 to develop the ceramics curriculum at Montana. She was able to increase her new involvement with clay, thus recognizing and fulfilling some of her own needs. A "Bauhaus baby," by her own definition, she had studied before the war with Laszlo Moholy-Nagy and Gyorgy Kepes at the Institute of Design in Chicago and had at first hoped to become an architect and later was interested in industrial design. Her belief that the idealistic tenet of the Bauhaus regarding the best and highest use of the materials was being thwarted by capitalistic, mass-production ideology caused her to turn to pottery to fulfill her desire to produce something beautiful, useful, and satisfying—"something needed by people who don't have much." She believes her years in Africa, where she was born, and where all objects were useful in some way, may have encouraged this attitude. In a conversation with the author, her response to the question, "How do you feel about clay?" was "I love it and it loves me." She then related an anthropologist friend's story about an African tribesman who said the best potter is the one whom the clay loves.

Senska's humanism was the special characteristic of her teaching attitudes. She advised her students to seek a broad background before specializing, and she left room for them to develop their unique talents. Now in retirement from teaching, Senska is involved in producing useful ceramic objects for the Montana market.

Two native Montanans, Rudy Autio and Peter Voulkos, registered as undergraduates in Senska's early ceramics classes at Montana State University. Their impact was to be felt throughout the United States, and one of them, within the next decade, was to alter the history of ceramics in a major way. Voulkos had considered architecture, engineering, mathematics, and commercial art before settling on painting as a major, and Autio had selected sculpture. Both had postponed taking a required craft course until their senior year and by the end of that year, both were fully involved with clay. Senska says, "In those days we didn't . . . have much specialization—everyone did everything. Rudy's main direction was sculpture, but he also did elegant paintings, prints, and enamels, etc. Pete was also good at everything he touched." Concerning one aspect of their treatment of the ceramic surfaces, Senska says that her pots were always ornamented, due probably to her love for African art. Regarding the work at Montana State in 1950, her comments were, "I guess we all drew on pots. The sculptural form wasn't the only thing—the surface could also be personalized. At the same time we all had a horror of 'pictures on pots' and tried to be sure that the ornamentation seemed an integral part of the pot." Only electric kilns were available to these artists, limiting them to lower-fired earthenware in oxidation firings.

When interviewed by Paul Soldner, a ceramicist who worked with Voulkos in Los Angeles in the mid–1950s, Voulkos said that during the Montana State period he was interested only in shapes, that he knew nothing about classical form, or about history; they spent a great amount of time digging and processing clay and glazes, learning to throw, and learning what clay was about.* And, he indicated that he competed with objects found in books and catalogs. In fact, the story is often told about Voulkos' having "duplicated" at several feet tall, a form he saw reproduced in a

* "Ceramics West Coast," *Craft Horizons* 26(June 1966):25.

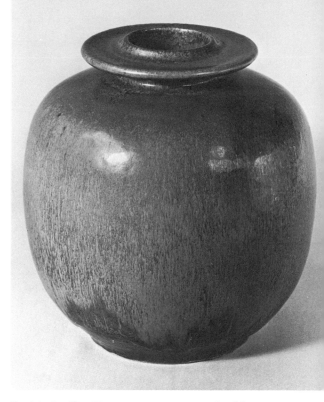

Paul A. Bonifas. Vase, 1954, stoneware, wheelthrown, reduction fired, two glaze layers, H. ca. 10. Coll. of John and Anne Hauberg, Seattle.

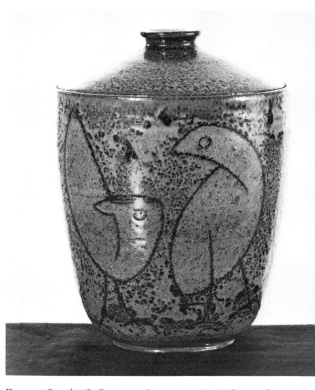

Frances Senska (b. Batanga, Cameroon, 1914). Covered Jar, 1953, stoneware, wheelthrown, chrome tan glaze, waxed inlaid line and spattering of brown slip, brown glaze inside, H. 6 × Dia. 5½. Henry Art Gallery, Univ. of Wash., Seattle.

magazine, which turned out to be, in actuality, only three inches tall.

There had not been many ceramicists with whom to compare Voulkos or his work or his phenomenal, almost superhuman psychic power. The only "individual" potters before the 1940s were the Appalachian crock makers, and they were not considered as artists. In the Northwest, self-taught Gus Lange, who dug clay, made up his own glazes, and threw vigorous crocks and bottles on a primitive wheel in Auburn, Washington before World War II, may have been the harbinger of the Peter Voulkos vitality. Lange, who also made cast pieces, threw bean pots for Sears Roebuck and Co. to use as bonuses on the purchase of washing machines. In the early days he had worked in the ceramics factories in the East.

On a world-wide scale, T. S. Haile, a young English potter who was active just before Voulkos began his studies at Montana State University, and who taught and worked in the United States, may have been a match for Voulkos. An article in *Craft Horizons* eulogized Haile at the time of his early death: "A great artist who was a . . . prodigal in his productivity. There was, possibly, no one of his generation in this field who rivaled him in vitality. . . His style was bold, noble, and imaginative in the most forward-looking and best of the contemporary manner. . . . The esthetic simplicity and power (of his work) bespeaks excellence, particularly noticeable in the manner Haile throws stoneware to the absolute limit of its yield point and structural strength before it breaks, achieving thereby a rhythmic tension quite of the same essence as sculpture."[*] This same description could easily have been made of Voulkos. Some of Haile's work pictured in periodicals of the day was not too different from the early Voulkos pieces especially in scale and form.[†]

Senska tells of bringing Rex Mason from San Francisco for a summer in the hope that Mason's vessels of more refined forms might have a "good" influence on Pete; Voulkos' work grew even larger and more impressive. He worked late into the morning hours during that year at Montana State, and it is said that the department chairman locked him out because he used so much material and made such a mess. On 9 June 1968, Voulkos was awarded a Doctor of Humane Letters degree at Montana State University. Voulkos' main contact with the outside world while at Montana State was to send work to some exhibitions, and his first entry in 1950 in the Ceramic National won an award.

Around 1952, Jayne Van Alstyne joined the design faculty at Montana State University, bringing with her a knowledge of high-fired stoneware from Alfred University where she had received a degree. This was the beginning of a long line of Alfred–Montana connections that exists to this day.

The Archie Bray Foundation

Before Peter Voulkos and Rudy Autio received their graduate degrees in 1952 at the California College of Arts and Crafts in Oakland and Washington State University, respectively, dynamic vibrations were being felt at the Western Clay Manufacturing Company in

[*] "T. S. Haile, Ceramist," *Craft Horizons* 9(Summer 1949):10.

[†] See E.A.B., "The Arts of Living," *Architectural Forum* (March 1949):178 for reproductions of Haile's work.

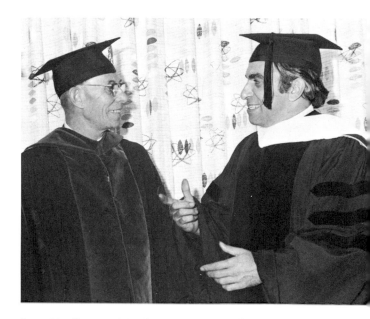

Peter Voulkos receiving honorary Doctor of Humane Letters degree, Montana State University, June 1968, from Dr. Leon Johnson, President.

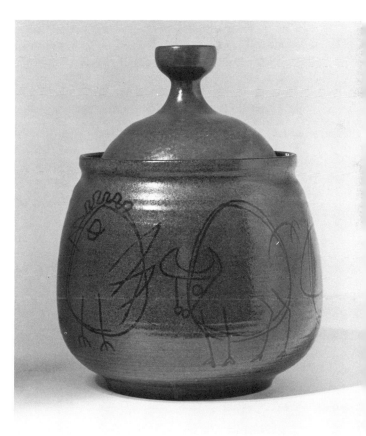

Peter Voulkos (b. Bozeman, Mont., 1924). Cookie Jar, 1949, made in Bozeman, local clay and glaze, wax resist, H. 13¾ × Dia. 8⅝ (covered). Awarded Purchase Prize at 15th Ceramic National, 1950. Everson Museum of Art, Syracuse, N.Y.

Helena, Montana, then owned by Archie Bray. In the early 1940s, Pete Meloy (now a judge in Helena) and his late brother, Henry, who had tried unsuccessfully to build a kiln on their ranch, were allowed by Archie Bray to fire their pots on top of the brick firings in the company's round beehive kilns, thirty feet in diameter. This activity interested Bray, who was dedicated to the goal of self-development and to the arts in general, and, who, prophetically, had designed a potter's wheel at age thirteen. He had graduated in 1911 in ceramic engineering from Ohio State University, where Arthur Baggs later was to emphasize the value of integrating good design with industry.

Bray enthusiastically suggested that a pottery be built in the brickyard. The Meloys and, later, Branson Stevenson, an artist who was to play a major role in securing support for the pottery, started, along with Voulkos and Autio, the construction of a building in 1951, which was to become the base of the Archie Bray Foundation, established also in 1951. That same summer they built two large down-draft kilns, one for salt-glazing and one for high-fire reduction wares, plus a twenty-five-foot stack to accommodate the kilns. These kilns offered the only opportunity in the Northwest to work in the very high stoneware range and in salt-glazing (throwing salt into the earlier available electric kilns would have ruined the elements). Frances Senska recalls that "the kilns they built at Archie Bray couldn't be kept from reducing, the gas pressure at the yard was so great!" After Voulkos and Autio received their graduate degrees, they returned to the Archie Bray Foundation as resident artists. The letterhead for the Foundation reads: "To make available for all who are seriously and sincerely interested in any of the

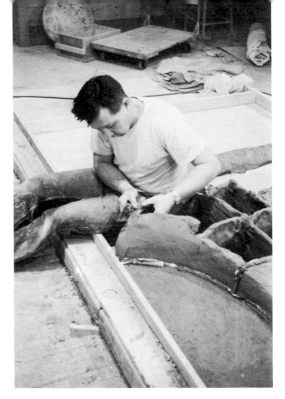

Rudy Autio constructing hollow-built relief panel.

Rudy Autio. Relief, 1957, brick, carved, H. 192 × W. 216. Gold Hill Lutheran Church, Butte.

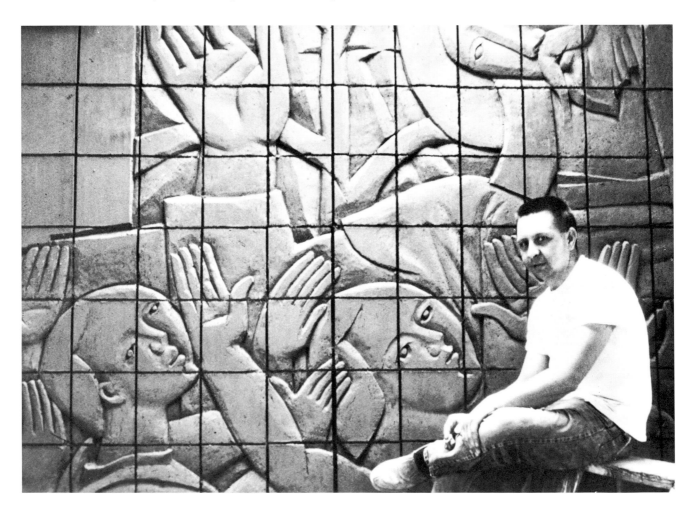

24

branches of the ceramic art a fine place to work." A high level of activity occurred at the Foundation from 1952 through 1954, and the many people who went there agree that they were affected profoundly by the presence of both Autio and Voulkos, although Autio's greatest influence was to be felt later than Voulkos'. There was still much emphasis on the production of functional wares, which were sold to keep the artists and their families alive.

Rudy Autio was involved largely with ceramic sculpture at the Foundation. He continued the three-dimensional modeled work he had started at Montana State and began working with slabs, a method by which he would construct, a decade later, some of his most powerful work in vessels. He commented recently that his slab work in vessels really began to work for him in 1961.

Some of Autio's early slab and tile work was related to a long list of public architectural commissions in Montana which began as early as 1954 in Great Falls with two large murals measuring 10' by 30' and 16' by 40' at the First Methodist Church and the Charles M. Russell Museum. Regular commissions followed for use in public buildings through his Archie Bray period and into his tenure at the University of Montana. Commissions executed during 1963 alone may be found in churches, banks, and libraries in Anaconda, Butte, Helena, Cutbank, Bozeman, Chinook, and Missoula.

The murals are high and low reliefs, some unglazed or subtle in color, others brighter due to the use of various oxides, often completely abstract or sometimes with deeply carved, stylized figures in the early religious works. The religious imagery was influenced especially by the Cubism of the early part of the century. Figures were abstracted into angular, geometric forms, sometimes with faceted prisms, and executed as if seen from more than one view. During the late 1950s Autio worked a great deal with horse imagery, modeling in deep relief for wall tiles, or in three dimensions, forms that seem related both visually and in vitality to the famous ceramic T'ang horses. Some of the abstract wall pieces are of hollow construction, the three-dimensional relief formed in sections with large clay slabs at right angles to the surface of the work. In 1959 Autio completed what is probably his best-known mural—the unique 6' by 70' work installed in the Union Bank and Trust Company in Helena which depicts scenes typical of early goldmining camps. He excelled at drawing and was influenced by his friend, Henry Meloy, and by artists such as Picasso. This influence appeared early in these murals and was always to affect his approach to the surface of his sculpture and vessels. The human and animal figures and wagons and other imagery in the Union Bank work were heavy line drawings in slip or mortar on carved clay that had been pressed and smashed over large sheets of plywood. Resembling a giant jigsaw puzzle, this work is rugged and two-dimensional with little feeling of illusionistic space. Senska remarked in a recent conversation with the author: "We've come a long way since the days at Archie Bray Foundation when Archie would bid in Rudy's decorative wall panels along with the bricks he was supplying for a construction job and at about the same price." She went on to say that "one of the cash jobs Rudy took on to help support the operation was making wax figures for a diorama at the Museum of the State Historical Society—the Lewis and Clark party on the Missouri . . . a very nice thing . . . but, with one detail that most historians are not aware of: all the members of the Lewis and Clark party look like Pete!" Another little-known fact is that Autio included a portrait of Peter Voulkos in the *Sermon on the Mount* panel in Great Falls.

Along with the murals and the vigorously modeled three-dimensional sculptures, Autio produced slab-built functional objects that were spontaneous and lyrical in feeling.

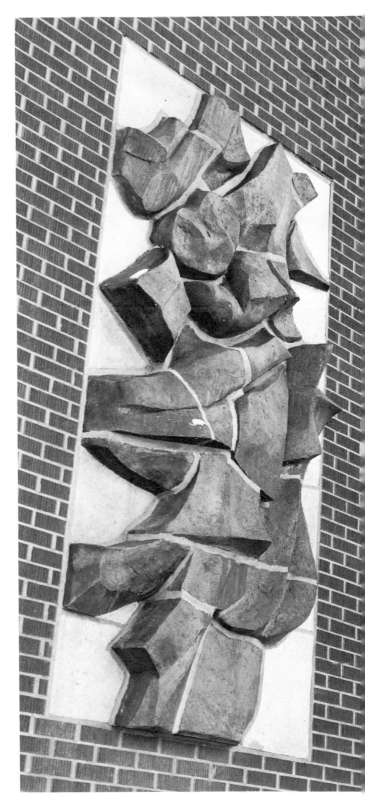

Rudy Autio. Relief Panel (one of three), 1961, terra cotta, hollow-built, iron oxide wash, blue and white engobes, light lead glaze over each relief, 96 × 48 × ca. 15. Montana State Univ. Library, Bozeman.

Voulkos continued his power throwing, which he had begun at Montana State. He launched into intensive clay body and glaze experimentation in the stoneware range, using as a base some of the glazes developed by F. Carlton Ball, who had received his advanced degree at the University of Southern California in 1934 under Glen Lukens. Voulkos took full control of the clay and began using it as an expressive medium. His gigantic vessels rivaled in size and form the work of the ancient Greeks, although Voulkos says he was not interested in Greek art as such and that these large forms had no connection with his Greek heritage. His powerful clay forms have always been basic to his work, but he has also approached the medium as a painter and draftsman, strengthening an already forceful form with surface treatment. In those early days he studied closely in magazines and books the work of the Cubists and the Fauves as well as Scandinavian work, adapting these influences to his own ideas.

Of the summer of 1953, when he was invited to attend the last of the controversial Black Mountain College summer institutes, Voulkos says his mind was opened and he became more aware of his own artistic potential. He met painters, dancers, poets, and composers (Merce Cunningham, David Tudor, Franz Kline, Charles Olson), and in New York he saw his first great contemporary paintings including those in the prevalent style of Abstract Expressionism. At the Foundation, even before he went to Black Mountain, Voulkos was thinking about nontraditional ceramics (although he thinks he made no distorted, abstract slab works before he moved to Los Angeles). A clue to his immediate future was couched in his comment at the Archie Bray Foundation that, "if it holds water, I call it a vase, and if it leaks, I call it a sculpture." Ivarose Bovingdon, a student of Voulkos' at the Foundation, who tells this story, quickly adds that he could make them perfect when he wanted to. As Voulkos stated in a recent interview with the author, "I was getting pretty good at ceramics at Montana and was concerned with, I can't even say 'quality,' I didn't know what form was about. I was more oriented to vessels that had a specific function. [He had learned about "craftsmanship" and about producing stoneware at the College of Arts and Crafts]. It wasn't until Los Angeles [after the period at the Bray Foundation] that I became more conscious of what form was about by . . . understanding

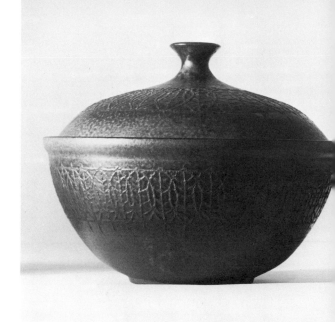

Peter Voulkos. Covered Bowl, n.d., made at Archie Bray Foundation, earthenware, local clay and glaze, dark green, wax resist decoration, H. 11⅜ × Dia. 13⅞ (covered). Awarded Purchase Prize at 16th Ceramic National, 1951. Everson Museum of Art, Syracuse, N.Y.

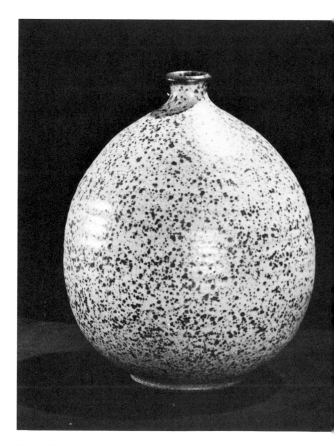

Peter Voulkos. Bottle, ca. 1953, stoneware, reduction fired, wheelthrown, glaze with iron spots from clay body, H. ca. 15.

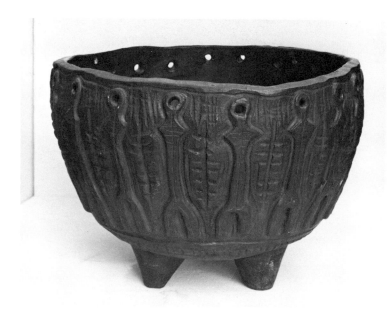

Peter Voulkos. Planter, 1951, earthenware, coil-built, carved surface, iron slip, H. 10 × Dia. 15½. Contemporary Crafts Gallery, Portland, Ore.

myself. . . . I began making more interesting . . . experiments. . . .
I started to learn to play the guitar; and listening to the teacher
talk about foreign music really turned me on. The combination of
really teaching in real classes and talking about form to the stu-
dents, I had to get turned on—quick."

In assessing the contribution of a creative figure such as Voulkos,
it is impossible to say which is more important: the inspiration
provided to others, or his artistic accomplishments. It must also
be considered that although many artists obviously have been in-
spired by his personal style and magnetism, it is also possible that
some were not able to cope with his innate power. In Voulkos'
own words: "What it comes down to is energy; it's not that it's
this or that [style], but I think there's a certain kind of energy
that comes out—physical and psychical energy. You can just feel
the energy in some places and in some places you can't. . . . I
think there's something there about energy that is really important.
Like people can be doing a hell of a lot of work but there's no
energy around. There's something—a creative kind of energy, a
mystical kind of energy. Even in Montana, there was a lot of energy.
. . . Just about every place I've been, I've been able to create a
kind of energy. But, it's hard to get out from under it. Without
being egotistical about it, I exude that sort of thing. I energize a
lot of people whether I like it or not."

Voulkos left the Archie Bray Foundation in the summer of 1954
for the Los Angeles County Art Institute, where he went to teach,
and by 1956 he and a small band of magnetized students and co-
workers had changed the traditional concepts of ceramic-making
for all time. In 1959 he became a permanent member of the sculpture
faculty at the University of California at Berkeley.

If Peter Voulkos was the most dynamic individual force in the
Northwest ceramics field from 1952 to 1954, the most dynamic event
was a week-long workshop conceived by Branson Stevenson and
offered at the Archie Bray Foundation in 1952. The workshop was
conducted by Bernard Leach, a British ceramicist who had studied
Zen Buddhism and pottery in Japan for many years, Shoji Hamada,
world-renowned Japanese ceramicist, and Soetsu Yanagi, founder
of the Mingei movement in Japan. All were long-standing friends
of Mark Tobey. The inspiration gained from their visit is still re-
flected today in conversations with people who listened to them
in Montana and other parts of the United States.

Paul Soldner, who has had a sustained interest in Raku firing
processes, remarked: "We owe a lot to Leach for opening our eyes
to another way . . . of thinking about art that had to do with humility
and oneness with nature—more with the spiritual than with the
commercial, . . . and he encouraged us to return to the simple ideas
of using clay and fire and fluxes . . . for the subtle beauty they
would bring."

Robert James, now head of the Department of Fine and Applied
Arts at the University of Oregon in Eugene, recalls: "Soetsu Yanagi
came to UCLA in 1952, and his lecture on Zen Buddhism aesthetics
absolutely brought me to a stop. I turned a corner; that was a
very, very large thing in my thinking. . . . You've got to remember
that time: the neo–Bauhaus 'plain is good,' everybody was eating
out of purest porcelain and painting everything they owned white,
. . . sanding everything down smooth—that Teutonic spirit. And
then this thing went "WHACK," and I said, 'That is exactly right,
isn't it!' "

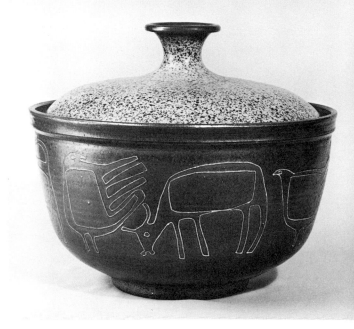

Peter Voulkos. Casserole, 1953, stoneware, wheel-
thrown, wax resist, sgraffito, white slip, iron glaze,
Dia. ca. 14. Coll. of Fred and Constance Jarvis.

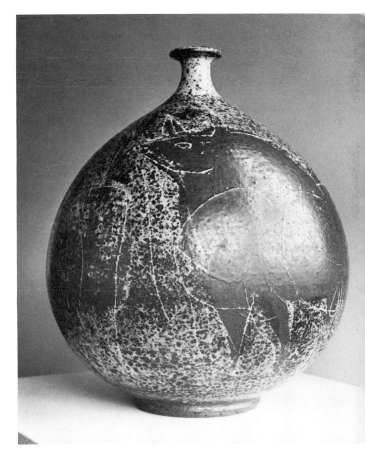

Peter Voulkos. Babe, the Blue Ox, ca. 1952, stoneware,
wheelthrown, wax resist, sgraffito, white slip, cobalt
and iron glazes, H. 15 × Dia. 12. Coll. of Katharine
MacNab, Portland, Ore.

Peter Voulkos liked Hamada very much: "I helped him—had to kick the wheel for him because he sat Japanese style, and so I got to watch him really close, and then Rudy and I drove him around the mountains. . . . I was very much taken by his whole attitude about form and pottery. I suppose it was then that I got turned on to what Oriental pottery really was. Up to then I was geared to the 'good design' attitude that was so prevalent at that time."

Yanagi's lecture at the workshop on "The Mystery of Beauty" and "The Responsibility of the Craftsman" had a great influence on the way the potters felt about their craft, as did Hamada's views about his own work. Leach's personal appearance at the Archie Bray Foundation brought to life the spiritual and technical views espoused earlier in his *Potter's Book,* which had been available in the Northwest states since 1945 and earlier. During a later visit to the Oregon State University in 1966, organized by Marian Bowman and Ted Wiprud, Leach, in his late seventies, was still as dynamic and inspiring as ever. David Stannard of the University of Oregon studied with Leach later at St. Ives in England. The message from the Oriental masters was for the potter to work naturally and unselfconsciously without regard for "artificial" considerations, such as making pots for exhibition or working in predetermined styles.

Paul Soldner recently suggested that Leach, in his sincere desire to spread the Oriental message, may have missed a critical point in his comments about American potters: "What he was saying was that American potters had no tradition, which made it almost impossible for them to achieve any heights. I think . . . with no tradition we were free to absorb . . . to create our own tradition. . . . American tradition in pottery is still changing . . . the road is wide open. That's why young Japanese potters come to America to learn about pottery. They don't stay in Japan."

The workshop at the Archie Bray Foundation was only the beginning. Frances Senska at Montana State University had brought as exhibitors or visitors such ceramicists as Gertrud and Otto Natzler, members of the San Francisco Potters Association, and Edith Heath, in the late 1940s and early 1950s; the Foundation also attracted many distinguished visitors once it was in operation. Giving lectures, workshops, and seminars were Marguerite Wildenhain, Angelo Garzio, Daniel Rhodes, Antonio Prieto, Val Cushing, Robert Arneson, Wayne Higby, Toshiko Takaezu, Warren MacKenzie, James Melchert, Henry Takemoto, and Ruth Duckworth, among many others. One of Voulkos' earliest students at Bray, Ivarose Bovingdon of Seattle, was self-trained in slab building and molded ware. Bovingdon had also had a few lessons in throwing on a small, rudimentary wheel from Sylvia Duryee, a student of Bonifas. At a chance meeting when he was showing at Gump's in San Francisco, Voulkos promised to teach Bovingdon to develop the throwing if she registered at Bray. From those first lessons until 1954, Bovingdon, Kay Perine, and Connie Jarvis studied with Voulkos about three times a year and transmitted what they had learned to many potters in the Seattle area. Robert Sperry, a painter and potter with a B.F.A. degree from the School of the Art Institute in Chicago, who would later become the head of the Ceramics Division at the University of Washington, worked at the Foundation during the summer of 1954, where he learned to throw.

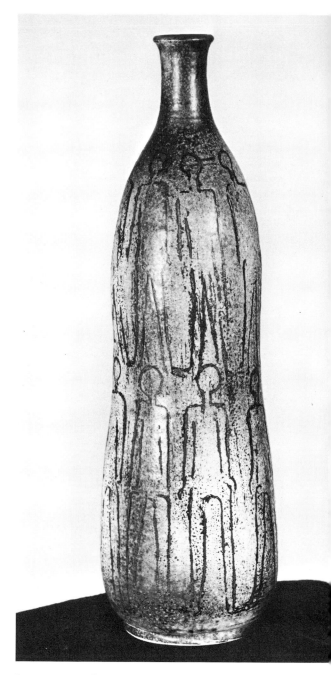

Ivarose Bovingdon. Bottle, 1958, stoneware, wheel-thrown, H. 17½ × Dia. 5⁵⁄₁₆. Henry Art Gallery, Univ. of Wash., Seattle.

Some other people who were involved during those formative years were Lillian Boschen, Bernice Boone, Maxine Blackmer, Eugene Bunker, James and Nan McKinnell, and F. Carlton Ball, in residence in official and unofficial administrative positions and/ or in the production of pottery for reasonably long periods of time. The informality surrounding the facility is perhaps best reflected in the differing information gained from a number of sources concerning the official titles and duties of the early participants. The Foundation was fortunate in later years to have as resident directors Ken Ferguson (1957–1963) and David Shaner (1964–1970), both graduates of Alfred University and both important contributors in getting the Foundation on a sound economic base after the assistance of Western Clay Manufacturing Co. was phased out upon the death of Archie Bray in 1953. Shaner, especially, who usually shunned organizational activities and paperwork, is credited by many with having saved the facility.

Ferguson's highly functional, covered stoneware vessels (casseroles, serving dishes, soup tureens, etc.) are made with ease and rhythm, and they reflect his love of making pots for people. After his early years in the East, he was so affected by the scale of the land and sky in Montana that he continued for a while to turn out casseroles that would not fit into an oven. A fine teacher, scientific in approach, he gave his students assignments for throwing forms of precise measurements from carefully weighed mounds of clay. He sees lost opportunity in the fact that more potters are not pursuing industrial techniques in their production or working in design for industry. For instance, today, he sees possibilities in bringing back the use of plaster molds for casting and jiggering forms as a welcome relief from the wheel work involved in making functional wares.

An equally fine craftsman, Shaner is capable of producing in quantity large-scale, simple, hand-built, or wheelthrown forms that imitate the delicate, mathematical balance in profile of classical Greek sculpture and architectural elements, yet Shaner's work seems more intuitively formed. Ferguson, as a graduate student at Alfred, had taught Shaner to throw. One of Shaner's most unique works, an award-winner in the Twenty-fourth Ceramic National in 1966, is a torn, expressionist slab partially glazed with a natural wood-ash glaze pooling in the center, a splash of white slip, and a hedge apple from an Osage orange tree burned on the surface. About that slab Shaner says, "I had just gotten back from a hike into the Escalante Canyon country—the Glen Canyon is all now inundated by the waters of Lake Powell—and, although I wasn't attempting to copy anything, that experience was uppermost in my mind: a hot, harsh, desert land with serene pools, a beautiful, powerful land. I don't know whether it shows or not, but I had pressed an oak leaf into the wet clay, amazed to find miniature oak growing down there."

It wasn't until around 1962 that Ferguson and Shaner, with the assistance of Bill Sage, a Washington potter who was in residence most summers from 1961 to 1969, dismantled the old, Voulkos–Autio, hard-brick reduction kiln and built the first soft-brick kiln at the Foundation.

After leaving the Foundation, Ferguson went to the Kansas City Art Institute, and Shaner, more interested in producing as an artist than in teaching, moved to Bigfork, Montana. The contribution of Shaner and Ferguson to the Archie Bray Foundation, with their experience at Alfred in functional pottery and glaze theory, cannot be underestimated.

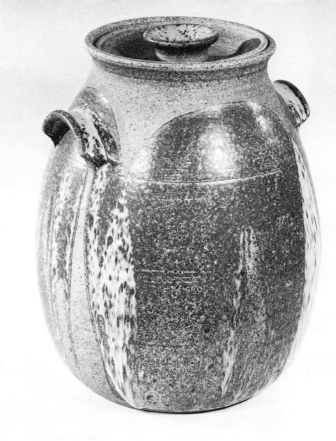

Kenneth Ferguson (b. Elwood, Ind., 1928). Storage Jar, 1964, stoneware, wheelthrown, iron glaze and unglazed areas, H. 13⅜ × Dia. 8⁵⁄₁₆. Henry Art Gallery, Univ. of Wash., Seattle.

David Shaner. Storage Jar, 1965, stoneware, wheelthrown, iron glaze, H. 16. Coll. of R. Joseph and Elaine Monsen, Seattle.

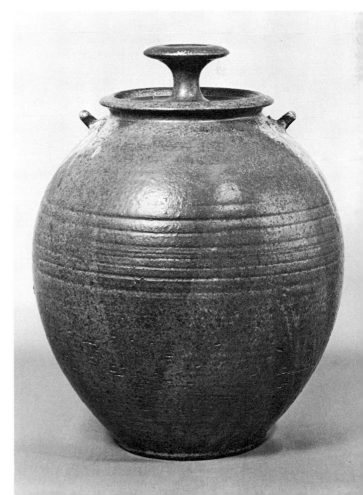

Dave Cornell, also from Alfred, and Judy Cornell took over as resident directors of the Foundation in 1971—Dave working as a glass blower, a medium that had been added in recent years; and Judy, in clay, especially porcelain. And, in 1977, Kurt Weiser, who had worked formerly in Michigan and in Oregon, was appointed director. Henry Lyman, in residence at the Foundation after his graduation from the University of Montana, has said that the Foundation's program helps an artist to become self-supporting. It deals with such questions as: How to price one's work? How to use one's time? How to balance practical affairs with artistic and intellectual matters? How to cope with the social environment? The practical considerations could be largely the contributions of Shaner and Ferguson, both trained in the pragmatic atmosphere of Alfred University. And, although the humanistic philosophies of the place can be attributed to many people, and especially, in the early years, to Archie Bray, Ferguson and Shaner also worked toward this end. As Shaner tells it: "It was a more honest approach to studying pottery. All the potters worked together—clay, glazes, kilns, philosophies were taken apart from the textbooks of a school environment and came to life in the hands and hearts of the potters."

Technical Developments

About the same time that Bernard Leach's teachings of Japanese aesthetics and production pottery techniques were filtering through the United States, technological ideas and improvements brought new possibilities for both functional and expressive aspects of ceramics.

Firing techniques in kilns evolved from wood through coal and oil and finally to gas, with electric kilns for low-fired earthenware and brightly colored glazes. The advent of natural gas helped to revolutionize the high-fired stoneware and porcelain processes. In the Seattle area the conversion to natural gas was made in 1956 using pipes that had earlier carried manufactured gas. Natural gas was cheaper, more available through expanded service, and, most important, a more stable fuel, making it ideal for kilns. Also, the new, soft insulating brick reached high temperatures much sooner than had the old hard brick and fired in a shorter time.

Bennett M. Welsh of Portland told of how he built his first kiln in 1949: "A wood burning updraft, cone 10 on the bottom, .06 on the top—you have to remember there were not many how-to-do-it books in 1949—½ cord of wood per firing, 74 hours to cone 10."

Robert Speelmon, Ralph Spencer, and John Polikowsky, potters in Seattle, designed and built some of the earliest marketable wheels in the Northwest around 1950, and Speelmon designed electric kilns and constructed them for sale or sold them in kits. The Scut family in Olympia, Washington also designed some of the earliest wheels and kilns for the market.

During the 1950s, Nan McKinnell, who earlier had been a student of Paul Bonifas, and her husband, James McKinnell, contributed greatly to the field of ceramics not only as artists of high rank, but also as masters of technique. In 1941, James, then a student in ceramic engineering at the University of Washington, completed his thesis, "The Making of Pottery and Glazes from Pacific Northwest Clays." Later, their travel and teaching throughout Japan and the British Isles, in addition to early study in France, England, and Scotland, gave the McKinnells a direct understanding of some of

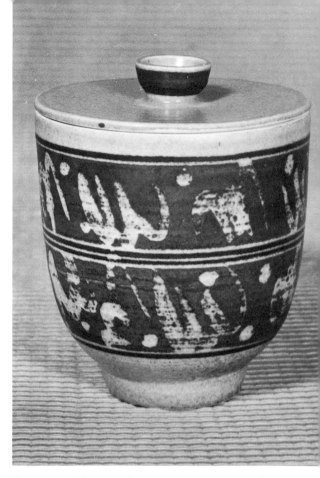

Nan McKinnell. Covered Jar, n.d., porcelain, wheel-thrown, wax resist decoration.

the production pottery techniques that Leach and Hamada practiced. One of their greatest technological contributions was their research and work in 1947 and 1948 on a loose brick (unmortared), gas-kiln concept in Seattle. They designed their first propane gasfired, two-chamber, high-temperature kiln at the Archie Bray Foundation in 1955 and a larger version in 1956 for Ruth Penington's Fidalgo Island Summer School of Art. By 1957 they had blueprints made and helped spread the idea over the entire western hemisphere.

The McKinnells' work has usually been functional vessels in stoneware with attention given both to surfaces and to form and with strict attention to fine craftsmanship in spouts, handles, and lids, probably the result of Nan's arduous training with Bonifas. Always innovative, yet firmly grounded in ceramic history, Nan's recent work includes large asymmetrical, coiled pots that recall those made by Nigerian women. James's latest specialty is "tramp" pottery, i.e., clay tramped underfoot and then formed into primitive-looking vessels.

F. Carlton Ball, who first came to the Northwest as artist-in-residence at the Archie Bray Foundation in 1954, had many years of solid experimentation with all technical aspects of pottery making.

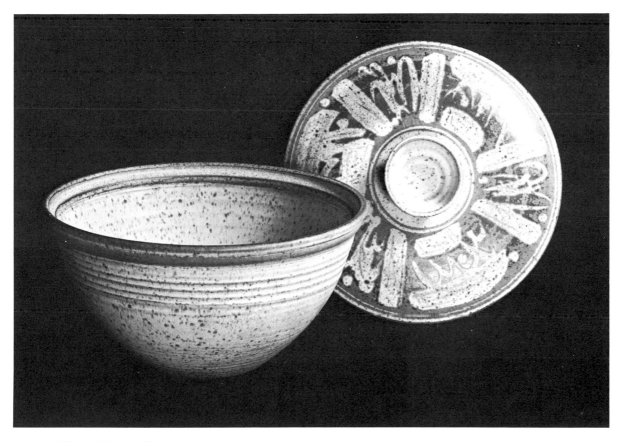

James McKinnell. Casserole, 1957, stoneware, wheelthrown, white glaze with green wax resist decoration, H. 7½ × Dia. 14½. Henry Art Gallery, Univ. of Wash., Seattle.

After graduating from the University of Southern California in 1934, he had, in 1939, demonstrated on a kick wheel at Treasure Island and soon after, started building the ceramics department at Mills College. By 1946 he was throwing large vessels, and was working in high-fired stoneware and porcelain and with salt glaze at Mills as early as 1949. By 1953 he had already contributed twelve articles to the monthly magazine *Ceramic Industry* on a wide range of technical subjects directed to potters and teachers. A large exhibition of his pottery, all executed at Southern Illinois University where he had served as head of the ceramics department, was shown at the Henry Art Gallery at the University of Washington in 1954. Ball's work has always been in vessel forms in stoneware with a wide range of decorative effects, some in the middle fifties in collaboration with the painter, Aaron Bohrod. Some memorable works are gigantic (some six feet tall) bottle forms constructed of wheelthrown or coiled sections. Ken Stevens, a former masters student of Ball's and now teaching at the University of Puget Sound, where Ball was head of the ceramics department from 1968 to 1975, praises him as a teacher and says that Ball had saved him endless hours by volunteering suggestions based on his own extensive experimentation.

In 1947 Hal Riegger, a graduate of Alfred University and for years a regular exhibitor and frequent award-winner in the Ceramic National at Syracuse, was hired as studio technician at the Oregon Ceramic Studio. For some ten years he conducted workshops in the Northwest and Canada. His interest was directed toward helping people to become more aware of materials, to see with a fresh point of view, to make do with what could be found. His workshops, usually held in an outdoor setting, offered pottery making from native clays fired either in Raku or in other primitive firings.

Some apparently minor advances helped to make great changes in the state of ceramic art. For instance, the process of wax resist, so popularized during the visits of Leach and Hamada, was made easier when Branson Stevenson, district manager of a major oil company in Montana, made available to the potters of the area his company's product containing wax suspended in water which replaced the tedious task of dissolving wax in kerosene and using it hot. The Archie Bray Foundation still markets the product today as "ceresist." And Rudy Autio, whose slab-built works were to have an enormous impact throughout the United States, was assisted eventually by the acquisition of a slab-making machine at the University of Montana.

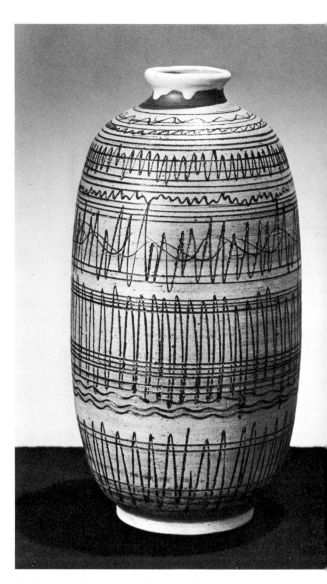

F. Carlton Ball (b. Sutter Creek, Calif., 1911). Bottle, 1955, stoneware, wheelthrown, white slip with sgraffito design, H. 12⅜ × Dia. 6³⁄₁₆. Henry Art Gallery, Univ. of Wash., Seattle.

PANOWACS

At the Pacific Art Association convention at the University of Washington in April 1951, the Pacific Northwest Section of the American Ceramic Society (PANOWACS) presented a series of papers dealing with technical matters, as well as philosophical, aesthetic, educational, and career aspects of working in clay.* Papers on the subject of ceramics as a therapeutic medium were also presented, recalling Lydia Herrick Hodge's interest in the importance of using clay in the education of the handicapped. George McAninch, a graduate in ceramic arts from the University of Washington, spoke on "The Modern Potter," with considerable discussion of the technology of clays and glazes, and Francis Ford, instructor in ceramics at the university, presented a paper entitled "Use of Local Glacial Clays in Ceramics."

* Transcripts available at Univ. of Wash., School of Art Library.

Even before Leach's visit to the Northwest, potters were beginning to catch on to the concept of producing larger amounts of work and, even, of the possibility of making a living at the craft. These ideas were echoed in "The Potter," a paper read by Thorne N. Edwards, associate in ceramic arts at the University of Washington, dealing with the preparation for a career in a combination studio and retail shop. Edwards advocated the exclusive use of the wheel in the production of high-quality work available at a low price to all, always with the owner contributing to the output. He predicted the existence of good markets in shops and department stores. In 1977, Edwards and his wife, Dorine, were helping to carry out his prediction by producing in their studio in Port Townsend, Washington some of the most beautiful utilitarian pottery available. Dozens of other potters set up studio/shops in the Northwest.

Lennox Tierney of John Muir College, in his talk on "Ceramics: Oriental and Occidental," discussed the Japanese system of pottery production. In that system families cluster about a kiln producing enormous quantities of high-quality ceramics, each piece coming from the hand of one individual. Tierney's opinion was that "America suffers from heterogeneous mixed traditions, rapid assimilation of diverse outside influences and a case of production technology advanced over taste and design [leading to] junk in quantity." He called for better wares at lower prices and for ceramic engineers and designers to exchange information and to learn from each other.

Shops and Shows

After the war, at the same time that ceramics technology was improving, European markets opened up and home accessory shops began appearing throughout the United States. Pure white porcelain of simple design from Germany which reflected the philosophy of the Bauhaus replaced the more formal Spode china and other similar wares from England and appealed to young homeowners who were beginning to live informally. Scandinavia, whose governments had nationalized their craft schools and whose designers had teamed with industry many years before, actively promoted and exported plain, earth-toned and crisply formed, high-fired stoneware and fabrics and furniture. Soon, Edith Heath, a California production potter, founded a dinnerware factory that mass-produced the earliest and very popular stoneware in earth tones. Two leading Scandinavian periodicals, *Form* and *Kontur,* which regularly reproduced individually produced ceramic ware by Sweden's designers were not available at most university and community libraries in the Northwest in the 1950s. However, Swedish-born Matts and Siri Djos showed some of their work in their shop and lent an exhibition of "Six Swedish Ceramic Designers" to the Henry Art Gallery in 1951. Mass-produced German porcelain and Scandinavian work was seen early in the Seattle area in such shops as Djos, Hathaway House, Miller-Pollard, Keeg's, Altman and Prechek, Allen Vance Salsbury, Manchester and Pierce, and Del-Teet's. These wares won easy acceptance because of the combined emphasis on moderate cost and quality of design.

This was also the period of the "good design" exhibitions sponsored by the Museum of Modern Art in New York City in conjunction with the Chicago Merchandise Mart. Meanwhile, this "good design" was being actively taught in most university art departments and was practiced by the ever-increasing number of furniture makers and most handcraftsmen of the day, including potters. It dictated that its practitioners take advantage of new materials and techniques; that the design should express the purpose of the object, never making it seem to be what it is not; that the design should be simple, with form following function; and that the design should fulfill the practical needs of modern life and express the free and informal spirit of the times. In short, the concept of "good design" was based on honesty and integrity.

Some of the local shops in Seattle began to show handmade domestic pottery as well as imports. Jim Egbert and Walter Kerr, perceptive owners of Keeg's, sponsored Voulkos' first solo exhibition in Washington in their shop in the mid–1950s. Miller-Pollard and Crissey's shipped in work by such eminent, nationally known studio potters as Gertrud and Otto Natzler. Bill Teeter, a community-conscious owner of the exclusive Del-Teet's furniture store, with the help of Lou Swift, a top designer, sponsored group exhibitions by the area's most recognized groups, such as Seattle Clay Club and Northwest Designer-Craftsmen. Hazel Hathaway invited members of the local art community to serve on a selection committee for the local objects that were to be shown in her shop. And Ruth Nomura and the late Scott Hattori made available for purchase in their unique shop, Haru, some of the first imported, high-quality folk pottery from Japan—a sharp contrast to the precisely designed wares from Scandinavia and Germany being shown in most other shops. The Braune Studio in Yakima, Harold and Rosemary Balazs' shop in Spokane, and Meier and Frank's in Portland all sold original work of Northwest potters.

In the early 1950s, running parallel with the increasing consciousness among Northwest ceramicists that work in clay provided an expressive outlet, was a growing demand for exhibition space. Three exhibitions were held in the '50s that showed Northwest ceramics and would become regular regional events. In 1950 the Oregon Ceramic Studio founded a regional, annual, competitive exhibition for clay with Glen Lukens as the sole juror. Lambda Rho Alumnae sponsored invitational crafts shows in 1950 and 1951 at the Henry Art Gallery at the University of Washington and established in 1953, with the Seattle Weavers' Guild and the Seattle Clay Club, the Northwest Craftsmen's Exhibition, a competition to be held annually at the Henry Art Gallery until 1965 and then biennially to the present day. These exhibitions have shown new and established talent, and the collections of these agencies, drawn from such regular shows, serve as a history of ceramics in the Northwest. These institutions and the Arts and Crafts Society of Portland have been more committed to ceramics than any other. In 1952, the Seattle Clay Club sponsored the Seattle Centennial Ceramic Exhibition at the Henry Art Gallery. Other museums such as the Seattle and the Portland Art Museums, and many other smaller institutions over the years began to show more ceramics, and the image of the medium improved among the art elite. The Charles and Emma Frye Public Art Museum showed the work of Seattle Clay Club members as a group for several years prior to 1960 and the members of Northwest Designer-Craftsmen in 1961. The Cheney Cowles Memorial Museum in Spokane and the Tacoma Art Museum both sponsored competitive craft exhibitions. The Syracuse Ceramic National was shown several times at the Seattle Art Museum and at the Portland Art Museum, and the Henry Art

Gallery and the Seattle Art Museum also showed the work of Bernard Leach in a solo exhibition in 1951. A solo exhibition featuring the work of Marguerite Wildenhain was circulated in 1949 to Great Falls, Montana and to the Portland Art Museum and the Henry Art Gallery. The first important work to be shown in the Northwest that heralded the revolutionary change coming in the Northwest ceramics field in the early sixties was a combination wheelthrown and slab-constructed stoneware work by Peter Voulkos which was shown in an exhibition titled "Twenty Four American Craftsmen" at the Henry Art Gallery in 1957.

In the 1960s the art dealers began to take an interest in ceramics. Eventually, the Fountain Gallery in Portland and Attica, Hall-Coleman, the Phoenix, the Berk Galleries, Polly Friedlander, Penryn, and Cone 10 in Seattle all showed ceramics. Cone 10, especially, later to be known as the Jim Manolides Gallery, brought to a specialized audience, avant-garde objects in clay by such artists as Paul Soldner, Clair Colquitt, Erik Gronborg, Jacquelyn Rice, Irv Tepper, and Robert Arneson. Because of this emphasis on newer, more controversial works, without great regard for the commercial aspects, Seattle audiences acquired works that otherwise would never have come to their attention. In the mid–1960s, Gail Chase, a potter with a talent for business, founded the Crockery Shed in Bellevue, Washington, a gallery that handles only ceramic wares.

PANACA, an outgrowth of the annual summer Pacific Northwest Arts and Crafts Fair in Bellevue, Washington, developed into a show and sales place for all crafts, including much ceramic ware. Also in the mid–1960s, the Northwest Designer-Craftsmen's exhibition at Century 21, and Friends of the Crafts in Pioneer Square in Seattle both offered exhibition and sales facilities for craftsmen. Northwest Designer-Craftsmen was established in 1955 with elitist quality regulations governing membership, and have, over the years, sponsored many exhibitions of the work of their members. Friends of the Crafts was formed in 1965 to create an atmosphere for lively involvement between laymen and craftsmen and to foster the best in contemporary and ethnic, regional, and international crafts exhibitions.

By the mid–1950s, ceramicists from the Northwest were appearing regularly in nationally recognized exhibitions such as the Syracuse Ceramic National, the May Show in Cleveland, and exhibitions at Wichita, Scripps College, and the Lowe Museum in Miami. In 1967, thirteen Northwest ceramicists were featured in an invitational exhibition at Museum West, a museum in San Francisco sponsored by the American Craftsmen's Council. Northwest craftsmen have been shown in New York City at the Museum of Contemporary Crafts and at America House, both facilities sponsored by the American Craftsmen's Council.

The need for documentation of all of these exhibitions was met with varying degrees of success by a number of magazines that began to appear in the early 1950s. These include *Ceramics Monthly, Design Quarterly, Studio Potter,* and *Craft Horizons,* the last published by the American Craftsmen's Council. *Craft Horizons* has given interesting and complete critical and documentary coverage of contemporary ceramics in the United States, and it rivals in the excellence of its coverage, reproductions, design quality, and format, all of the so-called "fine arts" publications in the United States. In recent years, "fine arts" magazines such as *Art in America* and *Artforum* have begun to accept articles about objects made of clay.

New Freedom of the 1950s

The intensity of the activity in Montana set in motion in the early 1950s was a compelling force, and by 1955 the potters of the Northwest were caught up in an almost joyous excitement. They began to be aware of their potential for full technical and aesthetic control of their work. Running parallel with a resolve to find solutions to the financial problems of production was an increasing consciousness of expressive possibilities. There was greater communication between the potters of the Coast and those of the interior Northwest states, and the finished products showed an integration of qualities that had become part of the aesthetic treasuries of each side of the mountain range. The architecture of the Coast states relied heavily on wood and was influenced greatly by the Orient. The prevailing architectural philosophy was that the residence should be designed to blend into the lush natural building sites, and the new muted gray, green, and blue glaze tones followed these guidelines. The Montanans' approach to making ceramics was expansive, not only because of the grandeur of the land and sky, but also because of the standards set by Peter Voulkos. In addition, clay was abundant throughout Montana, and especially at the Archie Bray Foundation, where the sheer quantity of materials and equipment and the tempo associated with the commercial manufacture of bricks acted as a catalyst in the production of handmade objects.

The appearance of ceramic objects had also changed drastically due to the increased capacity of wheels and kilns and to the influence of Leach and the Japanese ceramic tradition. High-fired stoneware was favored now in predominantly functional forms—bowls, platters, branch bottles, vases, casseroles, mugs—with tans, browns, and other natural-colored glazes on textured surfaces with sgraffito or wax-resist decoration and often with freely applied brushwork. The oxidation firing methods necessary for electric kilns, which most Northwest ceramicists had used in the earlier decades, were predictable and, for that reason, potentially boring. As gas-fired kilns became more prevalent and highly developed in the individual potters' studios, reduction firing and the excitement of not knowing quite what to expect when the kiln was opened caught on. Salt glazing, used by Eastern nineteenth-century crockery manufacturers, had not been possible in an electric kiln with its vulnerable elements, but now experienced a renaissance.

A ceramicist from Sweden, Ragnhild Langlet, arriving in the United States in the mid-fifties described American wares as fat-lipped, brown-speckled, semi-matte casseroles, and teapots with navel spouts, adding that American ware is an expression of opposition—of making certain that no one thinks it is made by a machine.

Many potters who had previously worked in a superficial way were beginning to experiment extensively with all aspects of the pottery-making process. Finding and mixing ones own clay and glazes became a moral issue. This new general dynamism was prevalent throughout the far West. In explaining during an interview the difference in the pottery idiom between the East and the West coasts, Robert James of Eugene, Oregon emphasized the "go ahead" spirit of freedom and independence of Westerners, the open, loose, easygoing attitudes as opposed to the more programmed attitudes of the East. At any rate, the differences between the East, with its commercial ceramic production concerns, and the West, with a greater concern for the studio potter who wanted to concentrate simultaneously on the creative aspects of ceramics and on limited production, were more evident.

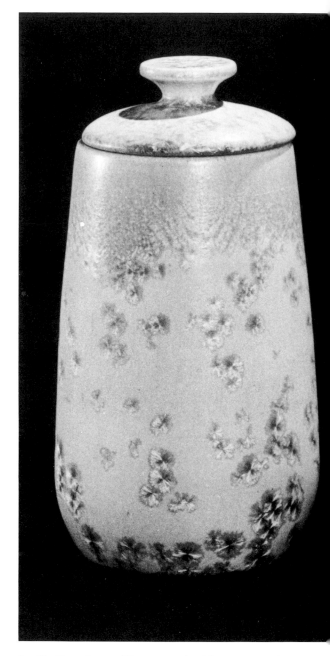

Lucille Nutt. Covered Jar, 1953, wheelthrown, crystalline glaze.

The Production Potter

The advent of the "production potter" was probably most positively influenced by the philosophies of Leach, Hamada, and Yanagi and by improving technology. In addition, an increasingly affluent public provided an energetic market, and dozens of potters saw the possibility of earning at least part of their income from sales. In the early 1950s, many individual potters—some heavily oriented toward production, others toward limited production—and small groups began to set up studios and to sell their wares at the Pacific Northwest Arts and Crafts Fair in Bellevue Square, a shopping center in Bellevue, Washington, the earliest market in the Northwest, established in 1947. Showing all of the visual arts, the fair was, and is still today, the largest and most successful crafts market in the United States. Its gross income in 1976 was about $274,000, a large percentage of this from sales of handcrafts, with ceramics heavily represented. From its beginning the fair gave Northwest potters the necessary encouragement to produce in large quantity. The potters represented early at the fair are too many to list, but it is safe to say that every Northwest potter producing enough high-quality work to pass the screening was in attendance for some of the years. A problem developing in recent years has been that so many potters are eligible, the turnover in acceptances for booth space is great, and few potters can rely on the fair as a sustained market. However, the dozen or so smaller fairs that have sprung up in intervening years have also served the market purpose.

Bertha and Bert Brintnall were participants in the Bellevue Fair in 1949, selling functional wares and animal forms, all produced in handmade molds from four types of clay blended together and decorated with their own glazes and original designs. They were just beginning to retreat from the influence of European Wedgwood, Spode, and Hummel ware, the only models many potters had had, until then, available to them. Jeanne and Robert Speelmon, graduates in ceramics from the University of Washington and much involved in the Bellevue Fair market by the late 1940s, had been pioneers in setting up Craft House, a studio and cooperative work center for craftsmen in Seattle. They were among the earliest ceramicists to produce nonmolded, handmade pottery. Both Speelmons had come from Midwest backgrounds of the Bauhaus and "good design" philosophies, and Robert Speelmon had already learned wheel throwing in Omaha under a teacher trained at Ohio State University. They served as inspiring teachers of the practical aspects of pottery to the many interested community members of the day.

Later, in 1953, five ceramicists—Lorene and Ralph Spencer, Lucille and David Nutt, and Francis Ford—founded The Potters, a shop in Seattle. Lucille Nutt became recognized regionally and nationally for her crystalline glazes, and the Spencers in 1954 became the first ceramicists in the Northwest to earn their living from making pottery. Lorene Spencer had trained in ceramics with Victoria Avakian Ross at the University of Oregon and was producing and selling out of Newburg, Oregon with Ralph Spencer, a chemist, around the time of World War II. After moving to Seattle, they continued to collaborate closely, with Ralph solving all the technical problems, making the clay and glazes and firing the kiln, and Lorene designing and throwing or building and decorating the forms. Their constant experimentation and knowledge of materials have for more than twenty-five years contributed immeasurably to the welfare of their clients who depended on them for a variety of clays and glazes. Since the premature death of Ralph Spencer in 1973,

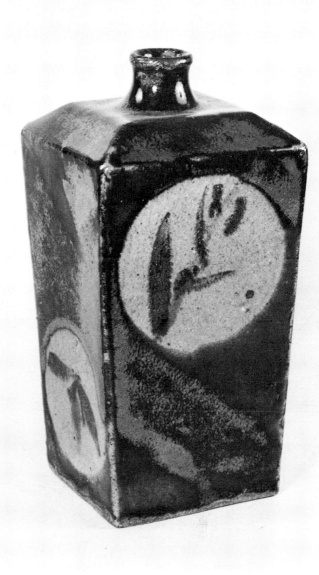

Shoji Hamada. Bottle, ca. 1946, stoneware, press molded, iron oxide and white slip, wax resist, brushwork. Henry Art Gallery, Univ. of Wash., Seattle.

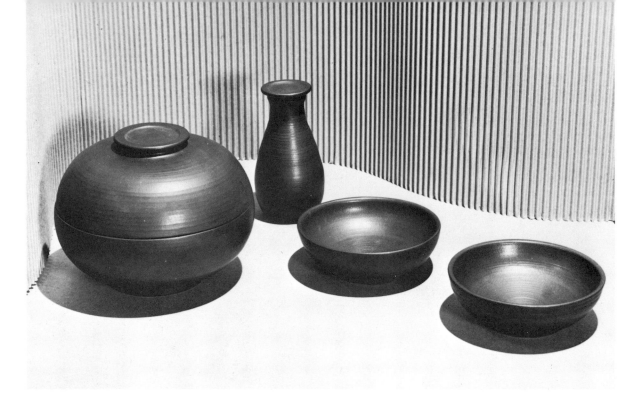

Lorene Spencer. Serving Bowl, Two Small Bowls, Sauce Bottle, 1952, middle range stoneware, wheelthrown, black matte glaze by Ralph Spencer, serving bowl: H. ca. 7 × Dia. 10.

Virginia Weisel (b. Seattle, Wash., 1923). Three Bottles, stoneware, wheelthrown, left: 1968, low-fire glaze, H. 7 × Dia. 5½; center: 1969, low-fire glaze, H. 5 × Dia. 5; right: 1968, low-fire glaze, H. 6¼ × Dia. 4¼. (Glazes brushed on warm, bisqued surfaces to build up thick coat, kiln turned off when glaze began to flow off foot, multiple glaze firings for richer color).

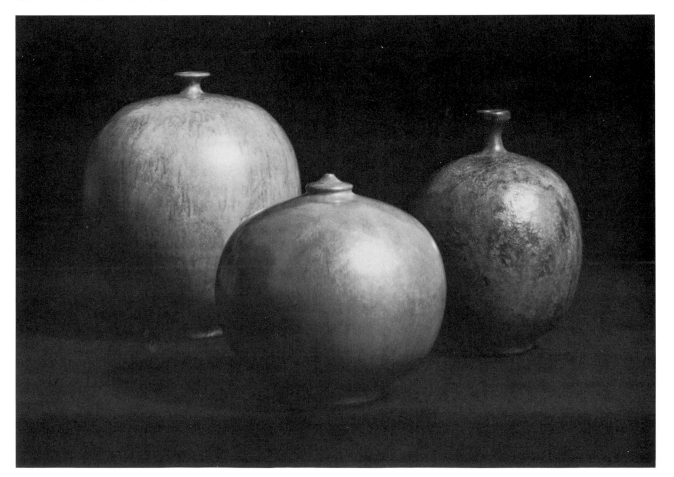

Lorene Spencer has continued to make pottery and to operate their successful clay and glaze-making industry, as well as the shop and gallery.

Another pair whose development somewhat parallels the Spencers is Di and Aldrich Bowler, who have been studio potters of functional ceramics since 1946 and have been selling clays and glazes on the banks of the Snake River in Idaho.

In Portland, Oregon, George and Pearl Wright have furnished clays and glazes to a large clientele since the late 1960s. Pearl Wright is a prolific potter of functional wares.

The main goal of Eric Norstad, graduated in architecture from the University of Oregon and a student of Victoria Avakian Ross, has been to make functional ceramic objects that people will use. He believes that "art museums gather dust. . . . If functional pieces are too expensive, the function evaporates." Norstad eventually set up a production studio in Corte Madera, California, where his main concern has been to maintain his own direct involvement with the clay while managing a production pottery that is almost too successful.

Louis Mideke, a self-taught potter from Bellingham, Washington, has worked since 1948 in delicately formed, wheelthrown stoneware and porcelain that is influenced greatly by the design and craftsmanship of early Chinese pottery.

Virginia Weisel, a painting major and student of Paul A. Bonifas in the late 1940s, and later, of Tony Prieto at Mills College, produced extensive amounts of functional pottery for many years and operated a successful studio and school, The Kiln, in Bellevue, Washington in the 1960s. Her exquisite, simple ceramic forms and superb craftsmanship reflect Bonifas' disciplinary training, and her high-intensity, jewel-like glazes may have been influenced by the romanticism of the Spaniard Prieto. Her awareness of profile, which was always to affect her concept of form, could have resulted from Bonifas' assignments to "draw one hundred vessels that will hold a rose, none the same." In contrast, Prieto, volatile and irrepressible, counseled her to "be open and expressive, don't talk about it, do it!" An interesting group of vessels started by Weisel in 1968 were weed vases, buoyant in form, bisqued high to make a hard body, then glazed and low-fired a number of times to create thick, richly colored surfaces in reds, blues, oranges, and greens. This unique glaze experimentation was directly inspired by the Natzler's glaze colors and by their experimental attitudes, which had wide exposure by the late sixties, but were executed with different procedures resulting in different effects. There was great contrast in these pots between the tension in the exploding spherical forms and the painstakingly developed surfaces. Weisel's technical experiments have always been to the extreme. In the 1960s, she turned her attention to sculpture in terra cotta as well as in many other media including wood and marble.

Among the many ceramics organizations represented at the Bellevue Fair was the Seattle Clay Club (sometimes known as the Clay Club), founded in 1948. For at least fifteen years, these were the most active potters working as a group in the Northwest. The by-laws of the club state that it was established "to bring together persons seriously working in ceramics and sculpture, to act as a clearing house for ideas and experiments made by individuals, and to promote a higher standard of excellence in the work of members and in the community." They also came together because of their need to acquire clay at the reduced prices that volume orders could bring. Some of the earliest members were Ken Glenn, Jane Wherrette, Eloise McKinnell, Sylvia Duryee, Mr. and Mrs. F. A. White, John Polikowsky, and Ebba Rapp and John McLauchlan, among others.

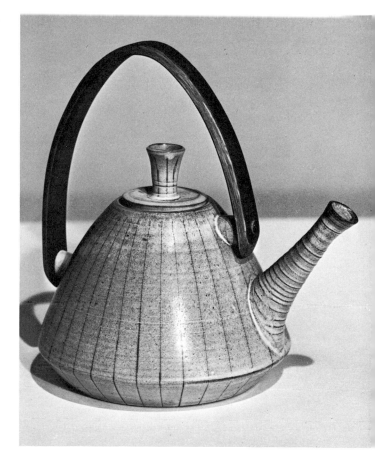

John Polikowsky (b. Pasadena, Calif., 1923). Teapot, 1954, stoneware, wheelthrown, matte glaze, laminated wood handle, H. 4⅜ × W. 5¾ wide. Henry Art Gallery, Univ. of Wash., Seattle.

Interested in ceramics immediately after the war, by 1951 Poli-kowsky was on the faculty at Helen Bush School in Seattle, teaching evening classes and supplementing his income by selling wheels he had designed. In 1954 he brought Peter Voulkos for a three-day seminar at the school. Voulkos' "power throwing" stunned all those who had not yet seen him in action. "Voulkos worked with absorption. He seemed hardly aware of his audience. When he talked, which he seldom did, counting on his actions to speak for themselves, he seemed to be talking more to himself than to his class."* Polikowsky was a dynamic teacher who was not only able to show his students how to work with clay, but also to articu-late the process in words. Influenced strongly by Scandinavian ceramics and by the work of Marguerite Wildenhain, he liked crisp, clean forms and experimented at length on delicate walls with thin, wet clay.

Another potter who was inspired by the Scandinavian work of the 1950s was Gladys Crooks, whose highly crafted functional works with natural matte glazes were prized by homemakers who were tired of the glossy surfaced, molded wares of the 1930s and 1940s. In 1958, Crooks won an award offered by the Washington Arts and Crafts Association for a cannister set that embodied "good design, good craftsmanship, sales appeal, and suitability for quan-tity production." These qualities reflected the basic philosophy of the association, which had been founded to develop a broader mar-ket for well-designed craft objects.

* Margaret Callahan, "The Comeback of a Potter," *Seattle Times*, 11 April 1954.

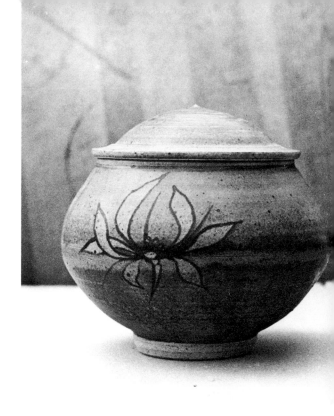

Jerry Glenn (b. Portland, Ore., 1936). Covered Jar, 1975, stoneware, wheelthrown, yellow ash glaze. H. 7⅞ × Dia. 8⅛.

Gladys Crooks (b. Manila, Philippine Is., 1912). Storage Jars, 1958, earthenware, wheelthrown, gold and rust matte glazes, right: *H. ca. 9.*

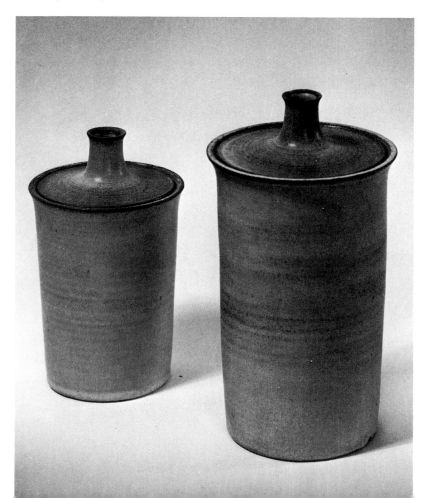

Barbara Rauscher, student in ceramics at Sophie Newcomb College in New Orleans, was active in the Clay Club and later in the Pacific Northwest Arts and Crafts Association in uplifting the design consciousness of the potters of the Northwest area. She was responsible for the first traveling exhibition of handcrafts sponsored by the Bellevue group.

Another strong contributor to the pottery markets since 1958 has been John Fassbinder, a faculty member at Central Washington State College from 1960 to 1963, who eventually set up a pottery studio in Claremont, California. Listing his training at the University of Washington and at Claremont College as most influential in his artistic and technical development, he cites his participation in the Bellevue Fair as the most important factor in his long and successful career as a production potter. Fassbinder is optimistic in that he sees "a real future for the craftsman. As we get into ecological trouble and use up the resources, it will be economically impossible to continue mass production of some goods. I can see craftsmen producing automobiles by hand, one at a time, with the populace adjusting the standard of living to accommodate the expense." His stoneware pottery is decorated with natural forms in flung glaze, applied decoration, incising, sgraffito, and brush decoration, and has evolved into a more colorful pallette in recent years. A lyrical painter early in his career, he now has switched, although not exclusively, from canvas to clay. He was influenced by Japanese folk pottery as well as by Henry Lin (a native of mainland China who produced functional wares reminiscent of the most beautiful early Chinese wares) and Shoji Hamada, and most profoundly by his teacher at the University of Washington, Robert Sperry. During his early days with Sperry, when Sperry was executing four-foot high sculptural forms, Fassbinder spent several months producing delightful, nonfunctional forms incorporating some human imagery. The lyricism of the functional work was present in these sculptures. Today, to fill his need for more expression, he shows his more visually significant large platters and tureens annually in a solo exhibition at the Northwest Craft Center in Seattle.

Potters from other states, such as Montana and Oregon, were also heavily involved in producing for the market. Ken Ferguson and David Shaner, whose combined terms at the Archie Bray Foundation covered more than a dozen years, traveled each summer to the Bellevue Fair for years.

Jerry Glenn and William Creitz, both students of Ray Grimm (who is head of the ceramics department at Portland State University) and both limited production potters, often referred to historical sources in their work—Glenn more often to early Chinese, and Creitz to such divergent traditions as Oriental, Byzantine, and Art Deco. While Creitz and Glenn did not work as a team, they did exchange ideas while they lived in Portland. Glenn's work is perfectly crafted, with experimentation in achieving rich glazes. One of his most successful is the copper red so well done by his mentor, Ray Grimm. In the 1970s, Glenn took time to experiment further in various glazes, some in earth tones and, especially, in a new white. Creitz has always been interested in pushing form to the point of exaggeration and in the ornate qualities of much historical decoration. Creitz and Glenn were members of the Linnton Potters Group formed by Ray Grimm as a studio workshop where he and some of his students (Mardi Wood, Phil Eagle, Jack Sears, and Bruce Stoner) produced from 1961 to 1968 for the adjacent market in the Linnton Community Center.

Other production potters in Portland in the early 1950s were Bennett M. Welsh and William Wilbanks, who shared studio space, after which Welsh bought and operated Pacific Stoneware from

William Creitz. Cookie Jar, 1967, stoneware, wheelthrown, glazes and luster, H. 10⅛ × Dia. 8⅝. Henry Art Gallery, Univ. of Wash., Seattle.

Bennett M. Welsh (b. Eugene, Ore., 1922). St. Francis, 1955, vase, stoneware, wheelthrown, sgraffito design, H. 12½ × W. 5⅛. Henry Art Gallery, Univ. of Wash., Seattle.

1960 to 1973. Pacific Stoneware was a remarkable place in that it furnished employment for dozens of fine production potters or potters-in-training in the Portland area. First handthrown vessels and then slip-cast gift items were sold through six retail outlets, eventually yielding a gross income of two million dollars annually. In 1973, Welsh sold out and is back producing in his studio in Gresham, Oregon.

Concerning the production potter, Phil Eagle, a student of Grimm's, says: " . . . a most valuable experience to learn the mechanics of throwing, but destructive when the primary emphasis is on quantity of output. . . . To allow each piece to evolve freely with only generalized repetition allows one to . . . see the complexities of each shape, the effect of fractional modifications, and [gives] the opportunity for innovation. If enough similar ware is produced one can group sets that 'feel' the same, leaving duplication to the slip casters."

A number of production potters are among those discussed in the section "Oriental Inspiration" in this volume.

Training Facilities and New Teachers

As technology developed and the enthusiasm over ceramics grew, the need for training grounds for artists and teachers expanded. Between 1954 and 1957, by the time college enrollment of GI's was spiraling, most major universities and professional schools in the Northwest states hired new ceramics division chairmen to develop the programs.

In 1957, Ray Grimm, a graduate of Southern Illinois University and assistant to F. Carlton Ball at that university, came to set up a ceramics department at Portland State University. Having started as a sculptor, he switched to pottery and had done extensive thesis work in high-fired bodies and on glazes, especially those used by the early Chinese of the Sung dynasty. His show at the Oregon Ceramic Studio soon after his arrival in Portland contained many incomparably beautiful functional forms in high-fired bodies glazed with copper reds and turquoises, celadons, and the Chun Yao, or Chun ware. Grimm also experimented early with Raku, a ware used in the Japanese tea ceremony. (Traditional Raku ware is hand-built, low-fired, porous ware taken from a hot kiln in a state of flux and cooled in the natural atmosphere, or for unusual iridescent effects, immediately plunged into water or a dense, smoky atmosphere.) In a recent interview, he said that he approaches a teapot (or any form) as a piece of sculpture. He will do several of one object similarly to solve a problem, since he must have a problem to solve in order to work. Then he must go on to something else. This intellectual approach is evident in most of his work. At one time he received a grant to work on clay and metal combinations and has since executed many crisply formed, covered stoneware containers (some very large) with substantial, forged handles skillfully fitted to the clay body. He has also combined clay with metal in a charcoal burner and in sculptural art objects resembling plant forms. The combination of metal and clay is echoed in a more recent series of gigantic, carefully formed stoneware planters and storage jars with slip and oxides in geometric designs and with heavy rope handles. His sense of humor and ability to fit two or more clay parts together is especially evident in a piece from 1959 called "Dancing Pots," a group of five tall, unevenly formed, uncov-

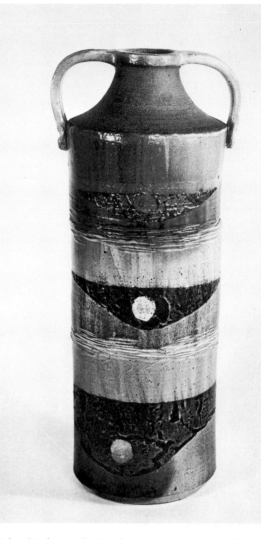

Richard Lolcama (b. Medford, Ore., 1936). Jug, 1962, stoneware, wheelthrown and joined sections, white, blue, and red glazes and slips, H. 24 × W. 10¼. Henry Art Gallery, Univ. of Wash., Seattle.

ered containers held together in a circle with huge spikes dropped down through ceramic loops built into the sides of the pots. Grimm has executed many public commissions in Oregon, including a number of liturgical works. He has also worked in naturalistic stoneware reliefs mounted on fire-scaled metal as decorative works for indoors or outdoors.

Jere Grimm, whose ceramic work was shown with Ray Grimm's at the Oregon Ceramic Studio in 1959, has collaborated with her husband on some of his commissioned work and also has done a series of plaques for the Coos Bay County Library. Phil Eagle describes Grimm as "one of the most natural . . . potters in the country, totally unruffled by current fashions and the rush for one-upmanship. He allowed students freedom and encouragement." Grimm probably has been the strongest and most sustained influence on formally trained students of the Portland area, many of them working successfully with the Chinese glazes while finding their own directions.

At the University of Idaho, George Roberts, sculptor and ceramicist, was named head of the ceramics division in 1955. In Wisconsin and Michigan he had been exposed to and profoundly influenced by a variety of artists and artistic and philosophical phenomena. He was an early slab builder, encouraged by Toshiko Takaezu and Harvey Littleton, both important forces nationally in the development of the studio potter. He was also greatly involved in the history and evolution of ceramics, having studied Chinese and Japanese art with Takaezu and the history of pottery with Professor James Marshall Plumer, and having seen Hamada and his work in context with Plumer's collection of ancient and modern Oriental pottery. He was influenced especially by Leach's teachings: the importance of having respect for materials; of exploring, but not violating; of the integration of form with glaze and decoration; and the concern for three-dimensionality, gravity, stability, strength, and utility. He studied Oriental philosophy, Chinese calligraphy, and bronze casting and became knowledgeable in the ceramic art of the pre–Columbian area. Much of his work over the last twenty years has been in series. Several of these series—*Helmet, Saddle, Stirrup*—were started with unique and expressively shaped jars, each with handles. Each large cover fit down over the outside of the jar and was designed to be a sculpture when removed. Many of the slab pots are huge, bulbous forms reminiscent of pre–Columbian funerary pots. Roberts also worked with zoomorphic subject matter. He was very much involved in the mid--1950s in the shift in emphasis from utility to expression and has always treated his own works, many of them vessels, as abstract sculpture. His work remained highly crafted and usually without strong color. He writes that "it is harder to be an artist in Idaho than in an urban area. Space and lack of restrictions help, but shipping costs for materials and finished work are high. Few local supplies are available. There are few artists, and little interaction. However, for me that has been desirable. . . . I like teaching [and] I'm involved in my own things and try to do them right as I see them."

Robert James arrived at the University of Oregon in 1955 to build the ceramics department there. James had been trained under two eminent ceramicists: Laura Andreson at the University of California at Los Angeles, and Maija Grotell at the Cranbrook Academy of Art. According to James, Andreson was a key person in his life, although this influence has not directly shown up in his work. While James had been at UCLA, Andreson worked in functional ware often with press molds and always with low-temperature firing. Although James works mostly on the wheel, he is an artist potter. His work, conceptually far from functional, has been in stoneware with a brilliant pallette of glazes, his understanding of which he owes to Grotell, for cone 10 reduction firing.

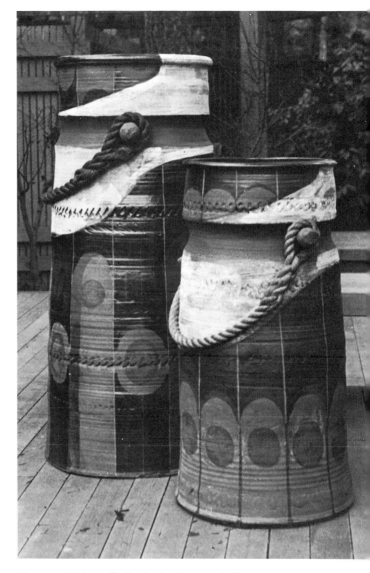

Raymond Grimm (b. St. Louis, Mo., 1924). Vessels, 1974, stoneware, wheelthrown, slip-decorated, rope handles; left: *H. 56,* right: *H. 26.*

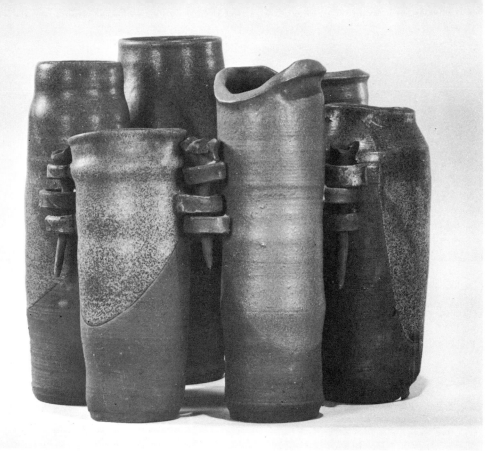

Raymond Grimm. Dancing Pots, *1959, stoneware,
wheelthrown and hand-built, cobalt and iron glazes,
H. 15 × Dia. 18.*

Raymond Grimm. Siuslaw, *1970, hand-formed stone-
ware and fire-scaled brass, H. 19 × W. 28.*

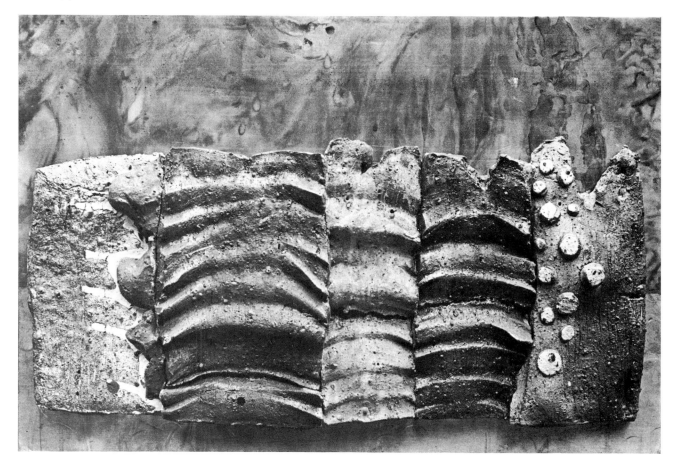

These forms—bottles, vases, plates—do not mean "function" to
him. As he says, "the plateness is residual cynicism. In not wanting
to account for myself, I just say they're plates . . . just plates with
designs on them. The work is a form of communication, not about
ceramics or painting or art, not to demonstrate virtuosity in art."
He is interested in subject matter, and these abstract designs come
out as allegory or metaphor. He uses sets of symbols which he
continues to rearrange on work after work (recently he did a series
of 200 plates using one set of symbols) as speculative studies—
studies of situations. "Knights of the Round Table" and "Robinson
Crusoe" are examples of these motifs. He has also decorated his
functional forms with semi-abstract landscapes. Some years ago
he produced a series of small, three-dimensional abstract sculptures
in two parts, which were meant to remain closed so as not to
yield up their inner mysteries. He is deeply interested in processes
(his work is not conceived until after he starts to work) and in
origins (the study of the past and of foreign cultures is important
to him). And, while much of his work seems transcendental, or
even magical, he approaches it intellectually. He maintains careful
control leaving no room for accidents. His most recent work has
been in pinched pots—small, primitive looking vessels formed with
the fingers out of lumps of clay.

In 1957, soon after finishing his graduate work with Victoria
Avakian Ross at the University of Oregon, Kenneth Shores became
resident potter at the Oregon Ceramic Studio. Although he began
his studies as a painter, he changed to ceramics as a more appropri-
ate medium for personal expression. While still in college, he
studied with Marguerite Wildenhain at Pond Farm and, earlier,
when she visited the University of Oregon. His debt to Wildenhain
is great, absorbing as he did her philosophy that full commitment
and dedication is what life as an artist is all about. Wildenhain
also instilled in him the belief in the discipline of long training
and of mastering technique—a belief reflected today in his view
that the "star quality" and the profit aspect currently in vogue are
corruptions of art. In a recent conversation he spoke of the impor-
tance of learning what one is about in order to have something
to say as an artist.

Although he was deeply affected by the Wildenhain philosophy,
his style is his own. In the early days his vessels were hand-con-
structed and coil-built or were sometimes wheelthrown functional
objects with natural-colored glazes. For many years, in order to
make a living, he produced appealing, stylized figures with natural
glazes influenced directly by the pre–Columbian ceremonial objects
in the collection of the Portland Art Museum, and by Japanese
Haniwa grave figures. These and other, later, more unique works,
were related to his lifelong love of anthropology and archaeology.
In 1966 he abruptly changed his direction, producing three-dimen-
sional, abstract stoneware sculptures and replacing the earlier
glazed surfaces with acrylic paints in bright colors. Slabs were
juxtaposed vertically and horizontally with spaces between and,
although completely abstract, they echoed the earlier figures. Shores
remained at the Studio through the period in 1966 when its base
was broadened to encompass all the handcrafts and when he was
named director. In 1968 he joined the faculty of Lewis and Clark
College in Portland. Meantime, he had become a world traveler,
an activity which he continues today as a means of constantly
broadening his artistic horizons. He has spent time in Mexico, North
Africa, Europe, and India.

Artistically, Shores seems to have matured around 1968, after
the earlier period of rich and varied experiences—one of the most
profound being his study for some ten years of Hinduism. Around

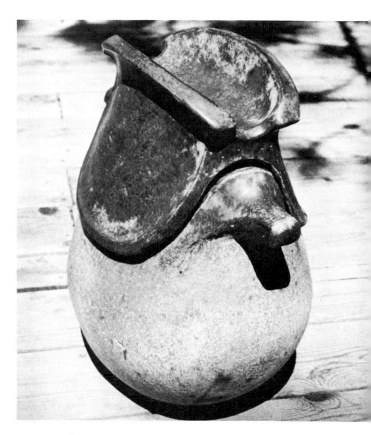

*George Roberts, Covered Jar, "Saddle" series, 1965,
stoneware, slab-built of grogged clay, glazes, H. ca.
20. Coll. of David and Beverly Christie, Seattle.*

*Robert James (b. San Diego, Calif., 1928). Platter, 1968,
stoneware, reduction fired, wheelthrown, engraved
and glaze on glaze (single firing to cone 9), Dia. 18.*

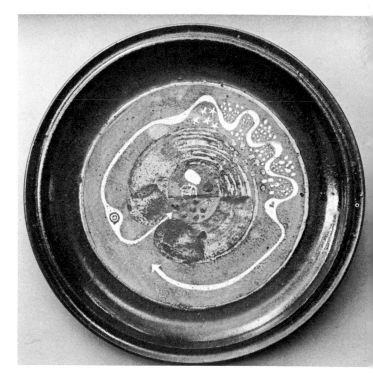

1968 he was able to rise above a limitation he had felt for many years: that of the minor status of "craftsman" traditionally assigned to creative people who work in clay. He was able to see himself as a "fine artist" and began work on his highly successful objects of feathers and clay. Although not unique in this combination of media, this work is individualistic as compared with, for instance, the work of the Californian, Dominic Dimare, who was also working in feathers and clay and had exhibited a series of pinch-pot masks with feathers at the Henry Art Gallery in 1968. F. Carlton Ball had also experimented with feathers and clay in the fifties. The beginnings of Shores's new work may have appeared as early as 1958 when he produced a series of tall vessels with featherlike appendages of clay, or earlier in 1957 with the Art Nouveau content of his master's thesis. The new work is of two types: "Those which are formal and hieratic, suggesting the rituals of some ancient sun religion and those which are freer, less symmetrical, and derive from natural forms, perhaps especially sea life. . . . On the small works, which the artists call 'ceremonial bowls,' the feathers form a sort of crown laid around the lip of the bowl. These bowls exist only for themselves, asserting the ancient beauty of the bowl form. The nature-derived pieces are quite different; their outlines and their surfaces are generally looser and freer."[*] In the naturalistic works the surfaces are matte finish, and feathers and clay blend together as if organically formed. The "ritualistic" pieces tend to incorporate glossy, metallic glazes and are elegantly sophisticated. All the works are mounted in exquisite Plexiglas boxes with mirrors as backgrounds to reflect their equally elegant undersides. All may be displayed on a horizontal surface or hung on the wall. Shores plans to continue to develop this body of work.

Rudy Autio, whose student and professional careers had been in the Northwest, chose to remain in Montana and was appointed head of the ceramics and sculpture divisions at the University of Montana in 1957. As an artist, he began to show nationwide influence early in the 1960s. He is revered as a teacher by those who studied with him, as is evident in these quotations from a few of the dozens of letters written recently by some of his students.

John McCuistion writes: "Rudy's greatest strength as a teacher is his genuine concern and belief in people." Jim Leedy sees as contagious Autio's "sincerity of purpose and Zen-like devotion to his art. . . . Rudy says more with a silent effort than most teachers say with years of lectures. Perhaps his greatest contribution to clay and to his students, aside from his endless line of inventive forms, shapes, and ideas, is his appreciation for the pot as a high art form." Martin Holt recalls that Autio "would make a dozen (pots) at a time—huge, slab-built—then . . . prop them to dry evenly. This small forest of Rudy's pots, lying down, leaning around at all sorts of angles looked like . . . a very slow motion ballet for ceramics. He has some special energy source and in the wake of a flood of pots, we get a glimpse of the genius and beauty that is captured in the heart and hands . . . of this man, a precious star." Others have said that he encourages his students to enter competitive exhibitions—the same shows that he enters. Such encouragement is not always part of the teacher/student relationship.

It is interesting to compare this approach to teaching, the gentleness of manner in dealing with people, with his approach to his own work in clay. He works spontaneously, and with great intensity, and during these times he is a prolific producer. Having given his entire time to the students in class, he often waits until academic

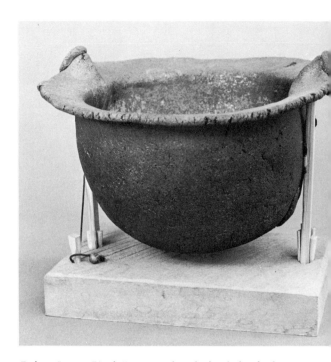

Robert James. Pinch Pot, 1977, barely fired clay body, finger formed clay and whittled wood base, string, carbon surface, 6 × 6 × 6.

Rudy Autio. Angry Young Bird, ca. 1959, stoneware, hand-modeled, iron oxide glaze, H. 21¾ × W. 15. Henry Art Gallery, Univ. of Wash., Seattle.

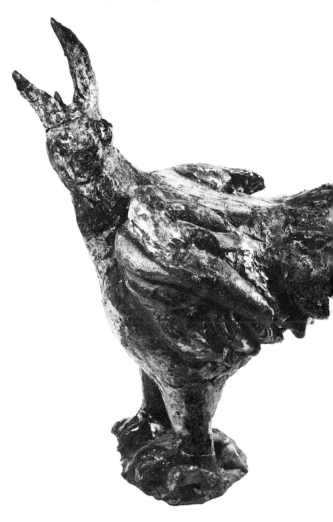

* Rachael Griffin, "Ken Shores," *Craft Horizons* 30(August 1970):26.

breaks to produce great amounts of his own work. Autio's later work of the 1960s in slab construction was to have great influence throughout the United States, not only in the many exhibitions and workshops in which he participated and in the magazines where his work was shown, but also through his students who now hold key faculty positions in university ceramics departments all over the nation. Early significant events for him after his move to the University of Montana were the visits of Peter Voulkos and James Melchert in the late fifties, at a time when Voulkos had just finished his most magnificent period at the Los Angeles County Art Institute and Melchert was to begin his association with Voulkos at the University of California at Berkeley.

At the University of Washington in the mid–1950s, Robert Sperry was at the beginning of a productive and dynamic career as an artist and teacher after receiving his M.F.A. degree in ceramics from the same institution in 1954. He began to lay the groundwork for what was to become one of the most influential ceramics departments in the nation. In the process, he also questioned the place of pottery in the twentieth century. At the convention of the Washington Art Association in October 1956 in Yakima, Washington, Sperry stated his view that "pottery can contribute to particularizing our individual environment and give a new sense of humanity to counteract the dehumanization of machines. . . . The potter must fulfill a new role in society as an artist and imbue each piece with individual personality to distinguish [it] from machine-made pieces. . . . [The potter] must make pieces that go beyond pure utility and communicate this intangible, inexplicable quality which, at least up to this time, the machine has been unable to do." But, he has also, steadfastly, during the twenty-three intervening years, paid homage to the belief that pottery should stress the utilitarian and the decorative, rather than the expressive. In an interview with William Hoppe, he stated: "The intent of pottery is to contain, not to communicate feelings and ideas," and "a pot's appeal lies in its utility, its sensuousness. . . . the traditional line drawn between pottery and sculpture is fine."*

As early as his first five producing years from 1955 through 1960, Sperry's reputation was already secure nationally through the many exhibitions in which he showed and the many prizes awarded.

He is noted for his discipline and his consistent output of high-quality, functional objects. When he works, he works intensely, throwing and decorating many pieces at once, to get a few outstanding pieces out of many. Most of his large solo exhibitions have been the result of such activity. Some indication of the level of his energy is shown in the statistics from two exhibitions mounted at the Hall-Coleman Gallery in Seattle in 1961 and at America House in New York City in 1962, produced in his large, newly installed gas kiln in his studio in 1961. Shown in Seattle were 200 pots, 40 paintings, and 10 ceramic sculptures ranging from four to six feet in height. From these works, twenty-six barrels of pots and five crates of sculptures were shipped to the New York show.

The surfaces of Sperry's pots are almost always profusely decorated and often with his favorite theme which is the sensuous quality of nature. His long-time interest in Oriental ceramics manifested itself as early as 1954, when he ran an experiment in Raku firing, reading from Leach's book. In 1963, his trip to Onda, Japan confirmed his interest in utilitarian pottery. He expressed beautifully the potter's point of view in his film, *The Village Potters of*

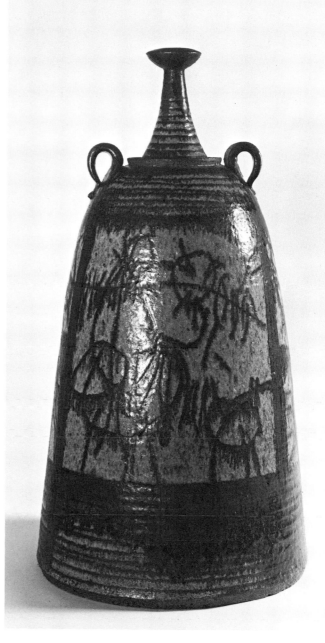

Robert Sperry. Covered Jar, 1964, stoneware, wheel-thrown, wax resist with iron oxide inlaid decoration, H. 33 × Dia. 15. Coll. of Earl and Marcella Benditt, Seattle.

* Interview with Sperry by Hoppe, 23 July 1972. Transcript available at University of Washington, Archives of Northwest Art.

Onda. His functional works are usually done on the wheel. Many of his works are variations on spherical forms, although he has made many square or rectangular, slab-built plates and covered boxes. For many years he has decorated his work in the manner of the Japanese, using only a few glazes with incised lines, brushed patterns, and wax resist. However, his insistent use of geometric designs could as well be inspired by the wares of the early Greeks or most primitive cultures, and the heavy, overall decoration of his surfaces owes as much to early Persian ware as it does to the work of such a potter as the Japanese Kenkichi Tomimoto, of this century. By 1964 Sperry had added, to his natural-toned pallette, gold lusters usually with cobalt blue oxides on lavishly decorated surfaces of functional wares. The production of these forms with their highly decorated surfaces has been punctuated occasionally with simple thrown vases of incredible beauty, with the most subtle decoration. One such spherical vase made in 1956 was covered first with light yellowish glaze and sprayed over with a darker color, imitating a Swedish glaze he had seen, but also resembling the golden brown Japanese Temmoku or Hare's Fur surface.

As a teacher, Sperry gives his students plenty of room to develop. He believes the only function of a teacher is to give information if the student wants it. He attempts to teach a method of working, of investigation. David Furman, one of his students, says that Sperry helps his students not to be so serious about themselves—to look beyond themselves. Sperry is also sometimes totally candid, not always saying what one wants to hear. In the interview with William Hoppe he speculated that the arts may be vital to only a few thousand people in society, and that if we took all the so-called high arts out of our society, it might not cause a ripple. His is the populist view that the arts must be connected to society as a whole, that today's pop culture is more meaningful than anything one sees in a museum.

Many schools sprang up or developed their ceramics departments in the sixties and seventies. Thorne Edwards in 1969 amplified the facilities at the Cornish Institute of Allied Arts in Seattle. Also in Seattle was the Factory of Visual Art founded by Lin Lipetz and with Charles Draney as head of the ceramics division. Pottery Northwest in Seattle got its start from Kay Perine and the Seattle Clay Club in 1966, and it was eventually directed by Ken Hendry, a student of Paul Soldner. The Foundation School of Contemporary Art in Bellevue was another outgrowth of the Bellevue Fair. And, the Sun Valley Center for the Arts and Humanities in Idaho started in the 1970s and has leaned heavily toward ceramics under James Romberg.

Ceramic Objects for Architectural Settings

Five years after World War II, throughout the Northwest, unique forms began to appear in "architectural" objects, especially in free-standing pieces or objects in relief for courtyards, entry halls, and gardens of residences, and in public spaces. Some of the first were at the University of Washington: the figures atop the administration building by Dudley Pratt and the large figurative relief sculptures at the medical school by Jean Johanson. Robert Speelmon and Ken Glenn assisted in both of these commissions by preparing molds from the artists' clay models for casting in clay. Betty Feves was commissioned to execute reliefs in stoneware for the public schools in Oregon and also prepared a large group of hand-constructed

Robert Sperry. Sculpture (plumbed temporarily as a fountain), ca. 1959, stoneware, wheelthrown parts assembled, black glaze on brown surface, H. ca. 36.

garden pieces for a solo exhibition at the Oregon Ceramic Studio. These were strong, volumetric works, some stylized figures, some plant forms, some completely abstract forms. To exhibit at the Bellevue Fair in 1961, Robert Sperry produced a spacious wall in relief, composed of sixty-four, foot-square, stoneware tiles, titled *'Twas the Eve of the Sabbath*. The wall's surface is actively decorated with dark-toned oxides—gouged, built up, pressed into—a fine example of an abstract expressionist handling of clay. The wall was purchased by Cascade Natural Gas Corporation in Seattle, who, in 1978, gave it to Lakeside School. Fountains were popular and were produced by Lorene Spencer, Robert Sperry, and Virginia Weisel. Sperry's fountain from 1960 was an uproarious, multi-spouted, thirty-six-inch-high tour de force that symbolized as appropriately as any piece from that decade the new freedom in ceramics. Harold Balazs of Spokane has probably executed more architectural art commissions than any other artist in the Northwest, many of them in ceramics. His carved brick murals may be seen in Washington on the Richland and Burien Libraries and the Bell Telephone building in Spokane. Howard Duell, of Washington, Ray and Jere Grimm of Oregon, and Rudy Autio, of Montana, among others, were actively involved in producing works in clay as architectural and garden embellishments. In 1961, Anne Todd, art critic for the *Seattle Times,* published a large directory of artists who were working with such objects, not only to document this activity, but also to serve as a catalog for possible commissions. Although some purist critics might not agree that these works could be classified as "fine art," compromised as they are in their integration with architecture, they are examples of the artists' search for expressive means.

A hilarious work in glazed clay from 1969 that fit the architectural art theme and predicted the present trend for 1-percent-for-art programs in most governmental art commissions reflects the sharp wit of Fred Bauer, its creator. Titled *Proposed Fountain for Dayton, Washington—To Be Fifty Feet Wide and Spray Butter*, its main imagery was a gigantic pile of tiny peas, laboriously modeled of clay and glazed with a brilliant, green, low-fire glaze.

Oriental Inspiration

While the immediate inspirational effects of the Leach–Hamada–Yanagi visit in 1952 were philosophical in nature, it was not surprising that ceramicists of the Northwest soon began to experiment with the technologies of the Orient, especially with the informal wares of the tea ceremony such as Raku, inspired by the "legitimate" Raku of Japan of the sixteenth century. We have also noted already a number of artists in the Northwest who were influenced in either form or decoration by the classical Chinese ceramic tradition—artists such as Paul Bonifas, Henry Lin, Ray Grimm. Because of the continuing popularity of both of these types of ware throughout the world, and also because of the close proximity of the Northwest to Japan and the constant interchange of artists from both countries, interest has remained high in the Northwest, and ceramicists have continued their use of Oriental techniques in varying degrees of imitation and innovation to the present day.

Paul Soldner, who had been exposed to Zen philosophy through Toyo Kaneshige, a master of Japanese Bizen ware and an early visitor to Claremont College, had started his long investigation into Raku in 1960. Soldner was surprised, during a visit to the University

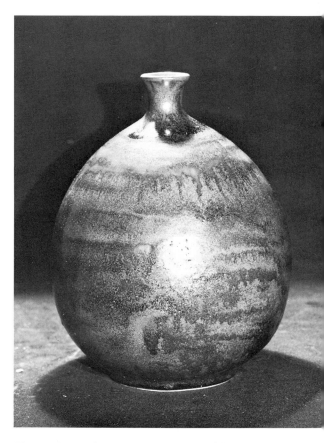

Henry Lin. Bottle, 1957, porcelain, wheelthrown, iron glaze, H. 7⅞ × Dia. 6⅝₁₆. Henry Art Gallery, Univ. of Wash., Seattle.

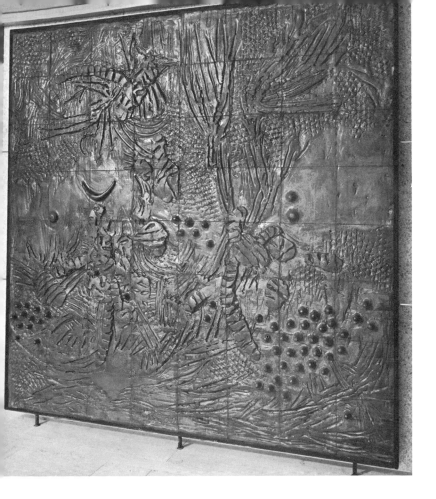

Robert Sperry. 'Twas the Eve of the Sabbath, *1961,
stoneware relief, modular construction, 64 slabs, H.
88 × W. 88. Cascade Natural Gas Corp., Seattle, pre-
sented to Lakeside School, Seattle, in 1978.*

Jean Griffith (b. Arlington, Nebr., 1921). Vase, *1962,
slab-built, Raku firing, H. 14.*

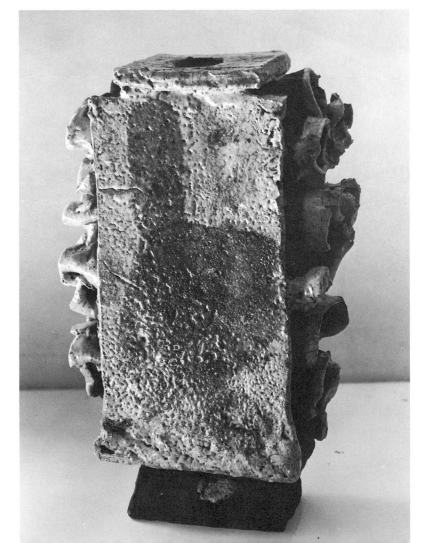

of Washington in 1960, to find that student Jean Griffith had been working with Raku and other primitive smoking techniques for a year. While Soldner was making discoveries with various nontraditional clay bodies, forms, and surface decorations, the work of Griffith and of Ngaire Hixson and Ann Johnson, who joined in with Raku experiments that year, ranged from tea bowls to medium-sized and large vases and other forms, and began to show up regularly in exhibitions. Southern Illinois University featured Griffith in an all-Raku solo exhibition in 1963. With this early work, Griffith had begun a long involvement (to date, fifteen years) with the Raku process, cutting and hand-shaping, or occasionally throwing, the forms, but usually creating the subtle asymmetry and spontaneity characteristic of the Zen aesthetic. Some of her most memorable works were from a small series of ritual pieces—shrines bearing such good-humored titles as *Garden Shrine to the Artichoke* and described by her as "recalling the ritual of the tea ceremony but translated into a mythical ceremony from the imagination." Although these primitively fired pieces are the bulk of her oeuvre, she has investigated other bodies and forms. Griffith is the artist who has, under the title of director, energized Pottery Northwest, a professional school in Seattle for ceramicists.

In the mid–1960s, Ngaire Hixson and Margaret McEachern had obviously been affected by Japanese influences, both working with textured surfaces and ash and iron glazes related to the Japanese manner. Interested in "rocks and driftwood and other basic shapes in nature," McEachern formed a large, rough slab piece in 1967. Its textured, brown surface was the perfect embodiment of the concept of the frozen moment in time as the piece came from the kiln.

Much Japanese–American interaction in the ceramics field occurred in 1963 starting with Robert Sperry's departure for Onda, Japan. This sabbatical netted him an extensive collection of Onda pottery which he and Edythe Sperry gave to the Henry Art Gallery.

In 1963 Henry Takemoto replaced Autio at the University of Montana, while Autio replaced Sperry at the University of Washington during his trip to Onda. And, this was also the year of the catalytic five-week visit of Shoji Hamada to the University of Washington, sponsored by the Center for Asian Arts which had a direct and profound influence on the entire Northwest ceramics community.

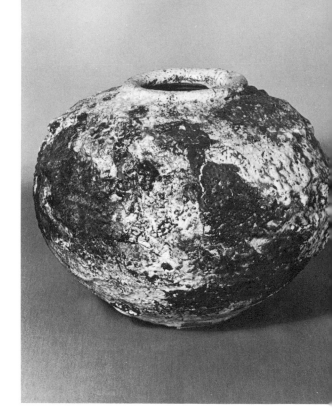

Ann Johnson. Vase, 1962, wheelthrown, Raku firing, Dia. ca. 18. Coll. of R. Joseph and Elaine Monsen, Seattle.

Margaret McEachern (b. Spokane, Wash.). Vessel, 1966, stoneware, slab-constructed, soda ash glaze, 19¼ × 19¼ × 11½. Coll. of Janet Wozniak.

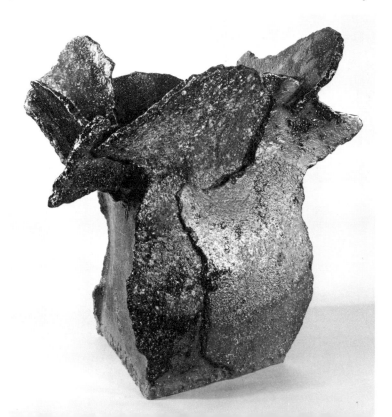

A large class of university students and community potters absorbed the teachings of Hamada, the traditionalist, recognized by the Japanese government as a Japanese Living Cultural Property. It is safe to say that it was a rich experience for Harold Myers and for graduate student Fred Bauer, both of whom managed the workshop, and for Patti Warashina, a graduate student who was soon to team up with Bauer. These three were some of the most individualistic ceramicists to have worked in the Northwest. It seemed paradoxical recently to hear the "Voulkosian" iconoclast Myers speak with reverence about Hamada and his workshop. This is a measure of Myers' understanding of the entire ceramic process as well as the need for the ceramicist to keep his freedom to create. During 1963 and earlier, Myers, Bauer, and Warashina all produced works that showed Oriental influence before striking out in directions that were to shock, titillate, entertain, and, generally, open the eyes of the Northwest ceramics community.

Seattle-born Marie Woo returned to Seattle from the Cranbrook Academy of Art and world travel in 1964 to teach for a year at the University of Washington and to produce exquisite Raku and other traditional types of folk ware, some with directly incised, calligraphic lines in textured walls.

Later, in 1966, thirty-two-year-old Mutsuo Yanagihara taught at the University of Washington as the visiting artist for the Center for Asian Arts and exerted a new semicontemporary, semitraditional Japanese influence on the ceramicists of the Northwest. Possessing a thorough understanding of the Japanese aesthetic, but a member of the new generation breaking these traditional bonds, Mutsuo produced during his first year here a great body of powerfully formed vessels, biomorphic in feeling, sometimes almost erotic, and glazed with traditional iron or ash glazes. Another group consisted of gigantic boot forms or simple mechanical forms with curving edges glazed Japanese-style with matte-finish iron oxide but decorated with sharply defined gold luster stripes. The work was highly crafted and intellectually conceived. Within a year, he had added more gold and silver lusters and high-gloss glazes over brilliant cobalt blues, moving further from the Zen tradition.

Korean-born Japanese John S. Takehara was converted from graphics to ceramics in Frances Senska's studio in 1963. He describes as an astounding experience his late study of the great Oriental ceramic tradition and his subsequent visits to Japanese kiln sites and his philosophical discussions with Hamada and Kaneshige and many young potters. Now on the faculty of Boise State College, he has traveled extensively throughout the United States, England, and Mexico, absorbing the great traditions. He wrote recently that he likes the "ruggedness of stoneware, the refined and colorful touch of porcelain, and the delicate feel of Raku—each has a place and merit," and he works in all three today. He is especially fascinated with the unpredictability of using copper-red glaze, which will vary from cherry red, to ox blood, dark purple, lavender, or transparent, depending on the degree of reducing atmosphere. He has recently experimented with sagger-fired pots. In this method a stoneware pot is stuffed with charcoal, straw, wood ash, or sawdust and placed in the kiln within a specially made clay container called a "sagger." The concentrated, specialized atmosphere inside the sagger makes possible unlimited variations of texture and color on the stoneware pot when it comes from the kiln. While most of Takehara's surfaces depend on glaze, color, and texture for decoration, he has recently completed a series of plates decorated with remarkably simple and serene subject matter from the *Thirty-six Views of Mount Fuji* woodblock prints

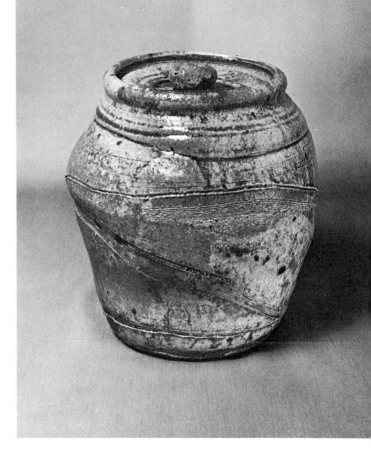

Marie Woo (b. Seattle, Wash., 1928). Covered Jar, ca. 1965, wheelthrown and distorted, H. ca. 9. Coll. of R. Joseph and Elaine Monsen, Seattle.

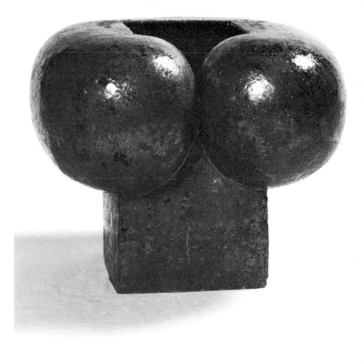

Mutsuo Yanagihara (b. Japan, 1948). Vase, 1967, stoneware, hand-built, iron glaze, 9 × 11½ × 11½. Coll. of Johsel and Mineko Namkung, Seattle.

by Katsushika Hokusai from nineteenth-century Japan. True to his heritage, Takehara believes the home is the most important center of our society, and he produces objects that are useful and decorative, and that can be treasured in private homes for generations to come.

In Oregon, Phil Eagle, a sculptor-turned-ceramicist, who still commands the respect of all who knew his work during his active Portland years in the decade of the 1960s, studied with and was inspired by Ray Grimm, and produced some of the most beautiful functional vessels of the period. Words like "Oriental," "Japanese," and "Sung" can be used to describe his works, which were thought to rival the works from early China and the ware for the Japanese tea ceremony. "I feel confident when dealing with Raku tea bowls, I know them." He says that in addition to his interest in Oriental wares, he was influenced in form by early American stoneware. His recent statements in a letter to the author concerning the Portland period deserve repeating: "I learned from Hamada in the summer of 1963 the necessity to understand each form so well that the resulting piece lacks the labored, tortured look. My time in Portland was primarily devoted to learning my craft, understanding the complexities of designing around a cylinder, a sphere, learning to draw. I draw almost every piece, including the glazing, although sometimes I turn to the wheel to explore the variation of a shape as well as to understand the effect of changing the scale. The drawings expedite endless experimentation on the wheel and allow me to work while sitting on a rock." Now in California and out of the ceramic field for the past four years, Eagle plans soon to merge his developing notions about sculpture, volumes, and materials into a comprehensive statement and begin working again in clay.

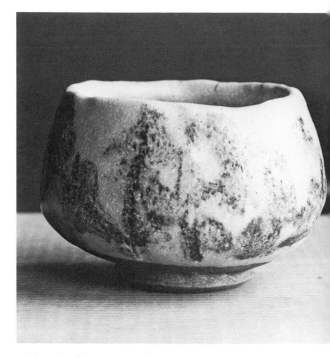

Phil Eagle (b. Denver, Colo., 1935). Tea Bowl, 1964, pinched construction, Raku firing, Dia. ca. 3½.

John Takehara (b. Sowan, Korea, 1929). Tea Storage Jar, 1976, stoneware, wheelthrown, combed surface, thin matte glaze, leather thong, 16 × 14.

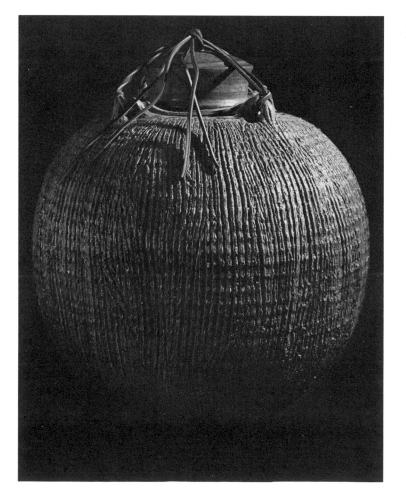

Among the many ceramicists in the Northwest who use the surface of the pot as a canvas is Tom Coleman of Portland. Coleman, whose work in both form and decoration is based on Oriental ceramics, for some time silkscreened hard-edge, abstract designs on the surface, but, more recently, has worked almost exclusively with the brush in plant and landscape imagery. He also produces plain or faceted forms in monochrome similar to early Korean wares. His porcelain work is fired to cone 11 for a slight translucency. Of a different, but still Oriental character, is his high-fired stoneware with earth tones. Coleman credits Shoji Hamada, David Shaner, Robert Sperry, Jerry Glenn, and William Creitz with providing inspiration. This artist was head of the Portland Museum School's ceramics department from 1969 to 1974 and now works independently as a fine craftsman and a consistent producer of high-quality pottery. Elaine Coleman builds small boxes of porcelain with exquisite impressed designs of Art Deco origin in delicate celadon surfaces.

Ken Stevens, professor of ceramics at the University of Puget Sound in Tacoma, also works almost completely in porcelains. A former student of F. Carlton Ball, he had earlier won a Ph.D. in chemistry and is well equipped technically to produce glazes and clay. The abstract designs and stylized landscapes are often airbrushed over stencils on the sides of the pots, whose forms resemble those of the most refined Chinese. He is also interested in monochrome celadon surfaces. Some exciting pots done recently with the pale green celadon glaze are covered jars, perfectly crafted with tight-fitting lids, but with edges delicately torn as a relief from precisely crafted pots. These pots seem intellectually conceived, yet spontaneous.

Tom and Julia Tibbs of Portland work in porcelain with large, spectacular crystals in the glazes. While little has been written about the provenance of crystalline glazes, much has been written about the technique, attesting to the critical aspects of the firing and the cooling. These crystalline effects are produced by the Tibbs's on vases formed in basically classical Chinese shapes as well as on slab-built vessels.

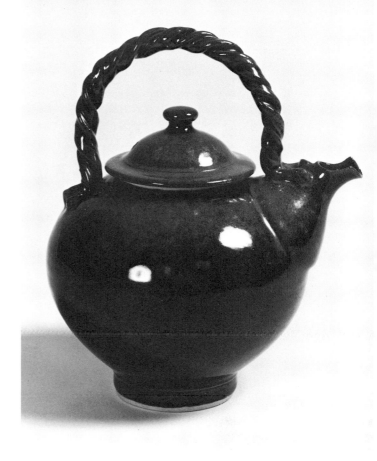

Tom Coleman (b. Amarillo, Tex., 1945). Teapot, ca. 1973, porcelain, wheelthrown, iron glaze, H. 8½ × W. 7. Coll. of Herschel and Carol Roman, Seattle.

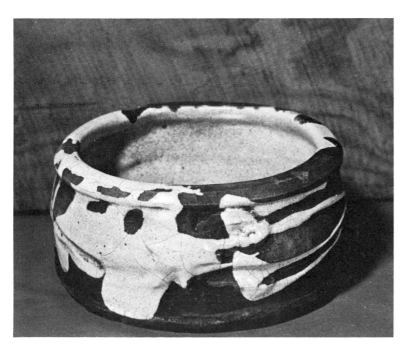

Phil Eagle. Tea Bowl, 1964, Raku firing, blue and green with thick tin crackle glaze, H. 4 × Dia. 9.

J. B. Blunk, a California artist, was in 1953 one of the earliest Americans to study in the Kaneshige workshop in Bizen, Japan. He was inspired, as a result of this experience, to produce a large body of Bizen-style wares, which he showed in a notable exhibition at the Oregon Ceramic Studio in the late fifties. One vase, still in a collection in Portland, was given the traditional long firing in a wood-burning kiln and was related in imagery to a shield figure of the Japanese Yayoi or Haniwa type.

Twenty-two years later, in 1975, a young Seattle potter, Eric Nelsen, studied under Mitsuo Morioka at the Bizen site where the family of Toyo Kaneshige has carried on this ceramic activity for over nine hundred years. Nelsen then returned to Seattle with Morioka, his teacher, bringing the spirit of Bizen and constructing on Vashon Island, near Seattle, a traditional, climbing, wood-fired kiln (a series of small chambers built on the slope of a hill to achieve more consistent temperatures throughout), in which they produced Bizen-type wares. Nelsen considers his best pot of the past two years to be the kiln itself.

Another younger potter who has borrowed from the Japanese is James M. Romberg, artist-in-residence at the Sun Valley Center for the Arts and Humanities since 1974 and former student of Paul Soldner. Romberg, like his mentor, works in Raku techniques, but the similarity ends there. He forms a "regular" Raku clay body into gigantic platters and flat-sided pieces on which he paints and trails glazes with handmade brushes. In a recent letter to the author, Romberg wrote: "I am concerned with the form of a piece. In the bottles with sculptured stoppers, I have been playing with the relation of the formed top and the painted bottoms. With the split platters, the idea of carrying this motion over into and allowing it to shape the platter quite literally [is the basic idea]. I have found that it makes such a difference, with the subtle tones, how these pieces are allowed to cool, not unlike a photographer developing a picture, working for something beyond zone five, black and white—the rate of development is critical!"

Romberg's bottles with stoppers sometimes run almost five feet tall. The stoppers of these huge vessels are an integral part of the contour of the form, often making up as much as one-third of the volume of the entire free form. The platters are a giant thirty-two or more inches in diameter. All of the works are decorated with hard-edge brushwork. As abstract forms, the works remind one of monuments or steles. Some of the bottles give the impression of twelfth-century Japanese warrior figures.

Gerald Newcomb of Arlington, Washington is another young painter-as-potter using Oriental techniques to his own ends. All his production work is done on the wheel, but he sees his spherical pots in two-dimensional terms, slip-trailing abstract designs onto the white-glazed forms in greens, blues, and iron reds. Some of his most interesting works are large, slab-built vessels with rectangular or semicircular bodies and thrown necks. He also works in rectangular, sculptural forms to which he adds fiberglass to strengthen the stoneware body.

Anne E. Hirondelle, a graduate of the University of Washington who has settled in Port Townsend, is also working in Oriental directions. Hirondelle produces many forms, such as casseroles, tureens, plates, tea pots, basket forms, and stacking forms, in the Japanese style. Some of the most exciting of these have cut or faceted outside walls much like early Korean or Chinese ware. Her work, both in the unusual glaze colors of orangey-salmon and gray and the fluid manipulation of the clay, is similar to that of Betty Woodman, a faculty member from the University of Colorado, who conducted a workshop at Pottery Northwest in 1976.

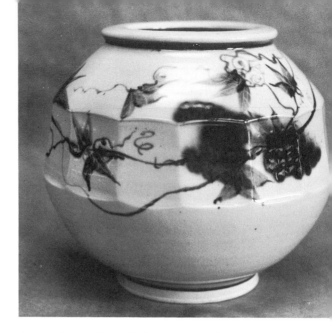

Tom Coleman. Vase, 1977, porcelain, wheelthrown, faceted walls, brush decoration, semigloss chun glaze with oxide brush decoration, H. ca. 10. Coll. of Mr. and Mrs. Alan Schwartzman, Seattle.

Kenneth Stevens. Covered Jar, 1976, porcelain, wheelthrown and torn, celadon glaze with blue and gold band at bottom, H. 13.

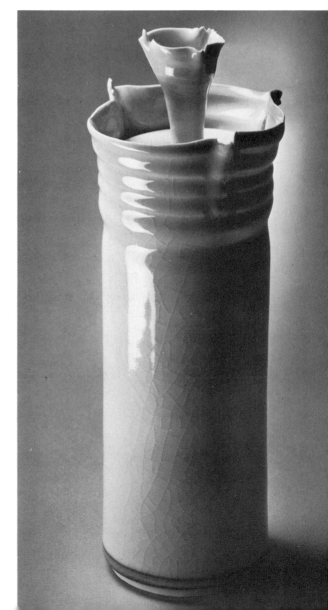

Frank Boyden, living in Otis, Oregon, makes wheelthrown as well as slab-built Raku vases whose surfaces are carefully controlled — in diametric opposition to the spontaneity of the Japanese aesthetic. The single similarity to Japanese Raku is his practice of pulling the pot in a state of flux from the hot kiln and reducing specific areas of the surface in a smoky atmosphere. After the designs are excised, some areas are covered with glaze or slip, and some raw areas are sanded to delete all imperfections, including finger marks. After firing, during the reduction treatment, the sanded areas readily absorb the smoke and become a matte black color, and the glazed areas are lighter gray. Boyden has recently been working with combinations of clay and metal, especially in functional woodburning stoves.

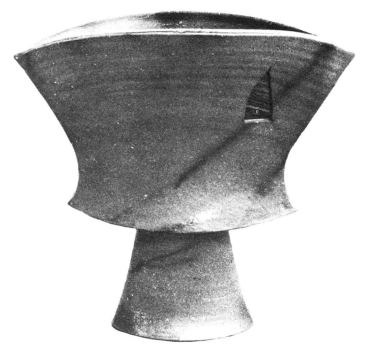

J. B. Blunk (b. Kansas, 1926). Flower Holder, 1953, Bizen-type ware with Hidasuki (red lines), sagger firing in straw, thrown, reformed, assembled, unglazed, 10¼ × 10¼ × 4. Coll. of Francis Newton, Portland, Ore.

Eric Nelsen (b. Seattle, Wash., 1954). Tea Bowl, 1977, wheelthrown, light ash glaze in anagama wood-fired kiln, H. 6 × Dia. 5. Coll. of Ruth Nelsen, Seattle.

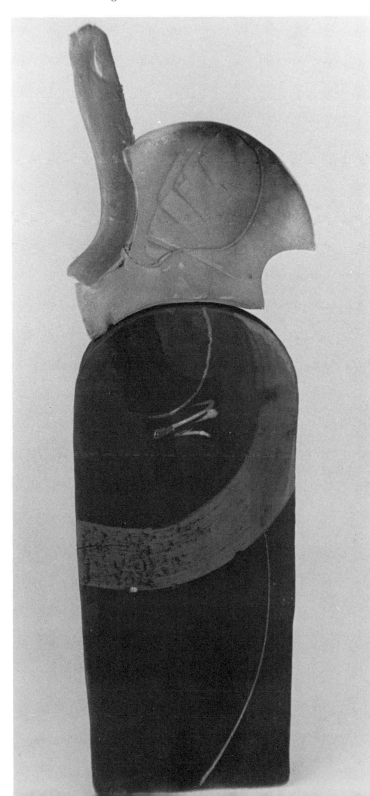

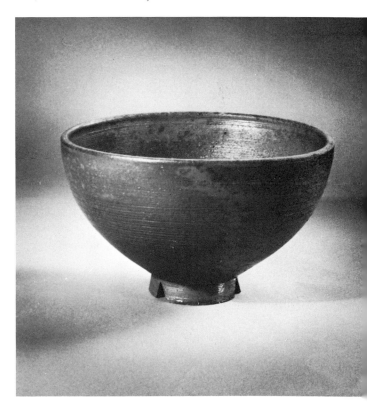

James Romberg (b. Austin, Tex., 1943). Night Wander, ca. 1976, bottle with stopper, Raku firing, brushed and trailed decoration, H. 52.

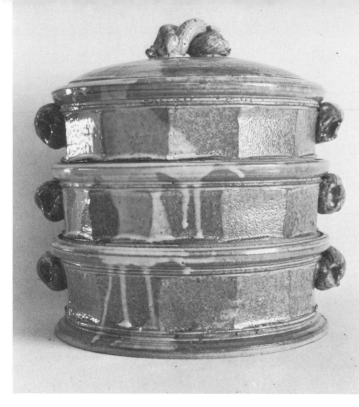

Anne Hirondelle (b. Vancouver, Wash., 1944). Stacked
Pot, 1976, stoneware, wheelthrown with hand-built
handles, apricot and white glazes, H. 11½ × W. 11½.

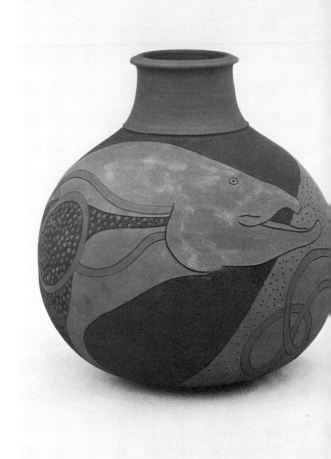

Gerald Newcomb (b. Yuma, Ariz., 1951). Slab Box,
1974, stoneware, hand-built, glazes and brush work,
22 × 28 × 6¾. Coll. of Ron Ho, Seattle.

Frank Boyden (b. Portland, Ore., 1942). Carp Vase,
1977, native Oregon clay, wheelthrown, glazed, in-
cised, sanded, and reduced surface, H. 18 × Dia. 14.

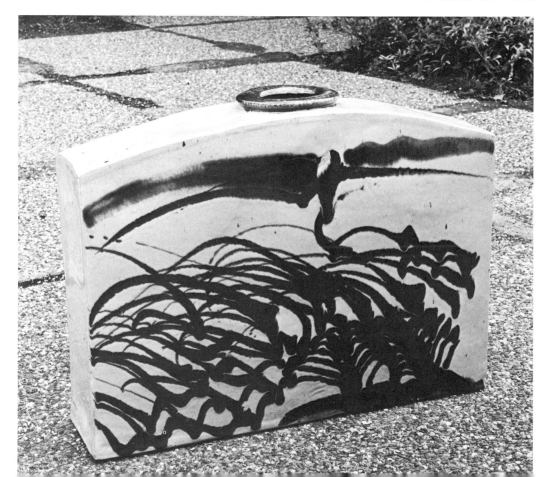

The Clay Object as Sculpture: The Turning Point

In the new lively atmosphere, it is not surprising that ceramicists of the Northwest experienced a deepening concern over the Renaissance-imposed distinction between the so-called fine arts and the crafts and the relegation of works in the medium of clay to the craft category. The liberalizing views of the Bauhaus had given a higher status to the crafts by linking them closely to the "fine arts," although this union was compromised by the emphasis on the need for integration of industry and the arts. By 1960 in the Northwest basic questions (and answers) to this unresolved conflict concerning the arts versus the crafts, or the major versus the minor arts, or functional versus sculptural objects began to be articulated by the artists through the objects they entered in the annual Northwest Craftsmen's Exhibition at the Henry Art Gallery in Seattle. Some objects crossed media lines (a garden piece might be a combination of wood and clay) or some behaved in an untraditional way by not being functional (a woven hanging might become three-dimensional and hang in free space, or a ceramic cup might be filled with a small sculpture, precluding its use as a cup). This was, of course, disruptive to the smoothly working media categories assigned for entries when the show was initiated in 1953, and to all such competitive "craft" exhibitions.

Long before this awakening in the Northwest, Peter Voulkos, on arrival in Los Angeles in 1954 from Helena, Montana had begun to lead a young group of iconoclasts in revolutionary activity in clay at the Los Angeles County Art Institute. This group released themselves from the traditional concern for the functional integrity of the ceramic object.

Together this group in California broke all traditions associated with the formation and surface treatment of objects in clay. In the July 1961 issue of *Craft Horizons,* five years before an exhibition at Irvine, Rose Slivka's article, "The New Ceramic Presence," had already incisively investigated this dramatic change against a historic and cultural American overview. What had happened in the Voulkos milieu in Los Angeles was to affect the entire field of ceramics, including the Northwest.

John Coplans indicated in *Abstract Expressionist Ceramics,* the catalog for the exhibit held in 1966 at the University of California at Irvine, that the sensibilities of the exhibitors were closer to those of the New York School of Abstract Expressionist painters than to those of Leach and Hamada, whose work some of them nevertheless admired, and to whose teachings some of them, such as Voulkos, had been exposed. Of that tumultuous period in Los Angeles from 1954 to 1958, Coplans writes: "The task these ceramicists set for themselves was to discover the essential characteristics of the medium. Obviously their first step was to free themselves of all dogma and convention." He further states: "Probably the most decisive shift by Voulkos was in constructing ware of multi-part form. Dependence on the repertoire of shapes inherited from functional vessels ceased; synthetic forms could henceforth be created. Although it took time to exploit this idea, it nevertheless inevitably led towards a more sculptural concept. Another important move by Voulkos was the use of epoxies for joining parts together; this was followed by the employment of epoxy paints side by side with glazes. In this manner the aesthetic concept of 'truth to materials' was abandoned and by this use of paint the

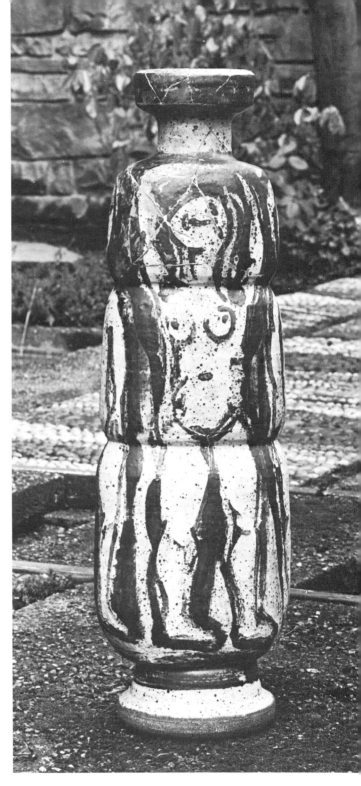

Peter Voulkos. Figure Vase, 1955, stoneware, wheel-thrown and reformed, cobalt and iron slip figures, semi-matte glaze, brush decoration, H. ca. 24, made in Montana. Coll. of Fred and Constance Jarvis, Seattle.

way opened for the development of polychrome sculpture on the West Coast."

In *Craft Horizons* (October 1957), John Mason, one of the group at the Los Angeles County Art Institute, attempted to clarify the term "craftsmanship," which had become so inextricably associated with "well made" functional objects: "The idea is one of a changing attitude of working with materials. The craftsman maintains a respect for skill, but enlarges his concept of craftsmanship by supplying himself with a series of techniques to meet his new conceptual needs, repudiating any technique or mechanical device which might encroach upon his freedom of action" (p. 41).

Although Robert Sperry continued to produce functional wares during most of his career, he took a sharp detour in the early sixties that was to last for a number of years. Between 1959 and 1962 he produced a long series of sculptural works in clay that refer only obliquely to other works of the period. Sperry and Voulkos had been associated for a brief period in 1954 at the Archie Bray Foundation before Sperry came to the University of Washington, and he was again exposed to Voulkos' attitudes and work during a seminar at the university later in the fifties. So, it is not surprising that some aspects of their work of that period are similar, such as, for instance, the use of cylindrical spouts jutting up out of tall constructions. Sperry's works were large (two to six feet tall) stoneware objects, constructed of slab-built, wheelthrown, and modeled parts, glazed in neutral tones. Although most of these forms were more sculptural than vaselike, it is not surprising, given his lifelong commitment to functional wares, that he was not as involved in destroying past references to functionalism as were Voulkos and his colleagues.

Running through most of Sperry's work are two contrasting concerns: as spontaneously conceived as much of his work is—the fast tempo at which he works, the effortless brushwork, the uninhibited expressive qualities, especially in the sculpture—he can sometimes spend hours painstakingly decorating the surfaces of the works, building them up with literally hundreds of bits of clay or carefully gouging the surface to create a dense, overall pattern or drawing designs on every conceivable inch of space in the manner of *horror vacui* of Barbarian or Islamic Art. Both of these qualities were part of his work of the 1960s.

The imagery of this period related to magic and totemic spirits, or oftentimes, to flowers and weeds, whose protruberances made emotional statements with erotic overtones. Some were figurative, some more abstract. However, few of these works exhibited the extreme qualities we have grown to expect in the Abstract Expressionism of the New York School of the forties and fifties or of the Los Angeles group of ceramicists: the action orientation, the immediacy and spontaneity reflected in the handling of the material, the distortion of the material, the gestural aspects, the use of bright color, the rejection of traditional tenets of "composition." Sperry's powerful works bespoke a personal revolution—an expessionism of sorts—tempered by his innate perfectionism. Most of these objects were shown, along with his functional wares, in exhibitions at the Frye Art Museum and the Hall-Coleman Gallery in Seattle in 1961, and in New York City at America House in 1962.

Sometime later, Sperry became preoccupied with experimental film-making, and in 1967 he produced an award-winning, surreal film entitled, *Profiles Cast Long Shadows*. He also experimented with film animation, using the same geometric designs or symbols that appeared on the surfaces of his functional wares. By 1970, after a year's leave of absence, he was back teaching and working in clay full-time.

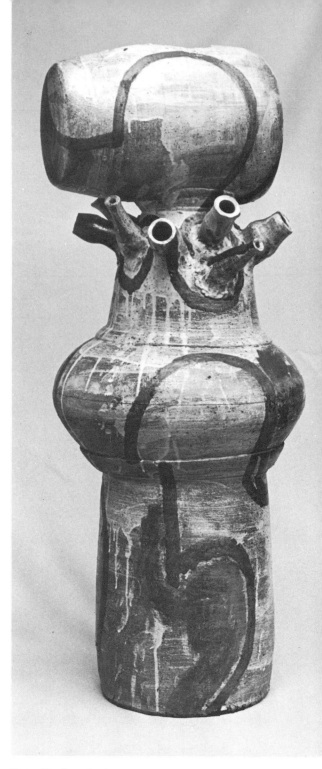

Peter Voulkos. Sculpture, 1956, stoneware, assembled of wheelthrown sections and spouts, brushed white and dark slips, H. 40½ × W. 16. Coll. of John and Anne Hauberg, Seattle.

Although Sperry's sustained public commitment has been to sensuously ornamented functional vessels, except during this short period in the sixties when his sculpture and films had broad exposure, he has continued to produce three-dimensional works in clay of emotionally charged imagery and form—expressive "works of art." In the 1970s he has executed, in addition to some of his most mature functional vessels, several series of works with surrealistic overtones.

At the time of his last work in film, he was developing some drawings for a projected animated film with the possible title, The War of the Organs, the imagery for which eventually found its way onto the surfaces of some large clay platters. These images, which he refers to as "The Blue Bag" images, were drawn in wide felt-tip marker in brilliant colors, and carried such titles as *The Cherry Bomber, Cosmic Penetrator Attacking a Flying Cherry Bomber, Cosmic Penetrator, Jr., Being Attacked by a Cherry Bomber, Labia Lip Lobber, Vertical Breast Bomber, Gas Ray Heaver, Flight of Utershooters Taking Off from Their Underground Silo,* and *High Speed Lung Lunger Rockets.* These images were inspired by the illustrations in a dentistry book and consisted of sets of teeth, tear drops, pipes, tubes, and bright blue bags, as well as birds, machines, bugs, butterflies, strange faces, keys, and more, all interrelated in the overall design. This wonderland of imagery, vaguely related to outer space and comic books or to the Beatles' films, was in 1975 adapted in brilliant underglaze colors to the surfaces of large plates of clay. The odd juxtapositions of subject matter were surreal and also illusionistic in that the designs were sometimes extended over the plate rim, and then glazed or not glazed in contrast to the center of the plate, with the rim approximating a frame. When the work is hung on the wall, there is always the question: Is it a rim or a frame? Is it a plate or a "picture?"

For some time Sperry has been working on a series of slab-built plates for hanging on the wall which are designed with crackle and "crawling" and heavily pooled glazes and lusters. He is at work as well on a series of three-dimensional sculptural pieces in clay which deal with the subject of violence: *Dueling Pistol* is in the form of a revolver handle combined with male genitalia, and a series of skulls deal especially with military violence.

Although these pieces are rarely shown, his gigantic expressionistic sculptures of the sixties, which were shown widely, played an influential role in the transition from functional to sculptural objects in the field of ceramics.

From 1960 to 1965, large numbers of unfamiliar objects in clay began to be produced especially among the ceramicists of the University of Washington and the University of Montana. Most of these artists worked more alone than together, and all served seminally as the link between the old and the new type of ceramics. The dynamic activity and high rate of production during this period matched the atmosphere that had surrounded Voulkos and his group at their peak in Los Angeles a few years earlier. Controversial as these artists were at the time, the juries for the annual Northwest Craftsmen's exhibition at the Henry Art Gallery in Seattle and the annual at the Oregon Ceramic Studio in Portland, as well as in other exhibitions throughout the United States, often accepted their work, which thus received wide public exposure and was, in some cases, purchased for collections.

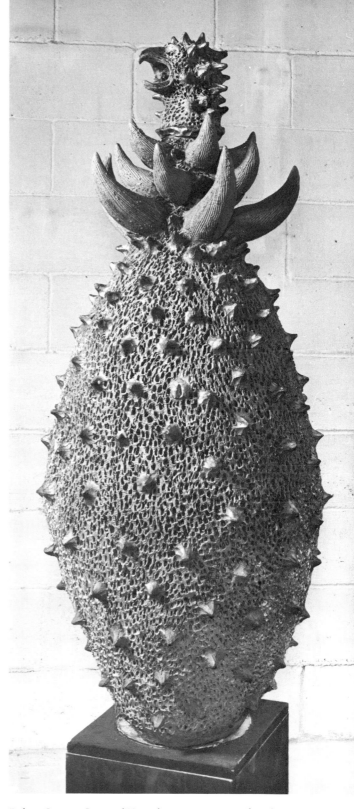

Robert Sperry. Covered Vessel, 1960, stoneware, hand-built, modeled and coiled, textured with stick, glazed, H. ca. 48.

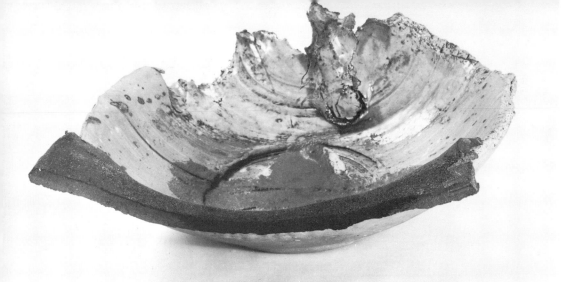

Peter Voulkos. Plate, 1963, stoneware, hand-built and wheelthrown, glazes, 5½ × 12 × 10. Coll. of R. Joseph and Elaine Monsen, Seattle.

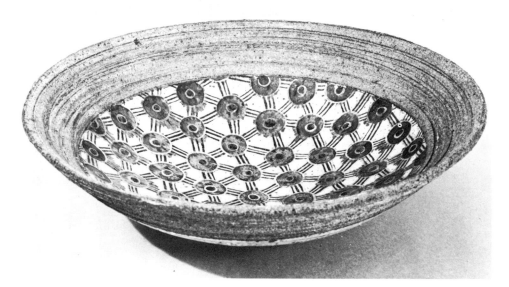

Robert Sperry. Bowl, 1965, stoneware, wheelthrown, glazed and unglazed, cobalt and iron oxides and gold luster, Dia. 17¼. Objects: USA. Coll. S. C. Johnson & Son, Inc.

Robert Sperry. Bowl, 1975, stoneware, wheelthrown, glaze and lusters, H. 5 × Dia. 16½. Coll. of Ron Ho, Seattle.

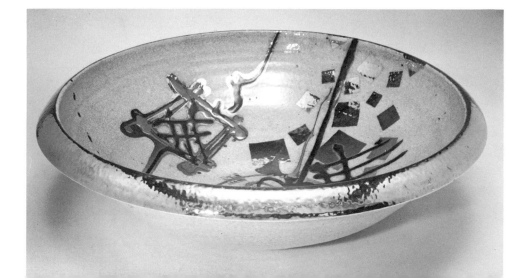

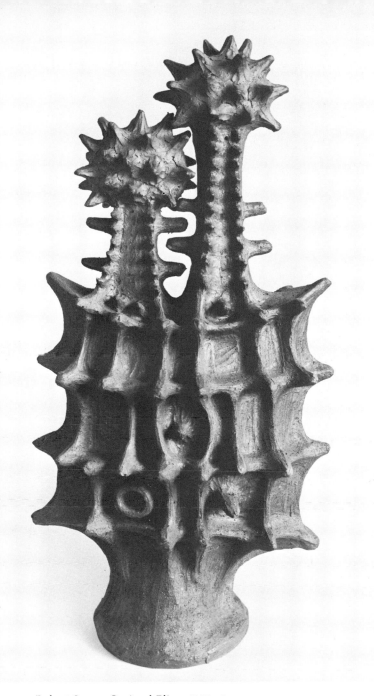

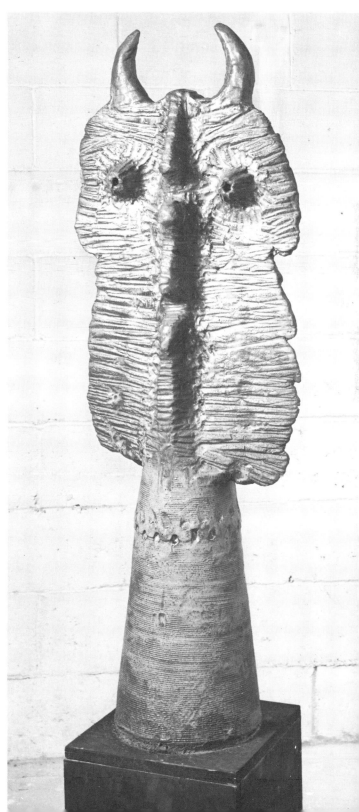

Robert Sperry. Sculpture, 1961, stoneware, slab-built, H. ca. 48.

Robert Sperry. Conjugal Bliss, 1960, stoneware, wheelthrown and modeled parts, assembled, unglazed, H. 38 × W. 18½. Coll. of Mar Hudson, Everett, Wash.

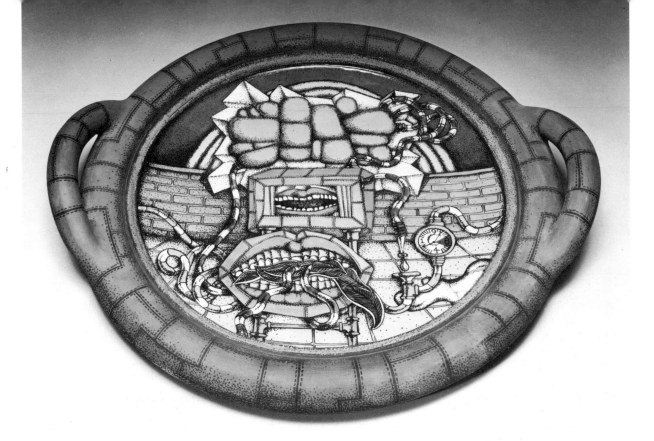

Robert Sperry. Platter, "Blue Bag" series, 1975, stone-ware, wheelthrown and hand-built, underglaze and glaze, H. 19 × W. 17.

Robert Sperry. Slab Form, 1977, stoneware, hand-built, glaze brushed and trailed, silver and gold lusters and iron oxide brushed and spattered. H. 14½ × W. 14½.

Robert Sperry. Spirit of '76, 1975, earthenware, hand-built, pinched, underglaze, glaze, luster, 10 × 8½ × 10. Henry Art Gallery, Univ. of Wash., Seattle.

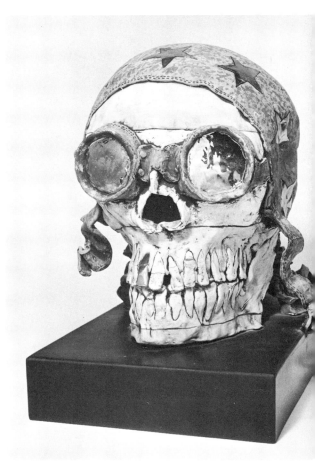

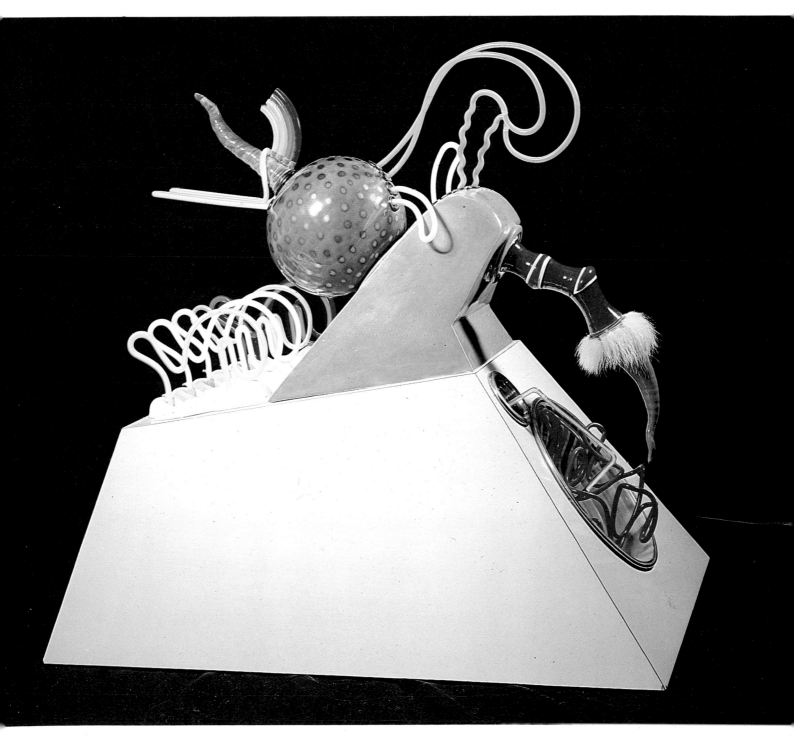

Opposite: Patti Warashina (b. Spokane, Wash., 1940). Construction from "Machine" series, 1963, stoneware, slab-built and wheelthrown, unglazed, H. 48. Coll. of Johsel and Mineko Namkung, Seattle.

1. *Fred Bauer.* Defunct Pump. *1970, earthenware with neon, wheelthrown and hand-built, Formica base, low-fire glazes, lusters, 51 × 35 × 48 (including base). Coll. of Mr. and Mrs. Herbert Pruzan, Mercer Island, Wash.*

2. *Fred Bauer. Hinged Box, ca. 1962, stoneware, slab-built, ash glaze, 32 × 17¼ × 9. Coll. of Stanley and Marian Gartler, Seattle.*

3. *Erik Gronborg. Table, 1967, stoneware, hand-built and wheelthrown, lead glazes, lusters, black-stained hardwood, 26 × 36 × 22. Coll. of Roger J. Porter, Portland, Ore.*

4. *Rudy Autio. Floor Vase, 1962, stoneware, slab-built,*
 sgraffito, engobes, 30 × 25 × 33. Coll. of Richard R.
 Policar, Portland, Ore.

6. *Joyce Moty.* A Fishy Date, *1975, earthenware, hand-built, underglaze and glaze, 17¾ × 8½ × 5¾. Coll. of John and Anne Hauberg, Seattle.*

5. *Patti Warashina.* Moon Dog Dream, *1969, earthen-ware, slab-built, low-fire glazes and lusters, 29 × 20 × 10. Coll. of Robert L. Pfannebecker, Lancaster, Pa.*

7. *Kenneth Shores (b. Lebanon, Ore., 1928).* Fetish 5–
11, *1975, stoneware, wheelthrown, pheasant and un-
identified feathers encased in Plexiglas, H. 4½ × Dia.
16. Reprinted, by permission, from* Oregon Rainbow
1 (Spring 1976):32.

8. *John Takehara. Vase, 1977, porcelain,
wheelthrown, copper red glaze, H. ca. 18 ×
Dia. 20. Coll. of Louis and Roberta Scherzer,
Portland, Ore.*

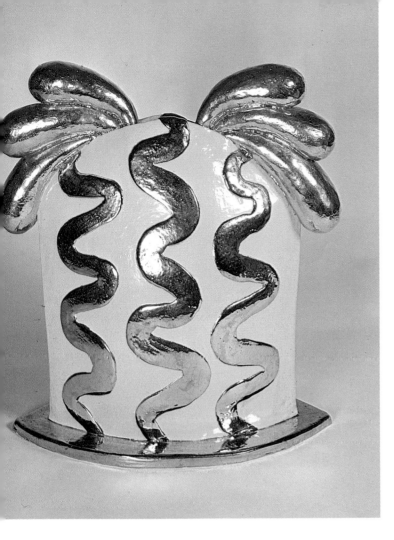

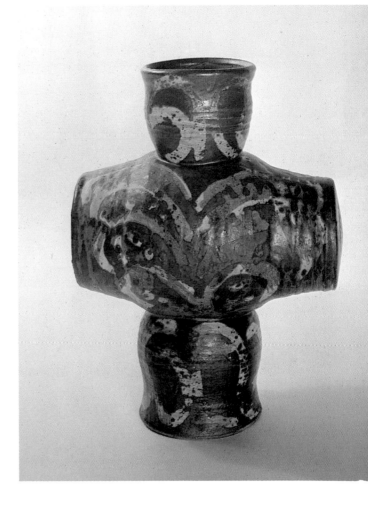

9. *Howard Kottler.* Lemon Punch Pot, *1967, earthenware, hand-built, glaze and luster, H. 17¼ × W. 16½. Coll. of Dr. and Mrs. Herschel Roman, Seattle.*

10. *Peter Voulkos.* Vase, *ca. 1954–55 (probably made in Los Angeles), stoneware, three wheelthrown sections, wax resist brush work, iron slip, transparent glaze, H. 14¾ × W. 10¼. Coll. of Earl and Marcella Benditt, Seattle.*

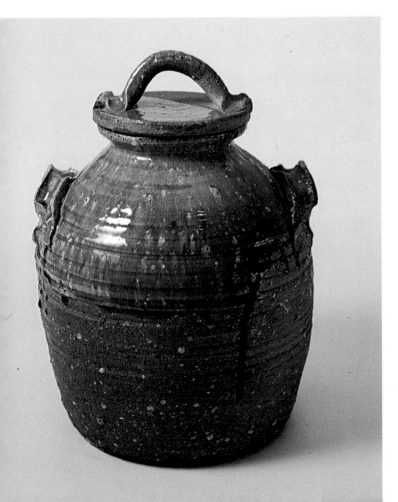

11. *Kenneth Ferguson.* Storage Jar, *1966, stoneware, wheelthrown, wood ash glaze, raw clay, H. 18 × Dia. 11.*

12. *Raymond Grimm. Bowl, 1965, porcelain, wheel-*
 thrown, Chun blue glaze, copper slip, H. 2½ ×
 Dia. 4.

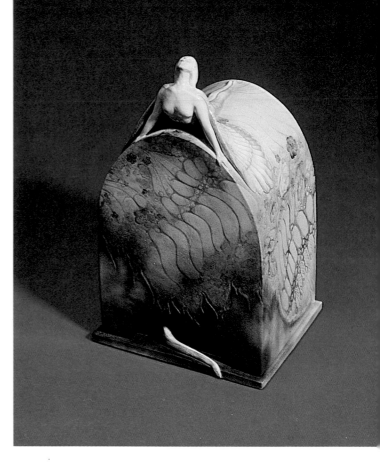

13. *Margaret Ford.* Phoenix Box, *1972–73, two-part*
 sculpture, earthenware, hand-built, underglaze,
 glaze, china paint, 10½ × 6 × 5.

14. *Robert Sperry. Platter, 1973, stoneware, slab-built,*
 glaze with cobalt and chrome oxides, gold luster
 (use of luster begun in 1965). Coll. of Johsel and
 Mineko Namkung, Seattle.

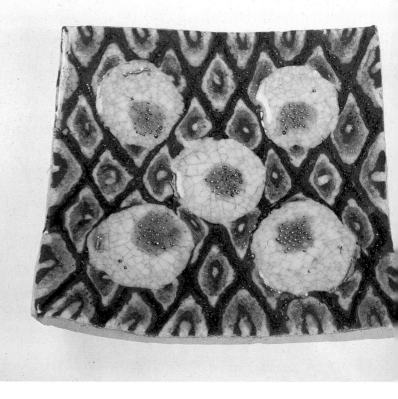

In 1960, concerned as most of the ceramicists of the Northwest were with the issue of ceramics as a major versus minor art, or functional versus sculptural objects, few in the art community were prepared for the arrival of Harold Myers, a Californian who came to join the University of Washington faculty in ceramics. One of the earliest of the "transitional" artists, he had just spent time working in Voulkos' new studio at the University of California at Berkeley. In his words, this time was "one of those peak experiences, to be allowed to learn from the artist who had single-handedly revolutionized clay work; he did it first and best. It was an intense and demanding nine months that changed my direction from making chic forms to exploring a kind of 'anti-form and anti-surface treatment.' I was strictly on my own at Peter's invitation; he always supported artists this way." Myers' work in Seattle was noticeably influenced by Voulkos: "It was difficult to get out from under that kind of influence." (It is interesting to note that Myers does not see Voulkos' work from the Los Angeles period as abstract expressionist; he sees it as "just Peter Voulkos.") But, it was not long before Myers had found his own way.

He worked mostly in stoneware, firing some pieces more than once with brightly colored, low-fire glazes. In his first exhibition in Seattle, the aptly titled pieces, *Big Pile* and *Little Pile,* which were artistically unique nationally (huge mounds constructed of soft slabs of stoneware with transparent glaze slopped on over oxides of iron, titanium, and copper) caused a furor with the local artists and other viewers. Later, the readers of *Craft Horizons* reacted similarly when *Big Pile* was shown in Rose Slivka's article, "The New Ceramic Presence."

The sharpest criticism and the most emotional, came from the nation's most revered, established potters. The big, black, ugly expressionistic *Baroque Vase,* from the same period, constructed of roughly thrown and sliced cylinders, frightened to tears some visiting school children. These works and others from their time were truly threatening. They were the way Myers externalized the Voulkos experience. Myers has stated that these pots were also the result of his "down view" of culture.

His years in Seattle were years of personal exploration. He was vitally interested in process and he recalls that his response to clay was not intellectual, but direct—almost like a sexual response. His achievements never seemed to be in relation to the "art world" but rather were the completion of a dialogue between himself and his work. His output was prolific. In an artist, this dynamic activity, with its attendant risk-taking, can be compared with the committed research of an effective scholar. But, for all of his experimentation, he was a purist of sorts, a traditionalist in many ways. Strange looking as his pots were, he could not tolerate a leaky one. He always insisted that in a successful piece, the surface treatment cannot be separated from the form. Much of his inspiration comes from an extensive historical knowledge of pottery. His sensitive understanding of Oriental pottery made the five-week workshop by Shoji Hamada at the University of Washington in 1963 a valuable experience. With the assistance of Fred Bauer, he fired the works and managed the technical end. He speaks of the Orientals as being the only ones who really understand the part that nature plays in the ceramic process, . . . "a moment of process frozen forever."

Myers played an important role in a discussion of the long-simmering conflict concerning the major and minor arts at the Fourth National Conference of the American Craftsmen's Council at the University of Washington in 1961. The speakers were divided among blatantly elitist "fine arts" spokesmen, "crafts" supporters who spoke diplomatically in favor of raising the down graded image

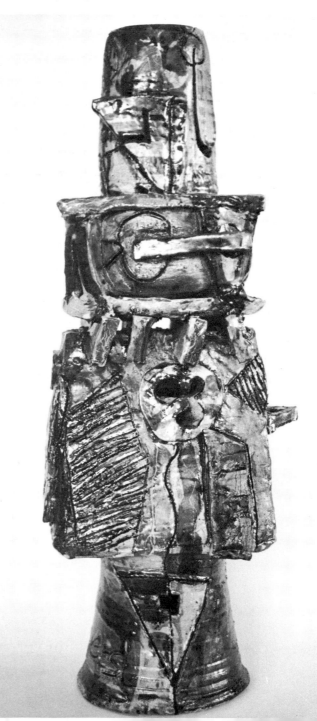

Harold Myers. Chaco, *1961, stoneware vase, wheel-thrown and hand-built, white glaze with iron and cobalt underglaze decoration, orange glaze over all, H. 32½. Coll. of Betty Dunn.*

of the so-called minor arts, and Harold Myers, who emphatically stated his belief that "a potter, once called only by the name of 'craftsman,' . . . can now, if his work demands it, be called by the name of 'artist'. . . . What he makes his objects of is not important, but the amount of truth in what he makes is important. Creation should be no different in clay than in paint."* If these statements caused an uproar at the conference, the objects he submitted to the exhibition that accompanied the conference scandalized the conferees.

Although ignored and misunderstood during his five years at the University of Washington, Myers through his revolutionary approach carried the new attitudes from the Voulkos milieu to the Northwest. He can be considered as pivotal in the changeover. As Myers states it: "It was tough going from the Voulkos atmosphere where students were encouraged to break every possible rule regarding ceramic form and surface, to the Northwest where the emphasis was on traditional functional ware. We had done everything we could to make a ceramic vessel not be pretty to look at and still bear some relation to ceramic form of the historic past." Voulkos, in a recent interview, compared dramatically the positive, upbeat conditions of his own move from the Montana outpost to the vital Los Angeles art scene, with the conservative atmosphere that Myers, coming out of California, found in insulated Seattle.

Myers worked in a relative vacuum except for the comradeship of a few interested students and one or two faculty members during those five years at the University of Washington, but he credits Robert Sperry, who characteristically offered him optimum freedom to work and to teach. In 1965, Myers returned to California where he now teaches at California State University at Hayward.

Rudy Autio played a major role in the transition between the old and the new ceramic work of the Northwest, both in his own work and in his influence on his students' work. Most of his time since 1957 was spent teaching and working at the University of Montana, with participation in short-term workshops and seminars throughout the country. His replacement of Robert Sperry at the University of Washington during the latter's leave in Japan in 1963 put all of the ceramicists who were most responsible for the change from functional to sculptural emphasis in clay under one roof for a few months. Around 1960, sometime after his appointment in 1957 to the University of Montana, Autio began working in high-fired, slab-constructed vessels with subsequent firings of low-fired, pastel and white engobes (clay in liquid suspension) and glazes. Autio was also using paint on the surfaces of his vessels in 1963 while he was at the University of Washington. Formed of slabs in varying sizes and shapes in rough configurations, many of the vessels from 1962 ran up to four feet high, their color applied freely. During the next several years these vases evolved from rugged forms, in which the dynamic art of construction was clearly evident, to smoother, more carefully joined, almost lyrical works with appealing blue, rust, and pink glazes and gold, silver, and copper lusters. About the same time, Autio built tall and voluminous vases with contours of chunky female nudes drawn on with a brush or scratched on. Some were boisterous, and some were rendered much in the style of Picasso's ceramic works of 1954. Around 1966, Autio made political comments through the drawings on his pots with appropriate titles.

Autio works always in stoneware and rarely uses the wheel, even in combination with his ever-present, slab-constructed work.

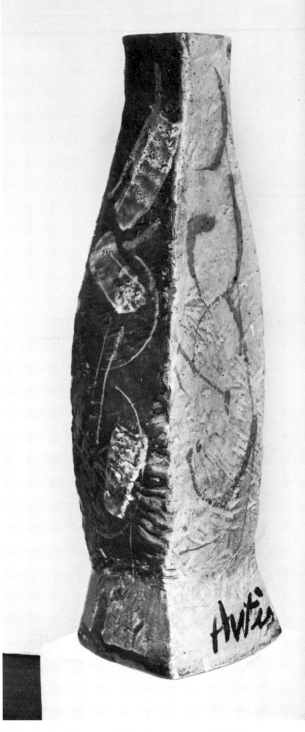

Rudy Autio. Vase, ca. 1959, stoneware, slab-built white, blue, trailing pink glazes, H. 29 × W. 8⅛. Coll. of Fred Peano, Portland.

* From "Research and the State of Becoming," transcript of a speech delivered by Myers at the conference, p. 65.

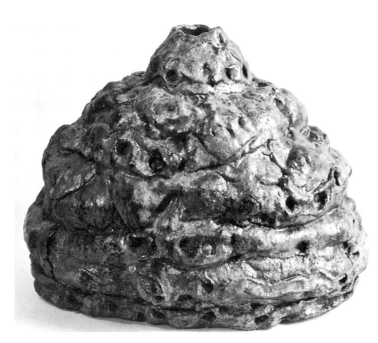

Harold Myers. *Pouch Form, 1963, stoneware, hand-built, polychrome glazes, 18½ × 23 × 14.*

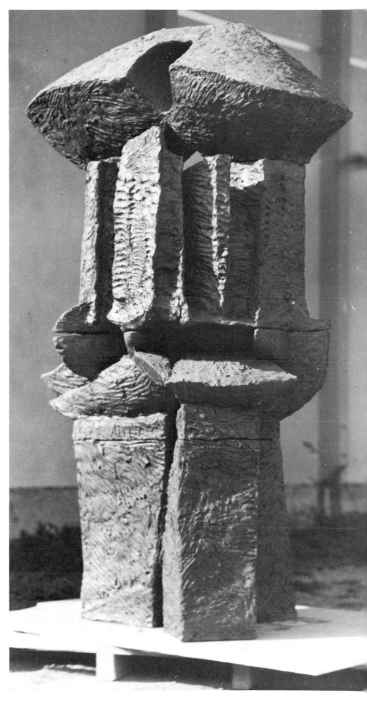

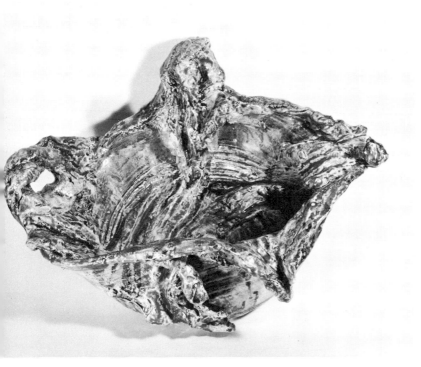

Harold Myers. *Bowl, 1965, wheelthrown and distorted, red lead glaze, H. ca. 8 × W. 20.*

Rudy Autio. *Construction, 1961, stoneware, hand-built, iron wash, H. 66 × W. 36.*

Although much of his work, including the taller three- and four-foot vessels of the early 1960s, displays a kind of lyrical and, sometimes, playful attitude, the expressive intensity and passion of the inner man are reflected clearly in the gigantic size and the rough juxtapositions of the slabs in the construction of the works. If one looks with squinted eye at some of the earliest of those roughly carved, slab-relief commissions, one can see the roots of the dynamic abstract vessels that were to follow. As a matter of fact, the brickyard at the Foundation may be the key, as alluded to in this astute observation by Ben Sams, Autio's student in the late sixties, in a recent letter to the author: "That first image of abstraction you are looking for may be locked into the process of brick making. Piles of bricks, fused together, slabs of brick melting, sintering, bloating, make interesting images. The shale, before it was crushed, and natural chunks of raw earth waiting to be processed into bricks, were piled all around the Bray. Moving through the process were various grades of pebbles, clay dust, all sifting finer and finer. Vats of brick slurry, rows of unfired brick, some cracking, some warping. Artistic consciousness builds strong clay images from such strong clay images." The Archie Bray Foundation was Autio's major environment for five years, and Voulkos' for two. How much did it influence the "abstraction expressionist" works at the Los Angeles County Art Institute?

In the move away from functional concerns, the artists of the Northwest, in addition to being affected by the California abstract expressionist ceramicists, were also influenced by the use of common objects in Pop Art, and even more deeply by the attitudes and objects of the so-called Funk artists who were based at the University of California at Davis under sculptor Robert Arneson. As ephemeral as the term "funk" was, and still is today, the objects assigned to it embodied alternately, or together, such qualities as sensuous elegance, gaudiness and tastelessness, erotic and scatological references, ambiguity and irreverence, meaningless Dadaist or irrational surreal combinations of parts, often with lumpy surfaces. Objects in the Northwest, especially at the University of Washington, began to take on some of these aspects about 1962.

Two graduate students at the University of Washington who worked closely for a number of years, and who were to become influential nationally, were Patti Warashina and Fred Bauer. Bauer had graduated from the Memphis Academy of Art and Warashina had been an undergraduate student at the University of Washington. Both were deeply interested in and knowledgeable about Oriental ceramics—Warashina through her heritage, and Bauer from earlier involvement in Zen philosophy at the Memphis Academy with Thorne Edwards. In 1963, their major work was still wheelthrown and functional, some of it Oriental-like with its spontaneity and molten glazes on the surfaces. Some of Bauer's vessels at this time were large and commodious with the throwing marks much in evidence, a characteristic of Oriental pottery as well as of the humble pots of Appalachia to which he had been exposed. As early as 1963, Warashina had constructed a large, bulbous-shaped container with a jagged neck and handles and a salt-glazed rugged surface, executed spontaneously in the manner of the Japanese, but, also, originating in the abstract expressionist sensibility.

During her graduate work, Warashina experimented with full-size "Victorian" clay chairs supported by three "hand turned" (thrown) legs, and decorated with applied clay in baroque designs. She recalls today that the idea for the chairs came from seeing simultaneously while walking through the school hall, the utility pipes hanging from the ceiling and the chunky legs of a table stacked upside down on another table. Her fertile imagination has affected

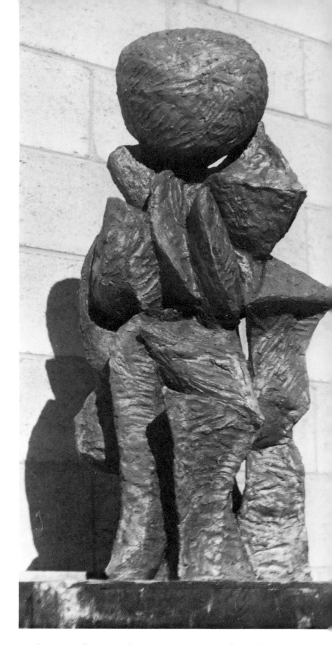

Rudy Autio. Construction, 1961, stoneware, hand-built, iron wash, H. 36 × W. 18.

her work throughout her career. These large chairs kept blowing up in the kiln, so she went on to "machines," inspired by the work of Louise Nevelson which she may have seen for the first time in the "Art Since 1950" exhibit at the Seattle World's Fair in 1962. This series of slab-built forms with thrown, ceramic "spools" inserted in the internal parts and as legs, resembled vaguely, in their construction, the clay sculptures of undergraduate Paul Nelsen from 1960, except that the Warashina works in certain contours and with the addition of the spools carried a connotation of movement. They were unique on a national scale. Warashina also built urnlike, covered jars with grand, baroque, applied decoration.

During this same period (1963–64), Bauer produced innovative, large, ceramic hinged boxes, or "sarcophagi," several feet tall, appliqued with clay. The surfaces of the early works in this series were roughly formed with glazes of iron oxide running freely down the sides. The seminal work has an appropriately primitive, slab-built base, which gave trouble in the firing and which was eventually replaced in the newer works with thrown, spool-type legs, and sometimes, legs of other materials. These early boxes were to evolve eventually with bizarre, low-fired, glazed relief decorations in brilliant colors. During the spring of 1964, while still in Seattle, Bauer painted part of the decoration on one of the boxes that failed in the firing with bright acrylic paints. He also did a series of giant, highly ornate covered urns with wooden spouts. All of these surprising forms, as well as many traditional functional forms, appeared in the joint graduate show of Bauer and Warashina in 1964 at the Henry Art Gallery, and in their two-man exhibition entitled "Clay" at the Northwest Craft Center just before their departure for teaching positions in Wisconsin, and then in Michigan. Both of these artists were young and dynamically involved in the change that was imminent nationally in the field of ceramics. Their sense of humor—Bauer's satirical, sometimes "black," and Warashina's very much "upbeat"—was irrepressible, and their imagination and use of language very sharp. They remained a professional tour de force through their years away from Seattle and after their eventual return in 1968, at which time Bauer joined the University of Washington teaching staff and Warashina taught at the Cornish Institute of Allied Arts. During their time away from Seattle, they both became aware of national trends, and one of their greatest technical changes, in addition to their use of low-fire glazes, was their replacement of glazes with acrylic paints on some works. Some striking similarities in form and technique evident in works created from 1963 to 1968 by Bauer and by Warashina could illicit doubt as to the validity of attribution of these works.*

Among Bauer's prodigious production, two memorable pieces from the mid-sixties are his *Rapid Transit Sour Ball Express,* a raucous ceramic "machine" with immovable wheels, and a highly refined ceramic chair with iron glaze and brightly colored decoration on the back. One of the later sarcophagi was decorated with a surrealistic, acrylic-painted face staring out from its front. The face image was inspired by a similar face on the back of a wooden chair purchased at St. Vincent de Paul's in 1959 by Bauer's friend, Paul Heald. Before Bauer's departure from the faculty of the University of Washington in 1970 for Mills College in California, he was working in his own brand of pop imagery with narrative themes in a sharply satirical direction, as well as in a profoundly expressionistic manner in some works. He threw large platters containing fantasy food modeled from clay. One, especially, *Timothy Leary's Breakfast,* embodies the illusionistic handling of the "silverware," which is partly drawn on the plate and partly extending outward, three-dimensionally. He did startling sculptures with threatening

* Regarding Bauer/Warashina questions of attribution, see Bauer to Harrington, 23 March 1978, Archives of Northwest Art, Univ. of Wash.

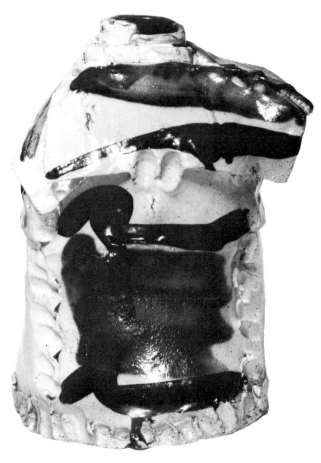

Rudy Autio. Vessel, 1964, stoneware, slab-built, majolica decoration, H. 15. Coll. of William Woodcock, Berkeley, Calif.

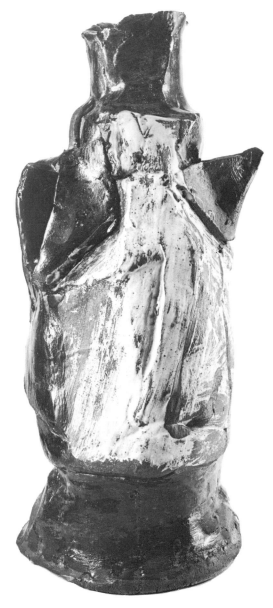

Rudy Autio. The Teapot, *1964, sculptured vase, stone-ware, slab-built, H. 21 × W. 10.*

Rudy Autio. Big Ellie, *1976, covered jar, stoneware, slab-built, engobe decoration, H. ca. 33. The Lannon Foundation, Palm Beach, Fla.*

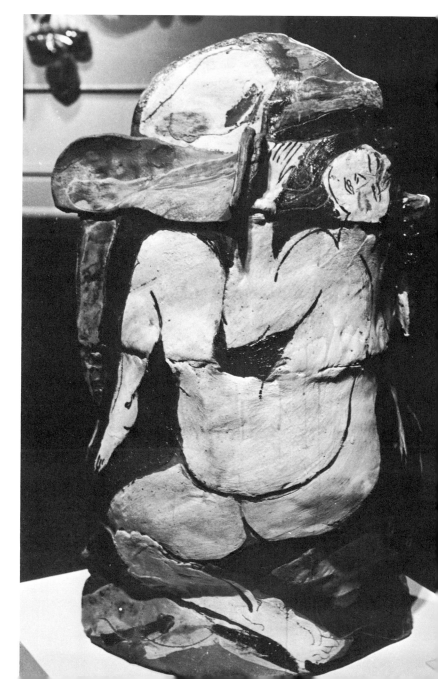

protruberances and visceral parts with blood red glazes on elegant celadons. As raw as the subject matter of some of these later works seems, Bauer's commitment to perfect craftsmanship never waned nor did his love of the glazes the Orientals used, especially the iron and celadon. As an artist, he was a perfectionist. This care also showed up clearly before he left Seattle in a number of his latest works which incorporated neon tubes. Bauer is one of only two ceramicists from the Northwest to have been invited to teach at the Haystack School, where he spent time in 1967 (the second is George Cummings of Oregon, in 1975). Joyce Moty was so affected by his teaching there that summer that she followed his advice and applied to graduate school at the University of Washington.

If Bauer's aesthetic was sometimes "heavy" and dark, Warashina's was outgoing and uplifting. She worked in series, producing many variations before going on to the next concept. By 1968 the Oriental technical references in her work gave way almost completely to low-fired glazes and acrylics, decals and mixed media, and an emphasis on messages and puns with qualities of surrealism and ambiguity and of fantasy involved in almost every work.

While much art today has an intuitive, nonrational quality, Warashina has developed, or is keenly possessed with a heightened ability for free association, or automatism, which was a major tool of the Dadaists in the art and literature of the early part of this century. She starts with an image of some common thing and develops it creatively into a major fantasy. Her ability for innovation seems endless. Other major qualities are her acute understanding of three-dimensional form as well as of design and surface treatment and her fine craftsmanship, which may be the result of her undergraduate and graduate work at the University of Washington, where a major basis for training is in the basics of design. While surface concerns may at times seem most central to her work (her interest and ability in drawing is a paramount issue, as is her love of color), three-dimensional form is also of great importance. In fact, her understanding of both is acute and many of her objects are studies in one or the other for the purpose of incorporating them in some future work.

Some works started in Seattle and developed in the East were spherical-shaped covered jars and vases, glazed overall with elegant gray celadon and decorated with bright colored, low-fired glazes. Her resourcefulness in controlling her work is evident in her comment that she turned away from reduction-fired decoration because she could not be sure of what the result would be after firing. The insectlike imagery on these vases, floating in free space (the convex vase shape lends itself to a feeling of space) is reminiscent of the Arshile Gorky surreal imagery of the later thirties and early forties, as well as that of Joan Miro, both of whom have deeply affected her work.

In 1967, Warashina began work with slab construction in a series of tall, hollow boxes with brilliantly colored imagery in low-fired glazes and acrylics. The titles, such as *Tokyo Rosie*, were flip and the imagery "mod" with strangely unconnected faces, lips, teeth, beans, and peas floating in a kind of surreal landscape, recalling some of the pop imagery of such artists as Lichtenstein. Her love of voluptuous form has always been apparent in her variations on a kind of "bread loaf" form, either alone, or blown up horizontally or vertically, or stacked one on top of another in pyramids or tetrahedrons. She states that both she and Bauer were greatly influenced by Wayne Taylor's solo exhibition of funky, slab-built forms at the University of Wisconsin in 1965.*

In 1970 she borrowed from the formal traditions of Japan in a series of earthenware "baskets" based on handbuilding with incred-

* Michael Boylen, "Letter from Milwaukee," *Craft Horizons* 25(March/April 1965):41–42. Illustrations of Taylor's work.

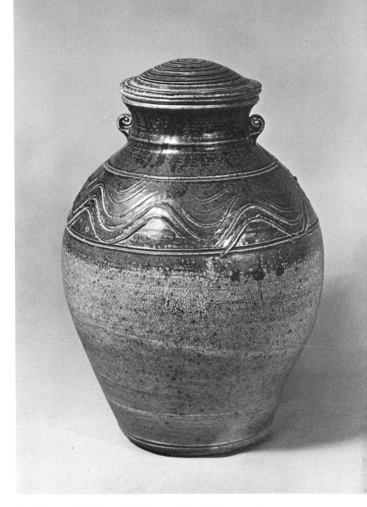

Fred Bauer (b. Memphis, Tenn., 1937). Covered Jar, ca. 1963, stoneware, wheelthrown, modeled handles, salt glaze, H. ca. 14. Coll. of John and Anne Hauberg, Seattle.

Patti Warashina. Vessel, 1962, stoneware, hand-built, salt glaze with rutile, H. ca. 16.

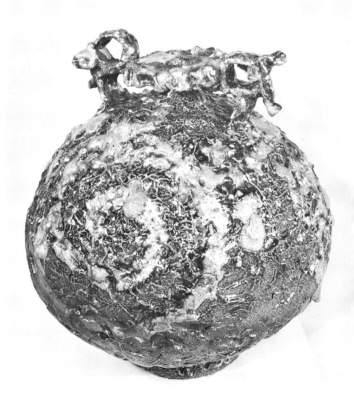

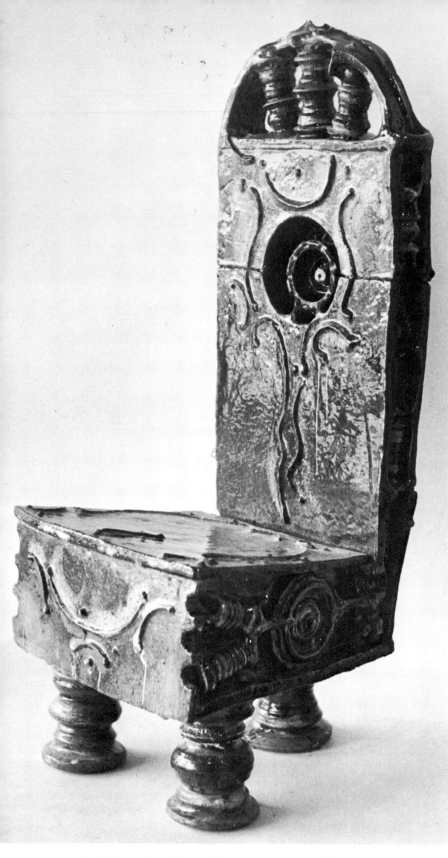

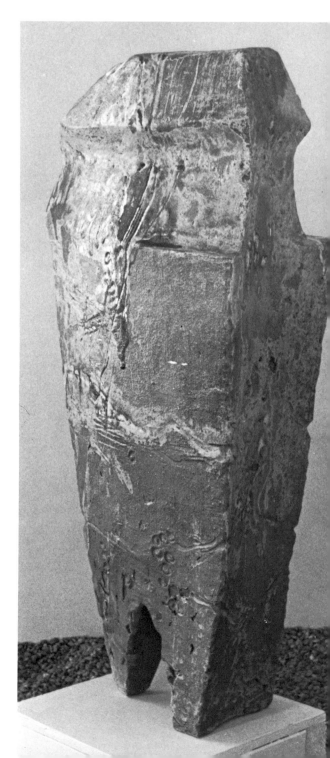

Patti Warashina. Chair, 1963, stoneware, slab-built in
two sections with wheelthrown legs, white slip, copper
and rutile oxides, applied clay decoration, H. 39.
Coll. of R. Joseph and Elaine Monsen, Seattle.

Fred Bauer. Wind Axe, ca. 1962, stoneware, slab-built,
ash glaze, H. ca. 36.

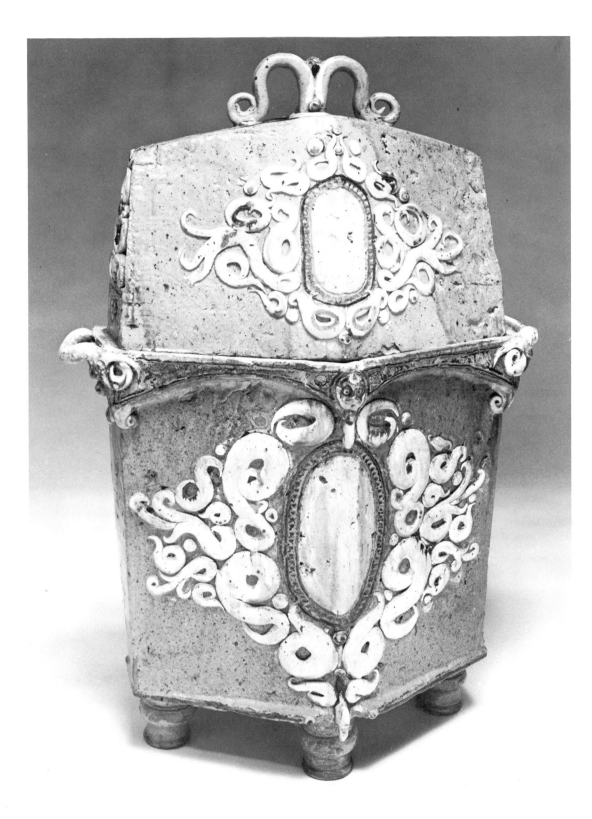

Fred Bauer. Hinged Box, ca. 1963, stoneware, slab-built
and wheelthrown, applied clay decoration, celadon
glaze, copper oxide, and white slip, 33 × 22 × 13½.
Coll. of Ron Ho, Seattle.

Fred Bauer. Rapid Transit—Sour Ball Express, *ca. 1966, stoneware, wheelthrown and hand-built, painted with acrylic in multicolors, 30¾ × 17¾ × 27.*

Fred Bauer. Chair, 1966, stoneware, hand-built and wheelthrown, iron glaze with ochre acrylic paint, 39¾ × 17 × 14¾. Coll. of Robert L. Pfannebecker, Lancaster, Pa.

Fred Bauer. Timothy Leary's Breakfast, 1969, sculptural wall plate, porcelain, glazes and luster, 15½ × 22⅓ × 2.

Fred Bauer. T-Ceremony Pot, 1968, porcelain, wheelthrown and hand-built with bicycle grip and reflector, plastic fringe, silver luster. Coll. of Jim Manolides, Seattle.

Fred Bauer. Teapot, ca. 1964, stoneware, wood ash glaze with white slip decorated with stick, cane handle.

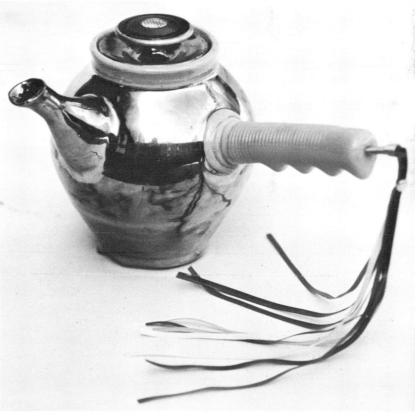

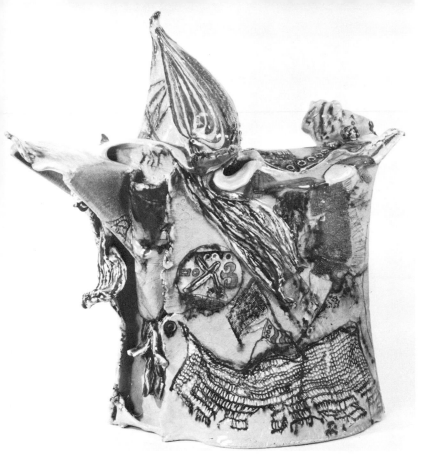

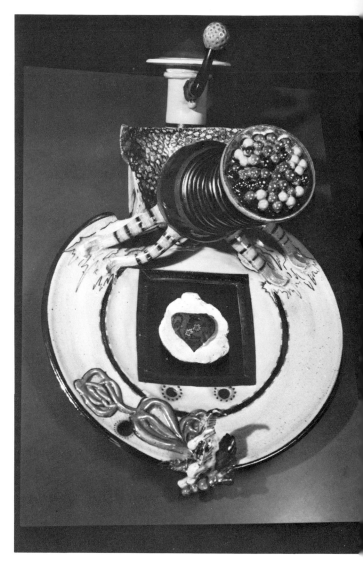

Fred Bauer. Plethora Voz, *1966, vase, porcelain, hand-built, blue underglaze, celadon glaze, copper, rutile, and cobalt oxides, slip, impressed decoration, 22¾ × 21 × 13½. Coll. of John and Anne Hauberg, Seattle.*

Fred Bauer. Admiral Bird as a Ball and Socket Joint Pondering a Square Ice Whole, *1969, sculpture, porcelain, wheelthrown, hand-built and assembled, 12 × 16¼ × 24 (not including base). Coll. of Robert L. Pfannebecker, Lancaster, Pa.*

Patti Warashina. Metamorphosis of a Car Kiln, *1971, earthenware, press-molded, underglaze, glaze, and luster, 20 × 36 × 20. Coll. of Robert L. Pfannebecker, Lancaster, Pa.*

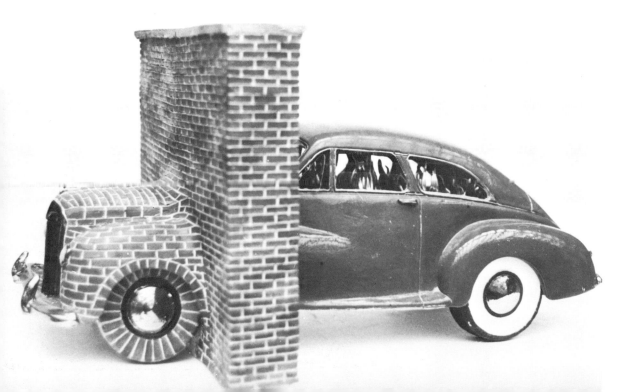

Patti Warashina. Vessel, 1967, earthenware, slab-built, painted with acrylics, 32 × 17 × 9.

Patti Warashina. Sure Fire Kiln, 1971, earthenware, slab-built, hand-formed, extruded, H. ca. 30. Palomar College, San Marcos, Calif.

Patti Warashina. Wash and Wear, *"Altar" series, 1976, hand-built, slabs, castings, underglaze and sprayed acrylics, ca. 25 × 16 × 13.*

ibly bright and beautiful color combinations and the use of decal imagery. These were, again, part of the "bread loaf" form. They developed into a "turkey" series: *Steamer Turkey,* a lidded tray with steam drawn on as a hint of the turkey enclosed; *Hot Turkey,* a three-dimensional, brown, glazed turkey form on a tray surrounded with bright red crab apples; and *Airstream Turkey,* a silver-lustered, machined oven form with turkey legs sticking out of the top.

Her ability as a master designer is clear in a series of stacked forms with titles such as *Moon Dog Dream, Ketchup Kiss,* and *Super Star,* executed during the height of popularity in the United States of the Beatles. These designs mix geometric, hard-edge, forms with organic-looking appendages. She combines black and white glazes and metallics with high intensity colors and abstract geometric and organic designs to achieve works of great elegance.

In 1971, Warashina created a series of "kilns," each a parody on the kiln terminology used by potters, and each piece made entirely of fired clay. She created the illusion of bricks on the surfaces of the kilns by drawing hundreds of tiny, inch-long bricks and luster-glazed "flames." Warashina's satirical humor was at its best in these works, variously titled *Car Kiln, Sure Fire Kiln,* etc. *Climbing Kiln,* she believes, may have some religious significance in that its flames took on the shape of a cross as she worked on them. This is tied vaguely to her discovery of a Zen altar in the cupboard of her converted Christian family's home.

Some religious and cosmic significance is related to her constructions of complicated "little worlds" or cosmos, some of which have grown to be four feet long, full of small, delicate objects that interact with each other. This started with her interest in triangular shapes and the construction of a single pyramid, which was developed into four pyramids in close "universal" juxtaposition. This group, titled *Sour Milk Temple,* resembles a community of four houses, and it was in this series that her use of painted worm imagery started.

"Burned out" after preparing a large variety of objects with emphasis on three-dimensional form for a solo show in 1970, she created, as a diversion, the press-molded "fish serving platter" series, each of them covered with delicate and fanciful drawings in which the two-dimensional aspects are played against the three-dimensional through form and surface treatment.

In 1975, Warashina developed the pyramids further into a series of "stacked" tetrahedrons (the stacked idea taken from Japanese lacquered food containers) in which there is a cartoon-like progression of imagery around the sides of the forms. The imagery on most of these is "portraiture," concerned with home and the family, with some works "in honor" of certain members of the family, including the pet dog. Although these works are full of gentleness, they are concerned with feminist issues, especially the one titled *Love it or Leave it,* a work executed at the time of her seventh wedding anniversary. The feminist imagery developed out of this stacked series into a series of twelve altar pieces in which three-dimensional parts of female figures are played against the two-dimensional drawings on the background of the altar—generally the face and part of the torso are drawn or spray painted in underglaze on the background and the cast arms and hands of the figure reach out from the background offering some cast or handbuilt object to the viewer, or, perhaps, the women involved are being offered in sacrifice. As usual her color sense is unerring.

Warashina's longstanding interest in automobile imagery is evidenced in her most recent groups of works in which she has added the brilliant colors of china paint to her techniques. These again

Patti Warashina. Love It or Leave It, *"Pyramid" series, 1974–75, slab-built, underglaze, rhinestones, 31 × 15 × 15. Coll. of Robert L. Pfannebecker, Lancaster, Pa. (view of reverse side, below).*

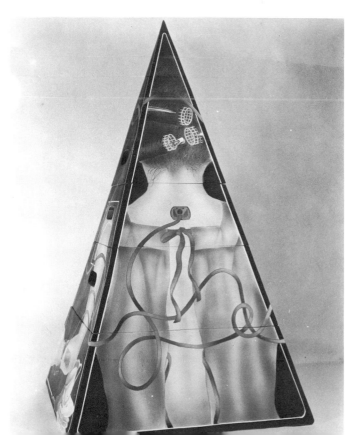

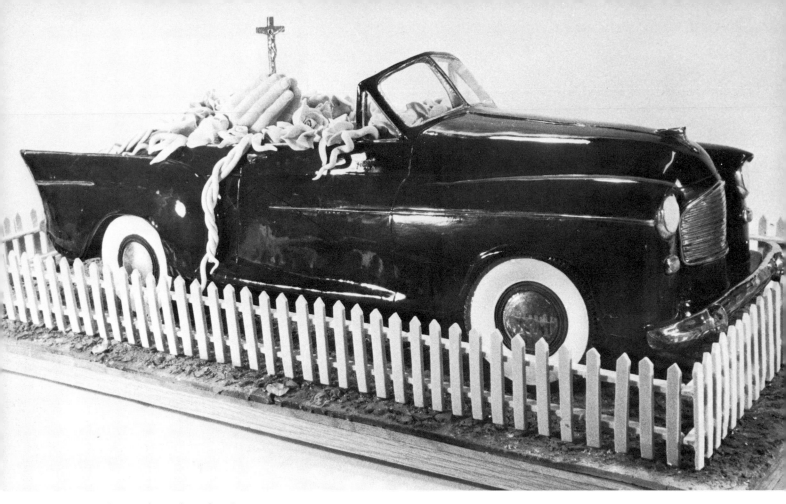

Patti Warashina. They Thought It Was My Last Trip,
*1977, low-fired earthenware, hand-built, underglaze,
glaze, china paint, luster, L. ca. 48. Coll. of Robert L.
Pfannebecker, Lancaster, Pa.*

Patti Warashina. They Thought It Was My Last Trip,
(detail).

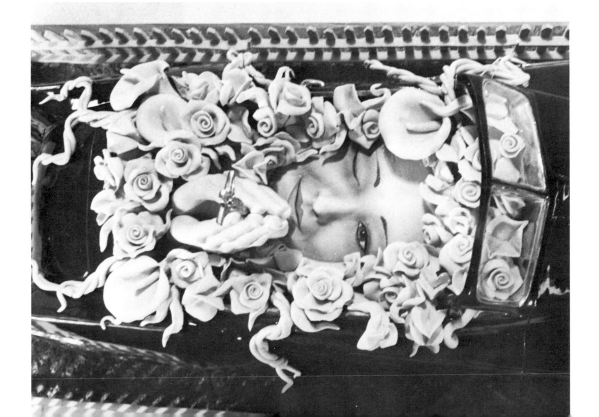

deal with feminist issues combining negative qualities of desolation with positive hope.

Although Warashina showed all signs of the true professional from the earliest days of her career and has always counseled her students to attain professional competence, perhaps her major contribution as a teacher is her direct, energy transfer and the example set by her prolific production. In this respect, there are close similarities between her contribution and that of Peter Voulkos. She began her teaching career at the University of Washington in 1971.

A handful of other students at the University of Washington, in addition to Warashina and Bauer, who, before 1967, produced objects that can be considered trendsetting in the Northwest, include John Fassbinder, Paul Nelsen, Jean Griffith, John Booker, Kris Jorgensen, Bruce Kokko, Warren Maruhashi, and Ron Gasowski.

John Fassbinder, who is known today for his twenty-year production of elegant functional ware, left Washington in 1958 and returned with a master's degree in 1960 from Claremont Graduate School. During this interim period in California, he conceived and executed a series of advanced forms that he called garden pots. These works were two to three feet high and freely constructed of thrown and hand-built parts, sometimes vessel-like, usually abstract but also with references to the human figure. Although these works were actually made in California while he was a student of Paul Soldner and within a few miles of the Voulkos' milieu of abstract expressionist ceramics, they resemble conceptually also the work, executed about the same time, of his teacher, Robert Sperry. They were part of the broad transition from functional to sculptural works in clay.

Paul Nelsen, a general art major at the University of Washington prior to 1960, had been doing slab work, including some lanterns that were Oriental in feeling. Robert Sperry encouraged Nelsen to sign up for independent study in clay outside the ceramics division for a quarter. Nelsen, who credits Sperry as his greatest inspiration and the slab work of Rudy Autio as influential, says today, "The 'Construction' series I began that quarter was done very spontaneously. I remember being very excited and mystified as to where the ideas came from. I produced them in independent study, working alone and showing them to Eugene Pizzuto [the painter who advised him] a few times. His major function was encouraging me to keep at them, not influencing what I was doing, which I'm not sure I appreciated at the time. It was a period of getting away from classes and teachers and finding my own way." These three or four pieces were some of the most innovative and exciting, if highly shocking, works to be produced in the Northwest before 1961. Nelsen's constructions ran two to three feet high in reduction-fired stoneware with iron slip that turned metallic during firing. Each resembled architecture in its construction: rough slabs stacked horizontally with open spaces and cubicles between, neither furnished nor peopled. Of the two or three pieces that were broken in shipping, one had won a prestigious award at the Ceramic National in 1960. The only one extant is in the collection of the Henry Art Gallery at the University of Washington. Nelsen is presently working in New York City.

Starting in 1961, Jean Griffith executed a few sculptured expressionist works of power during her master's candidacy at the University of Washington, placing her in the forefront of "the new ceramics" in the Northwest. Although much of her work has been in Raku bodies and primitively fired, these hand-built forms were in stoneware with salt glaze and were roughly textured and irregularly formed. Later, she made a successful detour to a series of architectonic forms in low-fired, white clay with pale, matte-fin-

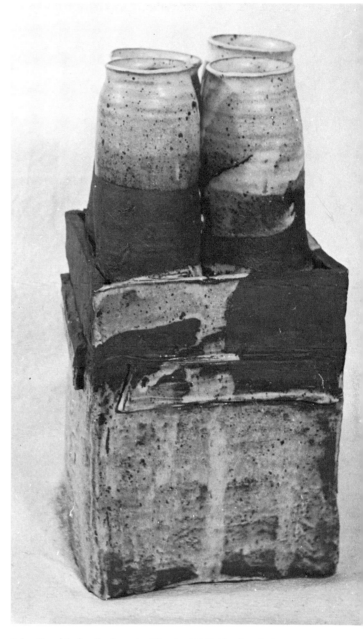

John Fassbinder (b. Seattle, Wash., 1931). Garden Pot, 1959, stoneware, wheelthrown and slab-built, glaze and white slip, ca. 24 × 12 × 12.

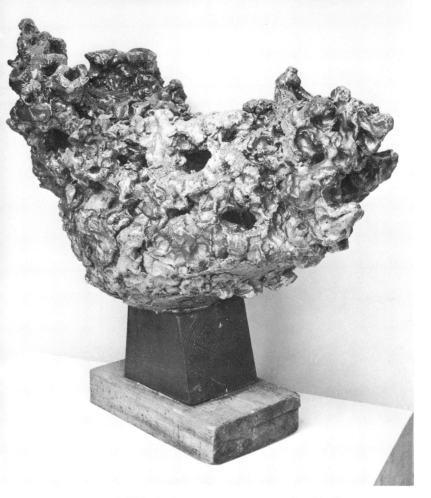

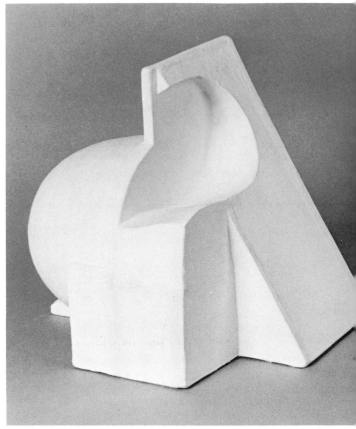

Jean Griffith. Sculpture, 1962, stoneware, hand-built, salt glaze, 19½ × 33 × 16 (not including base).

Jean Griffith. Sculpture, 1973, white earthenware, hand-built and wheelthrown, white slip, 15½ × 13½ × 17½.

Kris Jorgensen (1941–70, b. Seattle, Wash.). Nine Small Vases, ca. 1963, stoneware, hand-built, iron glaze, H. 3¾ to 6½. Coll. of Jan Jorgensen, Seattle.

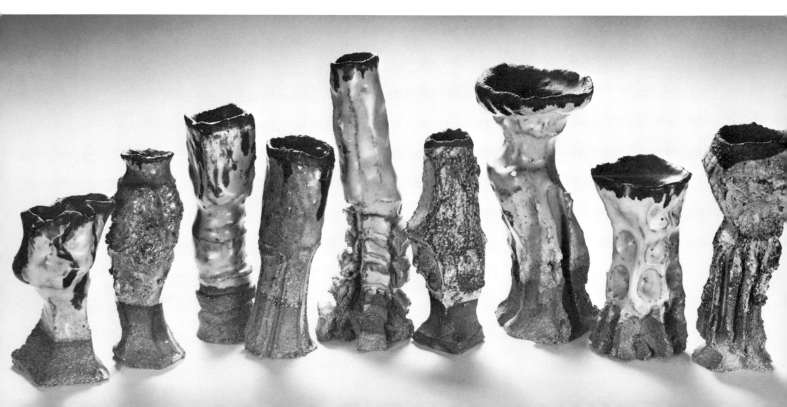

ished surfaces of slip in green and blues—the only work she has ever done that seems totally devoid of Oriental characteristics. Her work of 1977, still hand-built sculpture, is concerned with the image of the squash—all shapes and sizes of the lowly garden squash—with rich, jewel-like surface tones combined with smoky effects, sometimes individually mounted on ceramic slabs and sometimes in spare architectural environments, but always infused with light humor and a mystical spirit.

A student at the University of Washington who experimented with polychrome glazes at an early date was John Booker, whose small and unpretentious bowl submitted to the Northwest Craftsmen's Exhibition in 1961 was glazed with brilliant oranges and yellows.

During 1963 and later, another talented student who worked at the University of Washington was Kris Aage Jorgensen. Rudy Autio remembers Jorgensen as " a young man who was very thoughtful and serious about his work—an involvement with glazes and an interest in Pop." Kris had started as a painter and was led into ceramics. He worked in both sculpture and traditional vessel forms, crossing over these lines in some cases. Much of his work had a definite, Oriental character but was done with his own unique vision. Some of his most interesting works were of slab-built stoneware affected considerably by the philosophies of both Rudy Autio and Harold Myers who were at the university at the same time. A series of nine thin vases, the tallest no higher than nine inches, is representative of the abstract expressionist handling of clay—slashed, punched, and otherwise distorted—but also exhibits the qualities of most of the best Japanese objects in the artist's spontaneity of approach. Portions of these vases are glazed, and others are raw clay. Another interesting work is a black-glazed bottle, resembling a bag full of water, bulged as it is from a technique he used that might be described as "blowing into." Jorgensen kept himself abreast of the times and was involved in explorations into a kind of "pop" concern.

His contemporary work of 1963 was close to being Funk Art. He produced dozens of clay mustaches, some eight inches wide with threatening curls in the ends. The black acrylic surfaces were an early use of paint on ceramics in the Northwest. These mustaches were laced with string onto a Masonite board for exhibition. Later he built ceramic airplanes, one about four inches long and decorated with brilliant blue and white acrylic paint. When Seattle critic Tom Robbins organized the "Unidentified Funky Objects" exhibition at Attica Gallery in April 1967, Jorgensen designed a handsome silver poster as a handout. His tragic death in 1970 brought to a premature end a potentially brilliant artistic career.

In 1964 an aesthetically memorable and unique piece (at least, for the Northwest) by Bruce Kokko was his wheelthrown, iron-glazed, gallon-sized paint can with modeled brush sitting in the pail, made entirely of fired clay with rich colored, low-fired glazes to simulate paint spilling over the edge of the pail. The piece is important for its numerous transitional aspects. Kokko rejected tradition with this use of brightly colored, low-fired glazes and pop imagery, to which he had been exposed in California. However, the somewhat primitive handling of the clay can be classified as "warm" Pop, reflecting his unwillingness to accept the slick, commercialized images that made up most of Pop Art during its height. On the other hand, the handling of the clay and the glazes is "cool" enough to negate any classification of Funk Art, the California manner of working in which the lumpy handling of material was one attribute. Kokko's work reminds one of some of the earliest works of Robert Rauschenberg and Jasper Johns where the painterly aspects of Abstract Expressionism and the most primitive aspects of Pop Art are combined.

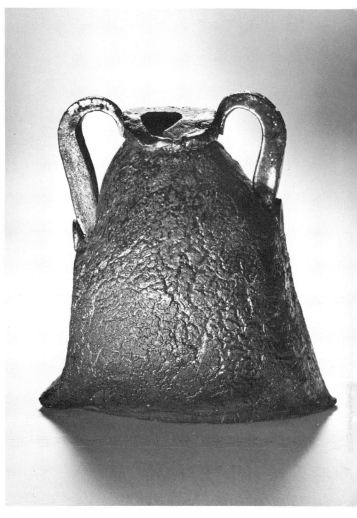

Kris Jorgensen, "Bug" Bottle (with handles), ca. 1963, stoneware, hand-built, iron glaze, 7⅜ × 6⅞ × 4⅞. Coll. of Jan Jorgensen, Seattle.

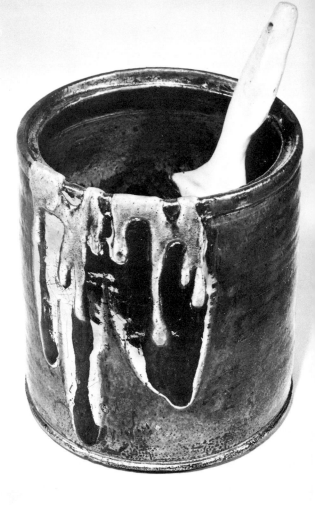

Kris Jorgensen. Airplane and Poster, *1967, airplane in earthenware with blue and white acrylic, L. 4½. Coll. of Jan Jorgensen, Seattle. (Poster designed for the First Official Exhibition of UFO's, Attica Gallery, Seattle; airplane submitted to exhibition.)*

Bruce Kokko. Paint Can with Brush, *1965, stoneware, wheelthrown and hand-built, iron oxide, low-fired glazes, luster, H. 9¾ × W. 6¾. Henry Art Gallery, Univ. of Wash., Seattle.*

Warren Maruhashi. King—Queen, *1973, earthware, hand-built, glazes, 4 × 21 × 9.*

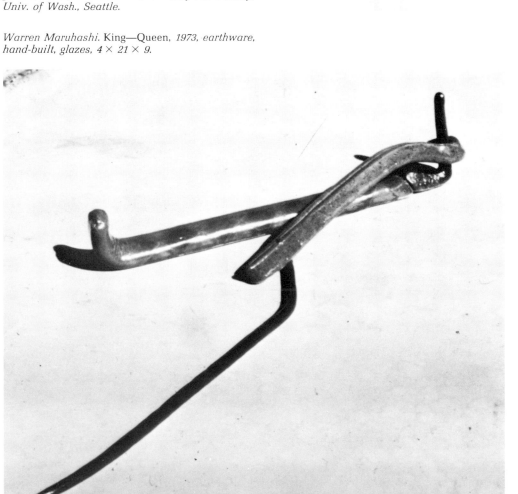

Warren Maruhashi, an undergraduate painting major at the University of Washington, turned to ceramics in 1964 after seeing the functional wares of Patti Warashina with their rich and subtle glazes and spontaneous Oriental spirit. But, he soon rejected the traditional pot form and began experimenting with Egyptian Paste after seeing the other students making small beads with this self-glazing clay body. He was encouraged in this work by Howard Kottler, his teacher, who was also interested in the technique as a single-fired source of bright color. He and Kottler added finely ground ball clay to increase the plasticity of the paste, and by assembling sections, were able to produce pieces up to seventeen inches in diameter. Maruhashi's strange, delicate, abstract shapes in blues, greens, oranges, and yellows have an ephemeral quality, but sometimes also carry an ominous tone. Later he produced ritualistic objects (*Bi-sexual Martian Mushroom* and *Flesh Altar*) in low-fired earthenware, the subject matter for which was derived from such sources as marine life, insects, science fiction, periodicals on sex, and various religions. Looking in retrospect at his whimsical and erotically bizarre subject matter, it is not surprising to hear him say today that he has always been inspired by Lucas Samaras. Maruhashi now lives in New York City and is experimenting in the field of photography and video.

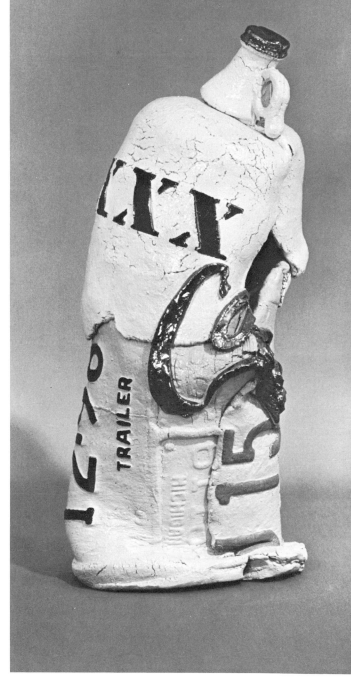

Ron Gasowski (b. Hamtrack, Mich., 1941). XXX Media Mash, *1966, stoneware, wheelthrown and slumped, glazes, lusters, paints, 17¼ × 7½ × 7½. Coll. of R. Joseph and Elaine Monsen, Seattle.*

The work of Ron Gasowski, a graduate of the University of Washington in 1968, embodied many of the qualities involved in the changeover from functional to expressive concerns. He had an extensive knowledge of the Dada movement of the twenties, with its outrage at the low moral state of society, and of the "Ready-mades" of Duchamp. He was one of the new "pop" generation of Americans with sophisticated intellectual capabilities. Some interesting early works were a series of "pop"-oriented objects with surfaces of epoxy and acrylic paint, surface techniques that he had been encouraged in by Fred Bauer while they were both at the University of Michigan in 1965. Three objects, a hand vacuum cleaner, a fire hydrant, and a capped, slumped, bottle in brilliant colors, were as "funky" as have ever been done in the Northwest, with their lumpy clay handling and satirical implications. Soon, Gasowski was inspired by products of the auto industry to do a number of works which are probably better crafted than the glossiest car from his home state of Michigan. He says he discovered Pop Art as early as 1962 and was well aware that hot rods were part of that phenomenon. He had been a custom car builder ("hot rods," which he sees as folk art) since age twelve and, from this, had become conditioned to modifying existing forms and to the art of assemblage, both of which were to affect his art. *Genny Motors: Detroit Wonder Woman* has hot-rod paraphernalia plugged into its ceramic torso, which rests in a glossy box sprayed with car enamel, a twentieth-century trophy with sexual overtones. Most of his works at that time were assemblages of many materials.

An interesting story of the turbulent, early 1960s concerns the arrival of Hawaiian-born Japanese Henry Takemoto in the Northwest in 1963 and his dramatic influence on the work of Brother Bruno LaVerdiere, a young monk at St. Martin's Abbey in Olympia, Washington. In the Northwest to replace Autio at the University of Montana, who was replacing Sperry at the University of Washington, Takemoto spent several weeks working with Bruno in Olympia. Takemoto had worked with Voulkos in California during the clay revolution in Los Angeles, and his gigantic, coil-built vases, along with other major works in clay by America's best-known, pioneering, contemporary ceramicists, Peter Voulkos, Win Ng, Robert Arneson, and John Mason, had been seen in "Adventures in Art," an exhibition at Century 21 in Seattle in 1962. Paul Soldner has described Takemoto as having the talent for bringing together

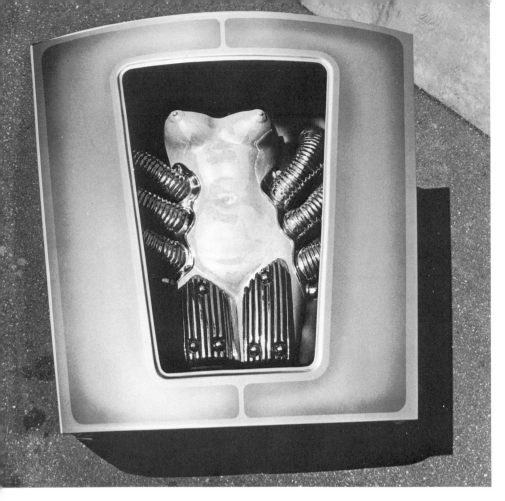

Ron Gasowski. Genny Motors, Detroit Wonder
Woman, *1967, stoneware, press-molded and assembled, lusters, Plexiglas, painted Masonite, wood vinyl,
upholstered, 30¼ × 33 × 32.*

Bruno LaVerdiere. (b. Waterville, Maine, 1937).
Stations of the Cross, *1965, stoneware, hand-built,
white engobe, sgraffito drawing, copper oxide stain,
glaze, 40 × 34 × 14. Coll. of R. Joseph and Elaine Monsen, Seattle.*

familiar and unfamiliar symbols from different cultures and periods and making a whole new thing with immediate acceptance. Bruno, who had been turning out wheelthrown, functional clay objects, quickly mastered the technique of coil-building, arriving along the way at many happy accidents. As he tells it: "The point when I gained control over the technique was a difficult time for me, there were no more happy accidents, and it was then that the attitudes I learned from Takemoto became his most important influence on my work. . . . What he taught me was how to keep growing. He would urge me to bring each piece to the brink of visual failure. I got lots of failures this way, but they ended up being sources of healthy energy. Those pieces that I struggled with and that failed to satisfy me are the ones I work from. Learning not to play it safe is the tool that probably caused any successes I might have had. In those early years I had another important source of energy. I was fortunate in having the Church as a continued patron of my artistic development for fourteen years. The Church has set a tone to my work to this day, although in the 1960s the spiritual sources were more obvious. It set deep roots of primary energy that will always be there, no matter how vague it may seem in the final visual form. The main energy now comes from the continuity of my work, including studying my failures."

Bruno's most accelerated rate of artistic growth before moving permanently to New York State in 1969 was probably during his residence in Olympia from 1963 to 1965 and between 1965 and 1969, when he worked and studied in New York State with occasional visits to Olympia. During his association with Takemoto, his prolific body of work developed abruptly from smallish, bland, functional objects to large-scale, coil-built and other hand-constructed works in a variety of forms, which, although of appealing naivete, clearly mark the artistic and philosophical struggle in which he was involved—his work was definitely expressionistic. It includes such forms as large-scale urns, casks, and a garden piece with a hand-modeled and decorated ceramic form hung from a heavy frame that has ritualistic or ceremonial overtones, a possible reflection of his early religious environment. During the period of his most dynamic experimentation, he was eclectic in his borrowing from history, executing in the sixties, for instance, a series of tall, unglazed vases with bulbous midsections and expansive, white spiral designs—similar to work from the prehistoric Mediterranean. Although born in the excitement of the so-called abstract expressionist milieu, Bruno's work had from the beginning an individual stamp.

In the Portland area, where the ceramics field has been dominated, since the early 1950s, by high- and reduction-fired, functional ware with its neutral and muted tones, Erik Gronborg, a newcomer on the faculty at Reed College and fresh from the University of California at Berkeley, where he had worked in a dynamic, purely sculpture-oriented atmosphere with leading California artists James Melchert, Stephen de Staebler, Harold Paris, and Peter Voulkos, brought to the Portland area the excitement of the "new ceramic way" during his tenure from 1965 to 1969. A native of Denmark, Gronborg moved to Berkeley and there worked as a sculptor in bronze-casting and wood with a strong emphasis on mass and volume and the other traditional sculptural values rather than the newer sculptural constructions and minimal forms. Immediately preceding his arrival at Reed, he had finished an assignment in Cairo as a photographer for an archaeological excavation where he saw great collections of Islamic ceramics with their highly decorative surface designs and narrative imagery, all in brilliant colors and luster glazes. The combination of these two major models was to affect his clay work dramatically. Where Ray Grimm probably

Bruno LaVerdiere. Feast Jug, *1965, stoneware, coil-built, white engobe, glazes, H. 48.*

Erik Gronborg (b. Copenhagen, Denmark, 1931). Cups, 1968, stoneware, lead glazes and luster, H. ca. 4 to 5.

Erik Gronborg. Family Portrait, *1967, stoneware, hand-built, bronze cast figures on black velvet, glazes in black, red, and white, 16 × 22 × 2.*

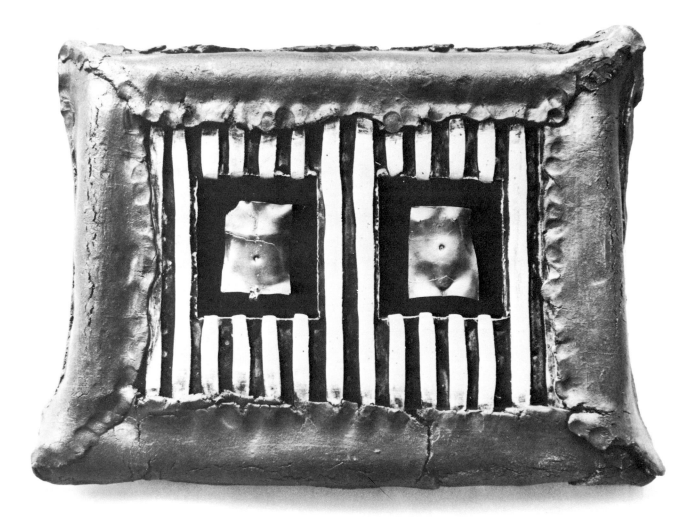

has served as the most sustained and significant inspiration to the Portland area in the high-fired, functional stoneware area, there is little doubt that Gronborg was the first in the area to use bright, low-fired glazes in a sustained way. The fact that the kiln at Reed was electric (limited to lower temperatures and resulting in brighter colors) and precluded the option of producing high-fired, nonbrilliant colors on the surfaces, obviously affected the finished products. About Gronborg's first solo exhibition at the Contemporary Crafts Gallery in Portland, one critic said that sunglasses were needed to see the show.

Gronborg used in his work commercial glazes, china paint, polyester resins, and applied clay. He combined unglazed, lumpy, almost funky portions of clay with glossy, jewel-like areas or with hard-edged stripes in highly contrasting colors. He had an early interest in the use of imagery, particularly contemporary industrial imagery, and in the use of the ceramic form as a vehicle for a message. His works incorporated decals and various types of stamps and other impressions, such as license plates and name stamps. From the beginning of his artistic career he had done figurative work. In Portland he drew images of the female figure on the clay and attached face molds or modeled breast forms or cast-bronze figures to his clay works. He also used wood with the clay in sculptural pieces and combined wheelthrown and slab pieces. He forced completely wheelthrown works to the limit—a concern inherited from the Peter Voulkos interest in process as well as from the bronze-casting tradition of the early 1960s.

Most challenging to Gronborg were container forms—traditional pottery forms such as plates, cups, teapots, and bowls rather than pure ceramic sculpture. The earlier Islamic models encouraged this approach; he wanted to explore the possibility of making plates or cups that would be as beautiful and artistically strong as those Islamic ones and still contemporary in the sense of form and imagery used. While his earlier work was loose and free, near the end of his Portland period, he was working entirely with slab- or hand-built forms and with a more tightly controlled use of color and images.

The content of his earlier work at Reed was often surreal and involved with the subject of death. And, during the McCarthy campaign he did a long series of protest plates dealing with the war in Vietnam and other political subjects.

Gronborg brought to the Northwest a sound understanding of the unique qualities of materials and the ability to exploit these qualities in the most creative but responsible manner. As committed as he was to innovation and experimentation, he always maintained a careful balance between extremes, the most obvious being his commitment, on the one hand, to the ceramic tradition and history, as well as his search for new forms that would respond to the current culture, on the other.

Gronborg feels that the first challenge of today's ceramic artists is "finding a meaningful contemporary form for ceramics, one which responds to our contemporary sensitivity in a highly mechanized and intensely colorful society. This form is approached through the use of forms and patterns of a mechanical regularity and colors bright enough to maintain a presence in our environment."* One of Gronborg's greatest challenges in Portland was to convince the public of the artistic validity of clay and the new ideas and forms associated with it. The monumentality of this challenge is reflected in the story of an event that occurred at Reed College and that may well have caused his days there to be numbered, the victim of his own zeal in carrying out the goals of innovative education.

* Lee Nordness, *Objects: USA*, p. 112.

Erik Gronborg. The Giant Killer, 1968, plate, earthenware, hand-built, zinc plate, glazes, lusters, H. 1⅞ × Dia. 14. Coll. of Sally Whitton, Seattle.

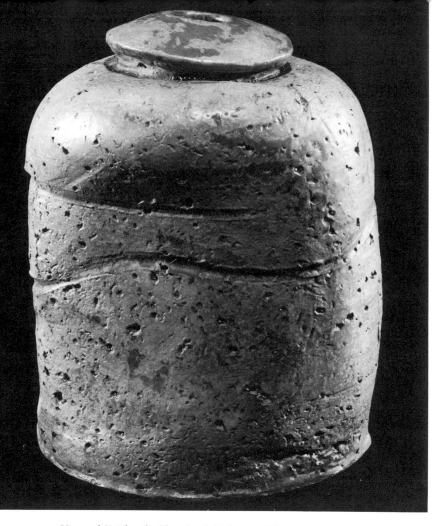

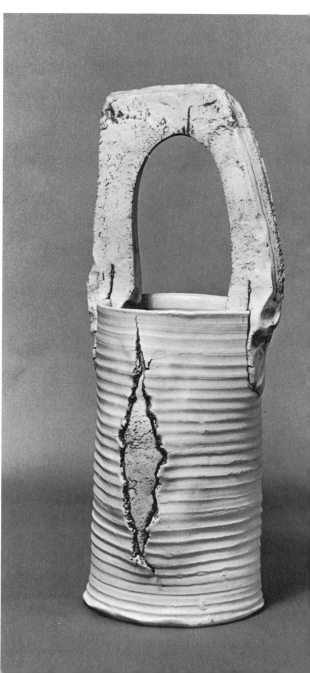

Howard Kottler. Basket, *1966, pot, porcelain, altered wheelthrown form and hand-built, underglaze stain, glaze, H. 15½ × W. 6¼. Coll. of R. Joseph and Elaine Monsen, Seattle.*

Howard Kottler (b. Cleveland, Ohio, 1930). Pot, *1964, stoneware, hand-built, glaze with crushed corncob texture, 12 × 8 × 7½.*

Howard Kottler. Vase, *1965, stoneware, glazes with Raku firing, H. 8 × W. 9¼.*

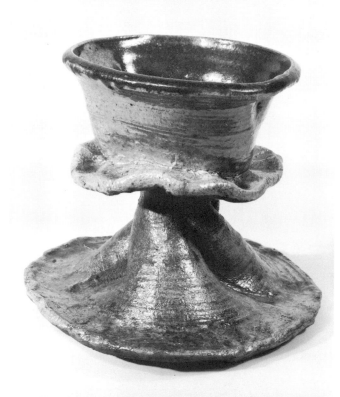

In 1966, in Portland's first showing of the work in clay of California's avant-garde artists organized by Gronborg, Robert Arneson, sculptor on the faculty at the University of California at Davis, chose to submit one sculpture from his highly controversial scatological works. This object was disturbing enough to cause the cancellation of the exhibition, and all future exhibitions planned by Gronborg. A sponsoring group at Seattle Center, informed of the subject matter of the show, also canceled a scheduled showing of the exhibition. If the presentation of new ideas is vital to a dynamic society, then Gronborg's activity at Reed was important, not only to his students, but also among the potters and the public of the Northwest. A recent inquiry addressed to the administration at the college concerning the history of ceramics at Reed brought the following response, which indicates that Gronborg's contribution was never understood: "Reed has taught ceramics in the past, but for the last several years we have only maintained the facility on an extracurricular basis."

In 1964, having just been awarded a Ph.D. degree in ceramic art from Ohio State University, Howard Kottler accepted a position on the faculty of the ceramics division of the University of Washington. As an actively involved studio ceramicist, he has an extensive academic record all in studio ceramics: B.A. and M.A. degrees from Ohio State University, an M.F.A. degree from the Cranbrook Academy and a Ph.D. from Ohio State University. During those years in the East, he was associated with such well-grounded and basically traditionalist figures as Maija Grotell and Toshiko Takaezu at Cranbrook, and Carlton Atherton (former student of Adelaide Robineau) at Ohio State. If the emphasis of the earlier years on industrial design was no longer paramount at Ohio State during his tenure as a student, neither was the active encouragement to deal with new ideas and attitudes prevalent. For instance, in Chicago in 1956, Kottler was inspired by an exhibition of the non-functional work of Voulkos and others of the California group of ceramicists, but the atmosphere at Ohio State was not conducive to manifesting this excitement in actual work.

Today, after fourteen years at the University of Washington, Kottler has brought a broad and deep range of gifts to the field in the Northwest as well as in the nation. In the years immediately prior to his arrival in the Northwest, the transition from emphasis on the functional to more sculptural and expressive concerns had, to a large extent, been made by such artists at Rudy Autio, Harold Myers, Patti Warashina, and Fred Bauer. Kottler was to carry this progression further beyond the vessel connotation of functional wares and into a more fully sculptural sensibility and later into even deeper conceptual development. Kottler also has added a new dimension to art history in the school of art through his course in the history of ceramics. His acute intellect, extensive knowledge of history, his sound aesthetic sensibility and technical knowledge, his unique sense of humor, and his provocative way of dealing with people were a formidable combination of qualities for an artist-ceramicist entering the field of teaching and exhibiting at a time when students seemed brighter and more sophisticated and the ceramics milieu was making a dramatic change toward sculptural and expressive concerns, and, eventually, especially on the West Coast, toward a more intellectual and conceptual orientation.

Howard Kottler has stated often that his desire is to produce objects for people who don't need anything. He calls these objects "palace art" (objects that are expressive of the individual's personality) as opposed to "folk art" (functional wares), in a system which he outlines in Nordness' *Objects: USA* that defines all types of art within these two classifications. Kottler is noted for his innovation and creativity, and his experimentation is informed by

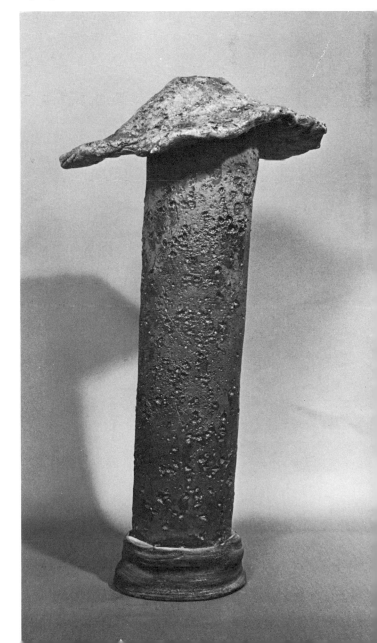

Howard Kottler. Pot, *1966, earthenware, hand-built, glazes with Raku firing 24¾ × 13 × 10. Coll of R. Joseph and Elaine Monsen, Seattle.*

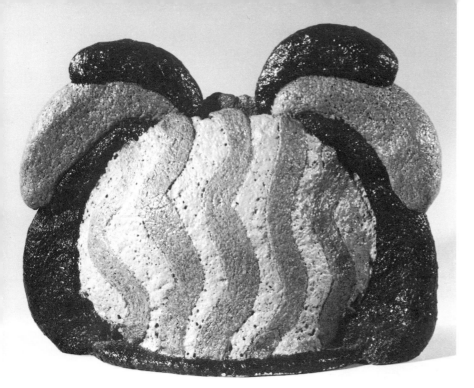

Howard Kottler. Madame Chiquita Pot, *1966, Egyptian paste, hand-built, cobalt blue and lead chromate, chartreuse Egyptian paste, orange acrylic paint, H. ca. 10.*

Howard Kottler. Paisley Covered Jar, *1970, earthenware, hand-built, glaze, luster, ceramic decals, 20½ × 14½ × 4½.*

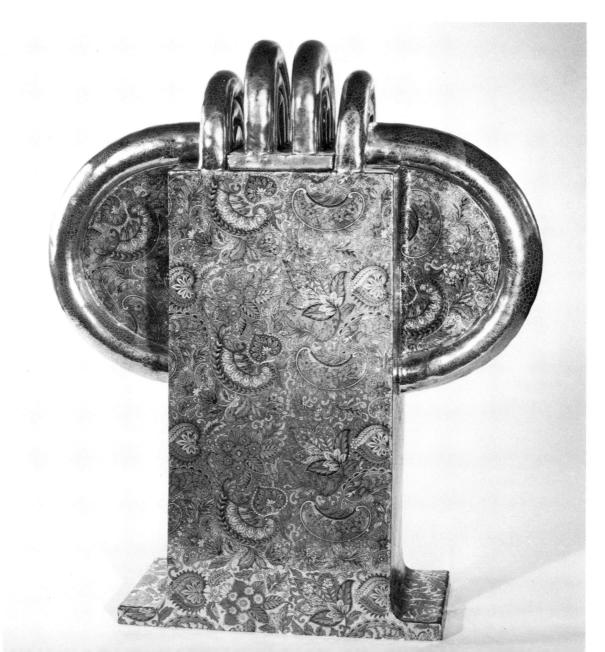

extensive historical knowledge. He often adapts old techniques and ideas to fit his unique contemporary expression.

During his first year in Seattle he continued experimentation in two areas which had been started as early as 1961 in Ohio during work on his dissertation, the so-called "corncob series" and "tear and repair series." The work on the corncob series was facilitated by his foresight in packing his pots for shipment to Washington in the ground corncob material he had been using in the experiment. This organic material mixed with the glaze on the stoneware pots, when fired out, left random pockmarks, an interesting textured surface. These forms are also interesting for their distortion, largely the result of his earlier interest in the wares of the Japanese tea ceremony. The spontaneous creation of these wares was an immediately underlying aspect of the so-called abstract expressionist handling of clay by the Voulkos group in California. The subtle eroticism set up in the forms of the corncob group was to become a major element of his style through 1967.

The other, parallel series of works, known as the "tear and repair" pieces, are large, white porcelain vases with glazed and unglazed portions constructed of wheelthrown sections and cut-and-torn pieces patched together and overlapped, sometimes with double walls slashed and pulled apart on the outer side to reveal the inner wall. Occasional sections of these vases are "upholstered" with luxurious silver or gold lamé fabrics and glazed with metallic lusters. The soft and sensuous fabric at the lip of the vase next to the hard, metallic-glazed inner surface, as well as the organic splits and protruding masses of clay, develop further the erotic tone of his work. The forms in this series are varied, including one loosely formed vessel contrasted with a flat slab-built, arching handle, reminiscent of Japanese folk ceramic rice or water containers. (After executing the "upholstered" works, Kottler found a reference to the attachment of woven fabric to the neck area of a ceramic bottle of the Egyptain Amara period.)

In June 1965, his interest in Oriental wares and in color, as well as an emerging fascination for the sensuous and elegant surfaces of Art Nouveau objects, led him to experiment with Raku vessels with soft, iridiscent surfaces. As with most of his works through 1967, these were likely to be expressionist in the handling of the clay and surfaces. The Raku works were usually containers, handbuilt in the tradition of the Japanese, but more misshapen. One such group echoes the distorted and twisted handles and lids which Harold Myers had used in the works for his exhibition at the Henry Art Gallery just before his return to the Bay Area in 1965.

After a short interruption, Kottler's work in Raku continued with other interesting forms and updated connotations. Kottler's Raku forms of this period began to show signs of Funk Art influence. One group in which the cylindrical walls are twisted many degrees is similar in spirit to forms found in the work of George E. Ohr, art potter from Biloxi, Mississippi who was active between the early 1880s and 1906. Both Kottler's and Ohr's styles embodied qualities of Funk Art, a type that has existed throughout history but was not yet formalized with a title in Ohr's day. Kottler's eroticism emerges with more vigor in two, tall, phallic Raku vases. A series of rectangular, rimmed, slab-built "platters" made during this Raku period are reminiscent in form of Bizen ware of the sixteenth and seventeenth centuries which imitated wooden plaques hung in imperial residences. In 1967, Kottler brought the viewer up to date by combining a closely aligned row of press-molded, ceramic "Barbie"-type dolls on one of those platters of Raku with the title *Target Practice Tray,* an example of both serial imagery (at its peak in the late sixties) and social satire.

Howard Kottler. Guilt Feeler, *1966, stoneware, wheelthrown and hand-built, glaze, luster, fur, 14¾ × 11¼ × 11¼. Coll. of R. Joseph and Elaine Monsen, Seattle.*

Howard Kottler. Hole Grabbing Bud Vase, *1967, earthenware, hand-built, clay parts, fur and ceramic decals, H. 16 × W. 13½. Museum of Contemporary Crafts, New York City.*

This talent at punnery, a major element in Kottler's oeuvre, also manifested itself in September 1965, when he began, with Warren Maruhashi, to experiment with forms in self-glazing Egyptian Paste clay bodies. Kottler's works had funny titles, such as *Blue Nibble Tips* and *Red Hot Blue-Cross Buns.* These may have been the first in an ongoing use of language to support his suggestively erotic forms. These works were also the first in which he used low-fired, bright color techniques. Kottler himself attributes to his inherent laziness his use of the paste body, which is colored internally and requires only one firing to achieve the colored surface. Other un-colored clay bodies usually require a first "bisque" firing and then a second firing to vitrify the applied, colored glaze. It is tempting to attribute his interest in paste to his study at Ohio State University where Arthur Baggs, with his industrial concerns, had earlier ex-plored the potential of self-glazing clay bodies for industrial uses.

One form in the paste series which has held Kottler's interest for several years is a type of curving vessel with vertically stacked "banana" forms applied to its sides with the ends poised immedi-ately adjacent to the vase opening. In paste, the walls of this type are constructed of various, small, hand built pieces, each of which, when fired, is a brilliant color with either matte or high-gloss, vitre-ous surfaces. Unable to achieve a bright enough orange, he painted the orange sections on one vase after firing.

This series was immediately followed with a series similar in form, with stoneware bodies and low-fired, brilliant glazes and metallic lusters. In 1970 and 1971, a third series followed in which he made use of overall, paisley-patterned decals and bright glazes and lusters on severe forms of white clay and stoneware that re-flected his interest in Art Deco objects, which he was collecting by that date. He was, concurrently, lecturing in Art Deco architec-ture. In a notable variation of this Art Deco series executed later in the seventies, the silver-lustered, curving, Art Deco-like pipes at the sides were played against the pot's ephemeral, air brushed, pastel surface, calling to mind the delicate, luminous surfaces of the work of Robert Irwin in California in the late sixties.

The year 1967 had special meaning to Kottler. He cites as influen-tial, in addition to his interaction with Maruhashi, the Funk show by Peter Selz at the University of California at Berkeley and the "American Sculpture of the Sixties" exhibition at the Los Angeles County Art Museum, both in 1967. In addition, there was the lecture at the University of Washington by Robert Arneson, leader of the "funk school of ceramics" at the University of California at Davis, who was visiting the Northwest around the time of Gronborg's aborted California ceramic show at Reed College in which Arne-son's scatological forms had caused a furor.

The recurrent qualities of "funk" in Kottler's works are probably best reflected in the combination fired clay and fur works of 1966 through 1968. Humorously erotic with lustrous copper, gold, and silver metallic surfaces, these vessel-shaped works, biomorphic in feeling, were wheelthrown or slab-built and framed with luxurious fox or glossy skunk furs, inviting the viewer to touch. Some are titled *Charged Box, Mommy Volcano,* and *Boobie Trap.* A fully realized work, in relation to his development in 1967, is *Hole Grab-bing Bud Vase.* This work combines a low-fired white clay with fox fur, lusters, and a very early use in the Northwest of slip-cast parts, and of applied-decal surfaces, which was soon to become his all-absorbing interest.

Examples of all types of Kottler's work to this time were shown in an exhibition in 1967 which traveled from the Henry Art Gallery to the Contemporary Crafts Gallery in Portland to the Contemporary Crafts Museum in New York City to Cranbrook Academy, and gave

Howard Kottler. Look Alikes, *"Look Alikes" series (set of four), 1972, porcelain blank plates, altered commercial ceramic decals, luster, H. 1 × Dia. 10¼. Henry Art Gallery, Univ. of Wash., Seattle.*

the first extensive exposure to this artist and his varied and contemporary body of work.

These works mark the end of his controlled expressionistic handling of the clay and of the use of elements of the vessel form as erotic elements in his work. It is interesting to consider Kottler's combination of two California approaches: the concern of the California group of abstract expressionists with the nonfunctional, abstract aspects of form, and the concern of the Davis funk artists for the construction of realistic images in clay. Kottler's juxtaposition of disparate, abstract elements evokes a form that is completely abstract while alluding brilliantly to a specific image. Titles intensify the impact of images. For instance, Kottler's sustained use of the opening, the primary functional aspect of a "pot," in juxtaposition with other elements in an assemblage (the slip-cast arms and hands in *Hole Grabbing Bud Vase*) is charged with pornographic and erotic significance, as are Arneson's "urinal" or "john" forms, or his Art Works series, replete with genitalia. Although in *Objects: USA,* Kottler unequivocally defines "palace art" as "objects that stimulate the intellect in places that stimulate the body" (p. 118), his careful disguise of his subject matter reserves distance between the work and the viewer, and possibly, subconsciously, between himself and the work.

In April 1967, Kottler started his work with commercial (hobby shop) decalcomania which was to fully utilize his aesthetic sensibility, his sophisticated sense of humor, his ability as a craftsman, and, especially, his intellect and gift for using language. In the first series, dozens of porcelain plates, he characteristically misused language in the punning titles and cut apart and reassembled the decals to form certain images. He also misused the plates themselves, applying decals to them as if they were "canvases." Although he at first threw the plates, he soon settled on commercially manufactured, porcelain blanks in order to emphasize the streamlined character of the finished work of art. He is quoted in the exhibition catalog *Illusionistic-Realism Defined in Contemporary Ceramic Sculpture* (Laguna Beach Museum of Art, 4 January–3 February 1977): "I like the perfection of industrial techniques and commercial ceramic ware. I am lazy . . ." Making his work sound deceptively simple, he relates that he uses "images already available—casting is simpler and faster than modeling. I purchase molded pieces already cast, use prepared glazes and junked ceramic objects; in fact, I seldom touch clay. I use other people's molds, other people's ideas and other people make my ceramic decals. I just assemble the parts." It is possible that Kottler's study on a Fulbright grant in 1958 at the Finnish Arabia plant, where he was well-conditioned to the mass production of ceramic objects, made his transition to the "plate series" a natural one. The porcelain plates were decorated, sometimes redecorated, with cut-up decals of various subject matter, reassembled in surprising, surreal, and uproariously funny ways, often unpatriotic and sacrilegious. His frequent use of repetitive patterns reflects the concern then for serial imagery in American art, and his dependence on the use of word play is consistent with current emphasis on conceptual art. The plates are often encased singly or in sets in exquisitely sewn envelopes of satin, or in boxes covered with mirrors. Subject matter, usually developed as satire, ranges from political commentary (*Flag Kit, Exhausted Glory,* and *The Peacemakers*), to altered masterworks of art (*Mona Lisa* and *The Last Supper*), to literary sources (*Knit on, Madame LaFarge* and *A Rose is a Rose is a Rose*), to images altered optically. *The Silent White Majority,* which shows the two heads in Grant Wood's *American Gothic* with blank faces and mouths, parodies a now-famous pronouncement by Spiro Agnew during the Vietnam war. Another alteration of the same

Howard Kottler. American Minstrels, *"Look Alikes" series.*

Howard Kottler. The Silent White Majority. *"Look Alikes" series.*

Howard Kottler. Personal Possession, *"Look Alikes" series.*

Howard Kottler. Hand Job, *1973, earthenware, hand-built and slip-cast, underglaze stains, glaze, 5½ × 11 × 4. Coll. of R. Joseph and Elaine Monsen, Seattle.*

Howard Kottler. Bushel and a Peck, *1973, earthenware, slip-cast and hand-built, glaze, ceramic decals, 6½ × 4½ × 5. Cleveland Museum of Art.*

masterwork, *Look Alikes,* changes the male and female images to two males. And, a series on *The Last Supper* is based on elimination of parts of decals. Other *Last Supper* series are based on rearranging of decals and relating of small images to large images.

In 1969 and 1970, before starting on his three-dimensional, molded-cup work, Kottler produced a series of assemblages of slip-cast industrial parts, one or more of which were shown at the Galerie Del Sol in Santa Barbara, California in 1970. The thirty pieces in the molded-cup series, fifteen of which were shown at the Henry Art Gallery in 1973, was conceived by Kottler and some of his students while driving to California during a break in 1973. Kottler says that he chose the 30 from some 150 ideas. This series is based on the idea of molded ware, with the actual cup mold included in each of the finished works. One work shows, on one side of the mold, a hand grasping the negative image of the cup handle, and on the other, hollowed-out side, grasping what looks to be the handle of the actual cup, which is really the reverse side of the mold. The same kind of ambiguity makes each of the works a three-dimensional pun. A second work, titled *Bushel and a Peck,* plays on several ambiguities: the artificality of the wood veneer decal on the base, the fact that the cup form is really its own mold, and the incongruity of the woodpecker covered with wood decals, as well as with the absurdity of the woodpecker eating a wooden, decaled cup, which would be made of clay if it really were a cup, and the metaphorical use of the cup as a bushel (container). The layers of meaning consciously incorporated into all of these works seem endless and can be added to indefinitely, depending on the creativity of the viewer. With these works, Kottler's private challenge was to make every element work in a formal way, beyond decoration.

The wood idea in *Bushel and a Peck* led him in 1974 to other three-dimensional works, which he refers to as the "wood grain series." He also executed in 1974 a third group of three-dimensional works, still using decals and molds, which are again involved metaphorically, this time with the use of paint brushes. All of these works are intellectual and far removed aesthetically from those executed before the decaled plate series of 1967, although the quality of personal detachment has remained a part of all of his work from the beginning. At the end of 1977 Kottler was involved in developing a portrait series based on the profile. The earliest of these are self-portraits, offering the viewer the first glimpse of the artist.

As a teacher, Kottler becomes involved closely on an intellectual level with his students, yet still maintains a distance, setting up a lively tension that keeps students on their toes. David Furman compares Robert Sperry and Howard Kottler as teachers: "Sperry broadened my horizons . . . gave me insight into myself so I didn't take myself so seriously. Howard, on the other hand, took me . . . very seriously. He was always joking and song-and-dancing-it, and coming out of his closet and being crazy, and it was tough to discern when he was talking to you and when he was horsing around. But, he was *always* talking to you, and it was up to you, the student, to listen, to read beneath those lines. He was always constructive and positive, and, if you weren't listening, you'd miss it, because of the way he presented himself. Metaphorically, he kicked me in the ass and said, 'It's time you start thinking about why you're doing what you're doing, and stop relying on things that you've been floating on without questioning.' He provided me that instrument to re-examine and re-evaluate what I was doing. He was a good teacher. He was solid."

Howard Kottler's work at the University of Washington through 1967 intensified the transition in the Northwest from functional to nonfunctional, sculptural concerns.

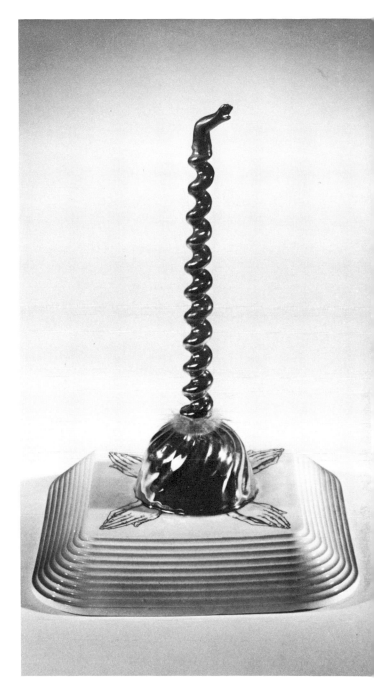

Howard Kottler. Motor City, *1970, earthenware, assemblage of hand-built and slip-cast, low-fired clay parts with glaze, fur, luster, and ceramic decals, H. ca. 9 × W. 5.*

99

Howard Kottler. Layed Back, *1974, earthenware, hand-built, ceramic parts with glaze and ceramic decals mounted on a wood base within a Plexiglas box, 8 × 12 × 8.*

Howard Kottler. A Touch of Reality, *1974, earthenware, slip-cast, glaze, ceramic decal, luster 9¼ × 14 × 8.*

Howard Kottler. Cracked Up, *1977, earthenware, hand-built with commercial cup, underglaze stains, clear acrylic, 14 × 12 × 4.*

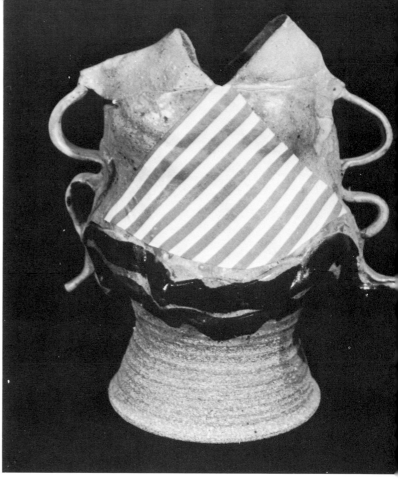

Leonard Stach (b. Chicago, Ill., 1933). Stripe Pot, 1967, stoneware, wheelthrown and hand-built, glazes, cotton fabric, H. 16.

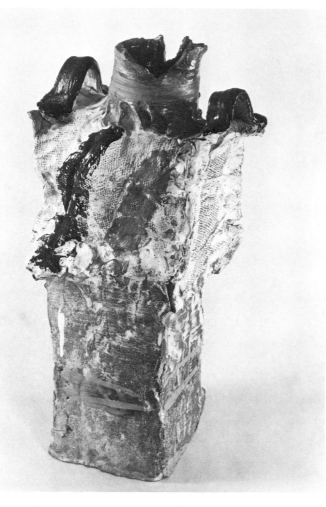

James Stephenson (b. Waterloo, Iowa, 1929). Pot "X", 1964, stoneware, wheelthrown and hand-built, brushed glaze, slip, 20 × 6 × 8.

Brian Persha (b. Shelby, Mont., 1943). Vessel, 1967, stoneware, hand-built, multicolored glazes, 36 × 21¼ × 8¾.

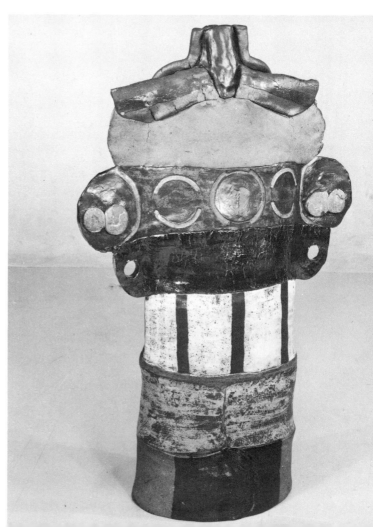

Second Generation:
The Late Sixties

Most activity in ceramics in the Northwest has occurred in, or as
a result of study in, the universities and colleges. True to historical
trend, the major changes of the late sixties occurred as a result
of discoveries in the universities in the early sixties. In Montana,
there was great activity in the area of abstract expressionist vessels
because of the lead of Rudy Autio. And, in Washington, the legacy
of the intense experimentation of the early sixties by Harold Myers
and Howard Kottler and by Patti Warashina and Fred Bauer and
a few other students, began to manifest itself in objects made by
"second generation students"—the objects were three-dimensional,
earthenware, nonutilitarian with brilliantly colored, low-fired
glazes, lusters, acrylics, and epoxy, sometimes funk-like or in the
Pop Art vein, expressing the artists' fantasies, as well as political
and social views, and often with a thread of high-handed or playful
humor. There has been a growing tendency to interrelate language
with the objects through the use of word play in titles of works,
largely the influence of Howard Kottler and his students.

A few of Rudy Autio's students in Montana were native Western-
ers, but dozens came from other states and left after graduation
to develop their work and to teach throughout the nation. The early
work in the 1960s was characterized by its large scale and rough-
slab or combination slab and wheelthrown construction sometimes
with a moderate use of colored glazes, and very close in feeling
to Autio's work. Examples of such artists are James Stephenson,
Leonard Stach, Brian Persha, and Martin Holt who staggered the
viewers of the Northwest Craftsmen's Exhibitions of 1965 and 1967
with their entries of large, freely formed vases and other containers,
all with a definite abstract expressionist bent. Holt was later to
go into production potting in Helena, Montana in his own studio,
the Peerless Pottery, and Stach and Stephenson went off to teach
in other states. Fred Wollschlager, who eventually went to Califor-
nia to teach, was another early student of Autio's who, in his latest
period in Montana, was producing high-fired vessels with unique,
overall embellishment in appealing low-fired colors. Ben Sams, an-
other native Montanan, has worked in constructed ceramic
sculptures or vessels of combined human and animal forms in ab-
surd combinations. The surfaces are densely decorated with
abstract stamped designs and applique and with small, bizarre
faces and parts of faces that peer out provocatively at the viewer
from unexpected places, a jungle of symbolism growing out of the
artist's accumulated knowledge and sensitivity to his world. Some
of these works, humanlike in a grotesque way, run as tall as eight
feet, with roughly formed heads and top-heavy trunks balanced
precariously on pipe-stem legs, and surfaces richly embellished in
relief. Sams was interested first in relief as early as 1964 at Oberlin
College when he embossed relief impressions into moist clay. A
recent letter from this artist gives some idea of the process a student
goes through in the search to fulfill ideas: "The printmaking process,
especially the 'collagraph'* taught me more about abstract two-
dimensional surface texture than any other work done before that
time. I applied this knowledge directly to my ceramics. Then, during
1965–66 I began to understand building with slabs of clay, which
was directly derived from Rudy Autio's abstract slab idea. I wanted

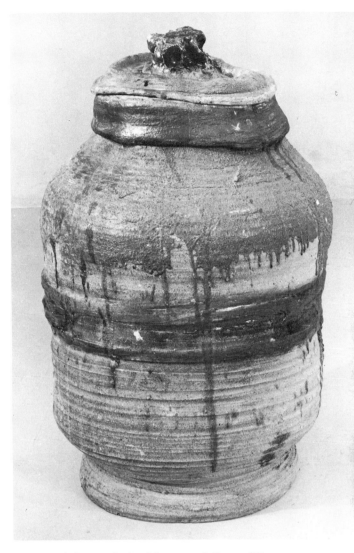

*Martin Holt (b. Deer Lodge, Mont., 1940). Covered Stor-
age Vessel, 1967, reduction-fired stoneware, ash and
copper glazes, thrown in two sections and joined with
slab, H. 40 × Dia. 24.*

* A technique in which a plate is built up into relief with various materials
and inked, wiped, and printed as an intaglio plate. The name "collagraph,"
from F. *colle-* (to glue) and *graph* (to print), was given this technique by
Glen Alps, School of Art, University of Washington in 1956.

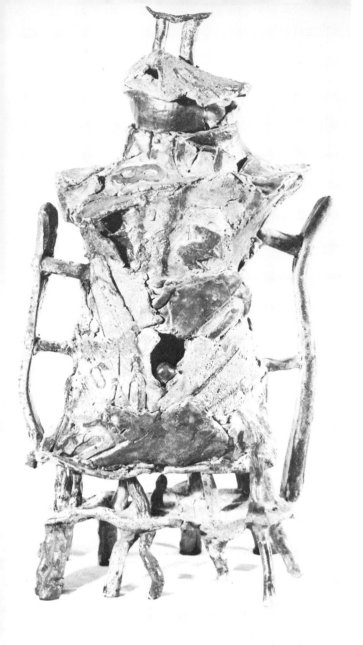

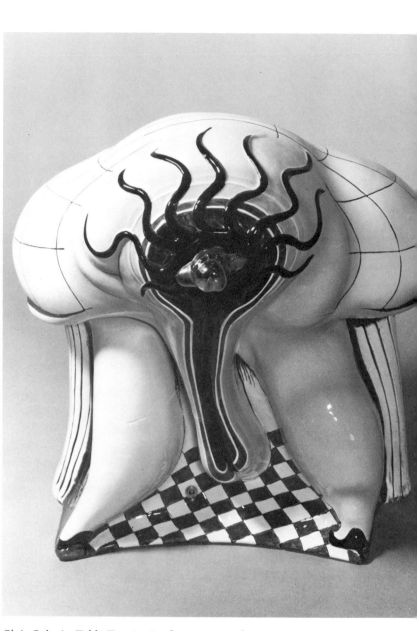

James Leedy (b. McRoberts, Ky.). Kukie Jar with Hole, ca. 1965, stoneware, hand-built, H. 25.

Clair Colquitt (b. Detroit, Mich., 1945). Cups, 1968, stoneware, wheelthrown and hand-built, low-fire glazes, luster, H. ca. 4. Coll. of R. Joseph and Elaine Monsen, Seattle.

Clair Colquitt. Table Top Air Purifier, 1975, earthenware, underglazes, luster, 20⅞ × 19⅞ × 17⅜. Henry Art Gallery, Univ. of Wash., Seattle.

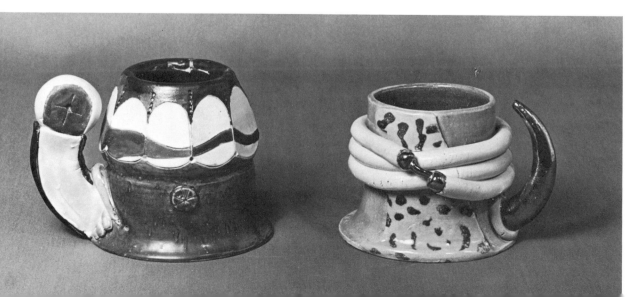

to maintain the vitality of the abstract, yet add definite, recognizable figurative modeling to the forms. . . . The question always arose, 'How can one truly abstract anything before he has tried to make that thing?' Imagine, now, that my 'real thing,' the thing I learned first, was the abstract slab pot. I . . . followed my native humor. Visual puns helped. A vase, for example, has a foot, a body, a lip, a hand, which are all verbal personifications of that pottery form. I explored visually the possibility of the foot having toes, the body having breasts, the handle with arms and hands. I think my most important contribution to ceramic sculpture was getting the visual weight of the ceramic form off the ground—the idea of a built-in base which became the leg section for my figures—the necessity to section the sculpture to be able to take the body and head off those legs during firing so that the weight didn't crush the leg area. Once the sectioning started to develop, I could make each section as large as I could physically carry alone. This gave me the method of making monumental ceramic sculpture. The early sculptural images I made did not reveal if I was pushing reality towards abstraction or abstraction towards reality, and the resolution of my problems always remained visually exciting."

From 1960 to 1964, James Leedy, who was a painter and sculptor from the East, came to teach at the University of Montana. He had worked as an abstract expressionist and translated this idiom into large, rugged clay (nonvessel) sculpture sometime during the sixties, either before or after arriving at the University of Montana. In a taped conversation, with the author, he acknowledged his debt to Autio for a new appreciation of the vessel form as distinct from sculpture: "Perhaps [Autio's] greatest contribution to clay and to his students, aside from his endless line of inventive forms and ideas, is his appreciation for the pot—he approaches it with the same respect and effort as . . . the so-called higher art forms. . . . All who are fortunate enough to experience this revelation leave with a different appreciation for clay that inevitably leads to their own new and serious discoveries." Leedy's prolific production of combination slab-built and wheelthrown sculpture and sculptural vessel forms, combined with found parts and some with applied, grotesque, press-molded face forms, were shown in a solo exhibition at the Museum of Contemporary Crafts in New York in 1968.

The expressionistic handling of clay sculpture and vessels has continued to the present at the University of Montana through the work of Rudy Autio. The work of Texas-born Ken Little, who joined the faculty in 1974, has added a new aesthetic dimension to ceramic form in the Northwest and probably in the nation. His work is concerned with the spiritual interconnectedness of his art medium, the land, the object, and the human being—a philosophy that has been traditionally associated with much significant art, but that has not usually been associated with the work of ceramicists. Since the early sixties, a number of students have traveled annually from across the country to do graduate work in clay at the University of Montana because of Autio's powerful work and his humanistic and constructive presence. Ken Little's philosophy and work carry this same potential for drawing students.

Clair Colquitt, an artist innovative in ideas and technical solutions and with a wry sense of humor, was a student of Fred Bauer's in Michigan, as Gasowski had been earlier, and brought to the University of Washington many of Bauer's ideas about the use of epoxy and acrylic paints. He used molds and low-fired, brightly colored glazes during his graduate years (1967–69). Like Gasowski, who was from Detroit, he has always been interested in cars and hot rods. Gasowski's main interest was in the surface treatment, while Colquitt was concerned with the construction of the car. And Gasowski's ceramic forms were unworkable models, while Col-

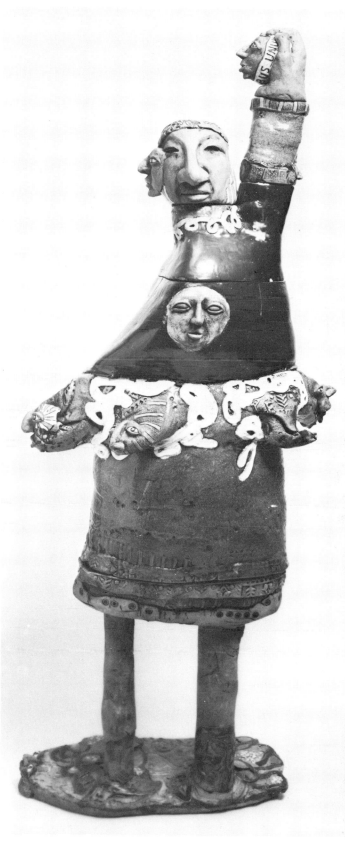

Ben Sams. The Juggler, *1968, stoneware, hollow-built, slab construction in five sections, modeled features sculpted to basic figure form, brush applied glazes, H. ca. 60. Coll. of Keith Petzold, Portland, Ore.*

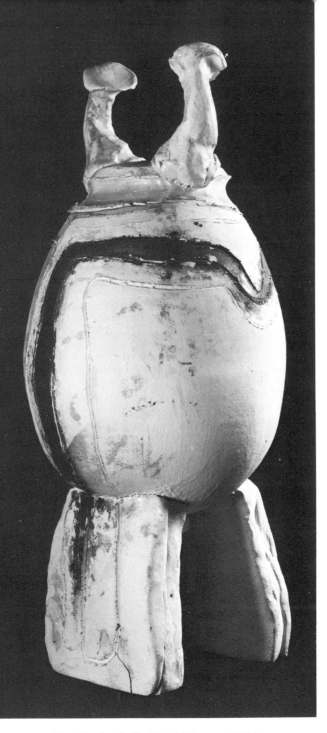

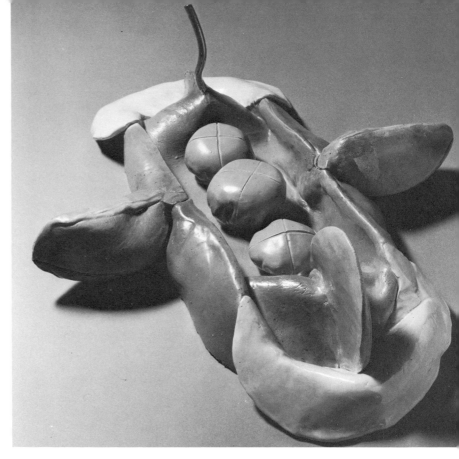

Jacquelyn Rice (b. Orange, Calif., 1941). Sculpture, 1969, earthenware, hand-built, low-fire glazes applied with airbrush, 8 × 21 × 24. Coll. of Joyce Moty, Seattle.

Pat McCormick (b. Longview, Wash., 1942). Three-piece Tubular Construction, 1971, earthenware, hand-built, silver luster, W. 22⅛. Henry Art Gallery, Univ. of Wash., Seattle.

Ken Hendry (b. Rockford, Ill., 1939). Bull Pot, ca. 1967, wheelthrown form turned upside down and parts added, white slip and clear glaze on horns, H. 26 × W. 11¼. Coll. of Earl and Marcella Benditt, Seattle.

quitt's cars, which he constructed from the bottom up and which are not of ceramic, do run. Colquitt's whimsical and sometimes sharply satirical humor is evident in the cars as well as in his ceramic works. Although his works in ceramic carry such titles as *Viet Napalm Container* (1968), he insists they are nonenigmatic and carry no message.

Colquitt says he is mainly interested in the design aspects of art, and he quickly loses interest when giving physical shape to his designs. He also says he was taught earlier that art would save the world, but the most he asks is that it make him a living. Useful works he has made and sold include a series of old radios that he restored and outfitted ingeniously with decorated ceramic cases of his own design. He relies on barroom movies, comic books, and cheap, Japanese ceramic pieces for his imagery. There is an incredible aesthetic difference between his precious, jewel-like cups of abstract design (1968) and the large, three-dimensional, figurative pop work titled *Table Top Air Purifier* (1975). Colquitt, whose erotic references are central to his oeuvre, is a master at creating the unexpected.

One of the most interesting pieces by Joyce Moty, another student at the University of Washington, and typical of her humorous style, was a Packard-like car that was modified by Colquitt to fit Moty's concept for her graduate show in 1970. Its entire dashboard, and the gas cap, door handles, hood ornament, clearance lights, and other accessories were all custom-made of fired clay and lusters by Moty, and it was upholstered in a garish, "Day-Glow" green and black leopard-print plush. Moty, like Colquitt, used low-fired glazes and lusters, and in 1970, produced an intriguing series of tea sets of combined thrown shapes. Moty's vocabulary of forms is broad, with functional objects decorated with drawings and decals and beautiful combinations of color, as well as purely sculptural objects. The surfaces of many of her functional forms are decorated with images of either food or food containers, sometimes an image of the same food container that is being decorated. A series of cookie jars was inspired by an encyclopedia illustration of a fish, but Moty's forms were fish heads with human bodies, some dressed, some nude, and all endowed with her special brand of satire. A more recent series of jars is built in human form and all are stereotypes of human beings. These works are hand-built with brilliant, glossy colors.

Irv Tepper, a graduate student at the University of Washington soon after Colquitt and Moty, also worked in clay with images of food, both real and fantasy. His TV dinners contained slip-cast molded food, sometimes smashed or distorted in some way, to fit his humorous and satirically biting subject matter. In 1970 he produced for a show at the Manolides Gallery (with Joyce Moty and Jacquelyn Rice) a series of slip-cast, airbrushed molds of rocks. His gift for using language in combination with his art served him well in his increasingly conceptual approach to ceramics and to the social commentary he is involved with in his work in video, photography, and mixed media in California. His intellectual brilliance and roguish personality were as much a part of his artistic aura as his work in clay during the short two years he resided and studied in the Seattle area.

Linda Coghill, who had been working in Portland in wheelthrown (nonpurist), Raku vases, began using low-fired glazes and lusters in 1970, inspired by the objects in Patti Warashina's solo exhibition in Portland and by the work of Erik Gronborg. Coghill produced in 1971 a notable group of large, molded, sculptural objects with various molded parts glued together with epoxy, one of which is entitled *Chrome Circus*. She was one of the earliest in the Northwest to use molds and flocking and photographic montages sealed with

Linda Coghill. Chrome Circus, *1971, earthenware, molded and assembled, lid lifts to reveal hands in sphere, low fired glazes and chrome overglaze, H. ca. 18.*

Lars Husby (b. Bremerton, Wash., 1945). AFROTC
*"Bust" series, 1970, stoneware, coil-built, press
molded, low-fire glazes, 20¾ × 21 × 7. Coll. of Howard
and Phyllis Yusem, Philadelphia.*

Leslie McKay Johnson (b. Chicago, Ill., 1946). Leslie
and the Box, No. 3, *1977, tile painting, earthenware,
hand-built, pencil drawings, glossy glaze, 17 × 18 ×
1½. (Double exposure of the work and the head of
the artist).*

epoxy resins. Her *Potato Eaters* is a hand-constructed, clay box with a photo of the masterpiece by Van Gogh glued onto the inside of the lid. Coghill's work usually has realistic imagery, sometimes in the pop vein, but, in its strange juxtapositions, always close to surrealism. This artist began working in the textile medium in 1974.

Ellie Fernald, a Californian who had studied with Paul Soldner before moving to Seattle, uses almost exclusively the imagery of food in her ceramics. Her work is straightforward pop, well-crafted and showing the spectrum of types of "fast foods" in our grocery stores and restaurants—hamburgers, ice-cream cones, fries—sometimes shown individually and sometimes in precise and cleverly constructed refrigerator containers of clay outfitted with electric lights. These works seem to be a chronicle of one aspect of life in America rather than a social criticism.

Ken Hendry, also a student of Paul Soldner, came to Seattle in 1966 to serve as artist-in-residence at Pottery Northwest. Although he has worked in a variety of ways with clay during his Seattle period, he says his early interest in architecture, which he never pursued formally, was reactivated in an abstract way, "as evidence of life, of life style, of the human place in eco systems." Out of this interest grew a series of sculptural works, a formal manifestation of his new thoughts about the human being and his environment, each a cluster of hand-built forms that resembles a house or a neighborhood of houses, all resting on generously formed, coil-built bases, the coil building learned from Bruno LaVerdiere.

In the late sixties, a number of artists in clay in Washington were most concerned with the formal qualities of their works. Jacquelyn Rice, a graduate student at the University of Washington, made abstract sculpture with subtle organic implications. The surfaces were low-fired with lusters and soft pastel glazes in greens, pinks, and white, applied with an airbrush. Many of her closed or partially closed forms contained "secret" objects of abstract form in fired clay. Rice has since taught at the Kansas City Art Institute and the Rhode Island School of Design.

Pat McCormick of Bellingham, Washington studied at the University of Washington before doing graduate work at the Cranbrook Academy of Art. Thus far he has produced an astounding variety of types of work, both functional and decorative, using low-fired glazes and lusters on earthenware and stoneware. Some of his most elegant and cerebral works were a series of forms, which Suzanne Foley, in *A Decade of Ceramic Art, 1962–1972,* calls "calligraphic descriptions in space with monochromatic tube shapes." These works, which were very refined, almost machinelike, and most often meant to hang on the wall, were black or white or, sometimes, in metallic lusters.

Lars Husby did an interesting series of "bust pots" that are biting satires on stereotyped groups within society. Because most viewers see these works as "sculpture," Husby is careful to emphasize that he sees his work as "sculpturesque," but conceives of it as vessels. Surreal images abound in his work. He adds, for instance, a single, long-stemmed rose to *What's Left of the NROTC?*—a bust of a too-perfect naval cadet—or, for humor, adds a dozen eclairs to *General Paunch Pot.* Husby has been greatly influenced by Magritte, but even more so by Richard Lindner, whose pop images were an inspiration for these busts.

The work of several students at the University of Washington in the late sixties exhibited a delicate approach to objects of great fragility. Leslie McKay Johnson created earthenware sets of "china" complete with flat ware and napkins formed of the thinnest of rolled clay. The carefully constructed Plexiglas cases in which these sets were mounted enhanced the delicacy of the clay objects. In the seventies McKay has been interested in assemblage and has pro-

Nancy Carman (b. Tucson, Ariz., 1950). Wisdom Tooth, *1975, porcelain, hand-built, coils and slab strips, underglaze, china paints, underglaze pencil, H. 13 × W. 8.*

Margaret Ford (b. Oakland, Calif., 1941). Fireflight,
*1975, earthenware, hand-built, H. 27. Coll. of Mr. and
Mrs. William Dwyer, Seattle.*

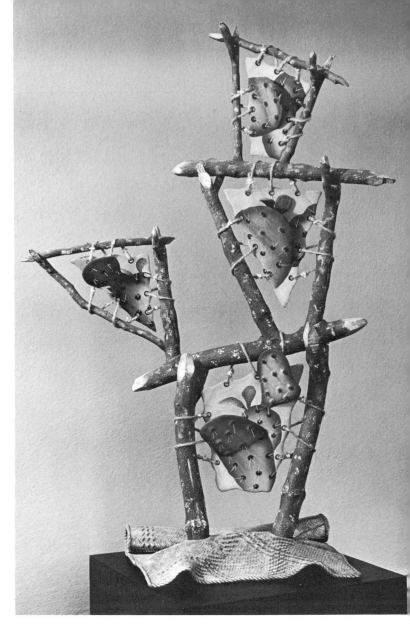

Michael Whaley (b. Pittsburg, Calif., 1946). Cactus As-
semblage, *1976, earthenware, hand-built, underglaze
with spray gun, H. ca. 36. Coll. of R. Joseph and Elaine
Monsen, Seattle.*

James Gale (b. Ann Arbor, Mich., 1943). Small Head:
Cretaceous, *1976, stoneware and porcelain, hand-built
and pinched, salt glaze, stamped texture, 16 × 12 ×
35. Coll. of R. Joseph and Elaine Monsen, Seattle.*

duced wall collages with pastel-colored, molded and hand-built body parts, such as lips and faces, as well as cubes and other small, hand-built forms, and drawn images on a background of thin, rolled and pressed layers of clay with delicate ragged edges. The fragility here is expressed not only with the pastel colors, but also through rolling the clay medium to the very edge of its limitations.

Another student, known variously as Barbara Brittell, Jessica Cornsilk, and Nirmal Kaur, is noted for her delicate, pastel clay reliquaries with eggshell-thin walls. Also a fine stitcher, Britell combines her clay objects with stitched sections and sometimes encases them in beautifully sewn cases of rich fabrics.

Sanford Sewa Singh Sussman has created "ritual" objects of pure white porcelain combined with found objects that heighten the mystical character of the work. He has also made tiny sculptural works composed of inch-long, porcelain animals frolicking among inch-high, porcelain trees, all on a matte-finished, porcelain base. Although some of these works are gently humorous and whimsical, there is a transcendental air about them.

At a time in the sixties when painters were showing a philosophical predilection for the use of materials that would not hold up physically in time, Chia Mann, a ceramicist, followed this lead in clay. His graduate exhibition at the University of Washington consisted of smallish objects of loosely formed, white, low-fired clay, all of an abstract and inexplicable nature.

In 1965, R. Joseph Monsen of Seattle, who, with his wife Elaine, had been a serious collector of Oriental art as well as of contemporary painting and sculpture, began to acquire contemporary American ceramics. This group of objects, one of the most extensive private collections in America, documents the historical and aesthetic significance of ceramics, especially on the West Coast, and is still being expanded today. Other collectors, in and out of the Northwest, began later to accumulate such work. Probably the most extensive public collection of recent sculptural objects, purchased under a grant from the National Endowment for the Arts, is at the Henry Art Gallery at the University of Washington.

1970 to the Present

A wide variety of work in clay has been done in the Northwest states throughout the seventies. The trend of the sixties toward sculptural rather than functional objects became more prevalent in all ceramics departments of the Northwest and was in the seventies strongly based at the University of Washington. For the students, this transitional period from the sixties to the seventies was dynamic, with the presence of Patti Warashina, Howard Kottler, and Fred Bauer (who was soon to leave the Northwest) producing sculptural objects, and of Robert Sperry, who had just returned from a period of professional rejuvenation away from the field of ceramics to once again bring credibility to functional wares.

The interest of the late sixties in surface treatment and bright color continued into the seventies, with the "cooler" social atmosphere of the seventies being reflected in ceramic sculptural objects. Margaret Ford, a student at the University of Washington (M.F.A. 1974) recalls the visit of Richard Marquis of California as a teacher at the university in 1971 and his use of slip-cast objects and underglazes, which emphasized for the students the fact that there were techniques being used in California which they had not yet utilized fully to achieve their expressive purposes. Howard Kottler brought back to the university in 1973 color slides of the large and highly

Margaret Ford. One in the Bush, *1976, earthenware, slip-cast and hand-built, underglaze, glaze, 34½ × 11 × 9. Coll. of Marvin C. Sharpe, Seattle.*

Mark Burns (b. Springfield, Ohio, 1950). Teapot, ca. 1974, hand-built and cast forms, assembled, earthenware, underglazes, 10 × 13 × 7. Coll. of Robert L. Pfannebecker, Lancaster, Pa.

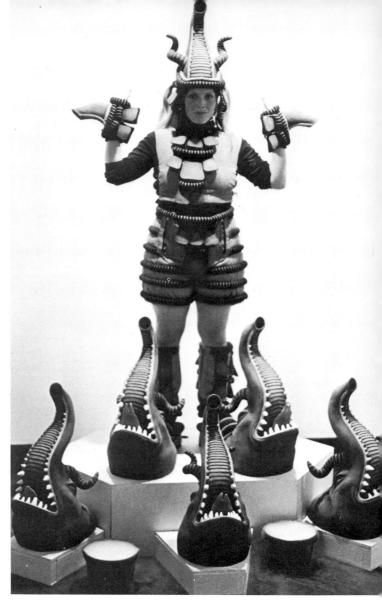

Robert Magruder. Dining Room Trophy, ca. 1975, white earthenware, hand-built, airbrushed and hand-painted, 32 × 14 × 12. Coll. of Mr. and Mrs. John Shipley, Portland, Ore.

Susan Nininger ("Rasha Hula") (b. Waterbury, Conn., 1952). Erak Erak: They Eat Peanuts, 1976, set and costume, earthenware, hand-built and slip-cast, airbrushed underglazes, fabric. Coll. of Preston and Janice Niemi, Seattle.

developed body of work in underglazes on porcelain, slip-cast assemblages that comprised the major exhibition by Richard Shaw and Robert Hudson at the San Francisco Museum of Modern Art.

A trend at the University of Washington since the early seventies has been toward the use of the smoother surfaces of underglaze colors applied with airbrush, and with images added in underglaze pencil or brush, without the addition of glossy, transparent glaze (underglazes, ceramic coloring oxides, are traditionally applied under a transparent glossy glaze for permanence). Extremely low-fired china paint with its brilliant color range has also been applied to slip-cast, bisque-fired forms in white clay body. (Most of these materials and firing techniques had been used in America in the thirties and earlier.) An intensified interest in realism has been evident, echoing the trend of New Realism in painting. The interplay of two- and three-dimensional formal aspects, as well as other devices of the "illusionistic-realists" of painting have been applied to many of those works. Real, contemporary situations and the common object as well as historical and literary references and surreal images have been presented, oftentimes humorously. Forms have been handled in a refined, impersonal manner, and selective use has been made of language in the titles, sometimes as an integral part of the work, either to clarify or consciously confuse the meaning. While these developments in ceramic sculpture have been centered predominantly at the University of Washington, works in this style are being created in other major centers of the four Northwest states. Margaret Ford says of her study at the University of Washington: "I am a product of the incredible energy generated by the ceramics department at the University. . . . There is so much sharing and support among those working in clay here. I think it must be an unusual phenomenon and should be documented." Ford's work is a mature blend of surface and volumetric concerns. Although her undergraduate ceramics study (1969–72) was done at the University of Washington in a milieu heavy with pop imagery and funk sensibility, Ford's approach to her work is gentle and the results subtle. Lacking any hint of vulgarity, which is evident in much of the newer work, her work is gently humorous, or refreshingly serious, combining fantasy and her broad knowledge of history and literature, as well as a great sense of her personal, inner being. The subject matter has great variety and is usually a combination of personal and unexpected surrealistic images. Whatever techniques she uses, her craftsmanship is perfect. Her work has been in a combination of wheelthrown, hand-built, and slip-cast parts, and she fires the work many times to achieve desired results. She has a sure sense for achieving rich combinations of color in glazes and sometimes uses the airbrush to arrive at the perfect surface effect. Some of her first works in undergraduate school were small, hand-modeled objects inspired by the decorative miniatures made by Fabergé in the early part of the century, some ritualistic with erotic overtones, but all as precious and elegant as jewels. There are obvious frustrations for exhibition viewers in these objects, whose snug fitting lids protect secret painted or sculptured imagery from prying eyes. Ford often used decals in these works, and slip-cast parts became important in her work. An interesting work is *The Wave* (1974), which she says "made itself." Inspired by the Japanese woodblock prints by Hokusai and the drawings of I. Bilibin in the Russian children's book, *The Tale of Tsar Saltan* by Alexander Pushkin, *The Wave* is constructed of three-dimensional, rectangular, slip-cast sections of white earthenware of equal size joined together in an overlapping and undulating fashion and colored with matte underglazes in a spectrumlike blend. She says this piece kept tapping her on the shoulder before she finally put it together. Her work has obviously been

Dennis Evans ("Ubu Waugh") (b. Yakima, Wash., 1946). Plates, 1974, reduction-fired stoneware, slab- and coil-built, iron oxide wash, no glaze.

Dennis Evans. Splints, *1975, sculpture, porcelain, hand-constructed, weeds, wood base, 6⅛ × 19½ × 12½. Henry Art Gallery, Univ. of Wash., Seattle.*

Dennis Evans. Box for Bow, Solar Skirr, Lunar Skirr, and Targets, *1976, (instruments for the performance of "The Hero Myth"), slip-cast porcelain skirrs, lacquered wood box, silk lined, 6 × 66 × 18.*

David Furman (b. Seattle, Wash., 1945). Greyhound Bus Depot—Men's Room, *ca. 1970, sculpture, earthenware, slab-built, low-fire glazes and lusters, 7 × 12 × 9. Coll. of Mr. and Mrs. Herbert Pruzan, Mercer Island, Wash.*

influenced by her interest in Zen philosophy and in Hinduism and spiritualism. She describes how the solution came for a piece she calls *Phoenix Box,* involving the symbolism of transmigration, when she stopped struggling with the technical problems of ceramics. A recent series of works in pristine, hand-built, low-fired white clay seems to be self-portraits, although they were not consciously so conceived. In one, titled *Fireflight,* an anthropomorphic work owing some debt to Egyptian sculpture, the image of a female face is integrated into a tall, eaglelike form. The eagle, which in the early Mediterranean was symbolic of the transmigration of the soul, is part of her lexicon. The importance of the eagle to her personally is possibly related to her grandfather's activity in ornithology. *Fireflight* eventually presented itself to her as a self-portrait, or as a symbol of her life, but this revelation did not become clear to her until it was finished. Her later work incorporates slip-cast elements and underglazes. The following statement made at the time of a recent solo show epitomizes her attitude toward her work and her life: "Clay is a sometime thing. To be overconfident is to court disaster. The materials and the process respond to the way in which they are handled, and when the work succeeds, you realize that you have only participated in the event." Ford's aesthetic development and her progression in the use of materials and techniques reflect the changes that occurred in ceramics at the University of Washington from 1968 through 1974.

A number of graduate students at the University of Washington have worked almost exclusively during the last few years in the newer techniques of slip-cast molds with underglazes and china paint. Nancy Carman, who studied previously at the San Francisco Art Institute, works with mystical, dreamlike images. Her delicate, pastel colors on glowing surfaces are carefully built up in many layers of underglazes and china paint and underglaze pencil.

Michael Whaley's earlier work, composed of slip-cast forms that usually have functional connotations and with meticulous surfaces, are super-realistic renditions in clay of his ancestor, Buffalo Bill Cody, or of buffaloes. His more recent works are free-standing assemblages of all clay, slip-cast parts, connected with twine and mounted on appropriately decorated clay bases. One of these, which plays two-dimensional aspects of form against three-dimensional aspects, is connected with the subject of cactus plants.

Mark Burns, while at the University of Washington, was one of the first to use bare, matte-finished underglazed surfaces, which he had already experimented with as an undergraduate in Dayton, Ohio. He executed a series of works of combined slip-cast forms each of which technically incorporated all of the necessary parts of a teapot disguised by imagery executed in the trompe l'oeil vein in underglaze pencil. All of the forms could have represented symbolically, for him, the end of functional wares, much as Arneson had done in 1961 with his capped ceramic pop bottle titled *No Return.*

Robert Magruder, who has returned to his native California from the University of Washington, made slip-cast forms using decals and handpainted underglazes and china paint, as well as airbrush techniques, to achieve so meticulous a realism that the objects look as if the artist had made them without touching them—a machined look. Many of these works incorporate images from a ranch that had meant much to him personally—snakes, horns, jack rabbits—and some work is in the form of large deep-sea trophies for hanging on the wall.

Susan Nininger is interested in performances and combines hand-built and slip-cast clay parts with fabric in the costumes she designs to wear in her theater pieces. Sometimes assuming the name of Rasha Hula, she has collaborated professionally with other ceramic

Dennis Evans. Genesis Plates *(one from set of eight), 1972, earthenware, slab- and hand-built, low fire underglaze, lusters, H. 7 × Dia. 15.*

John McCuistion (b. Lamesa, Tex., 1948). Ceramic Environment/Interaction Piece, *1975, extruded clay (50% fire clay, 50% perlite), inglazed raw clay, fired at various temperatures, random lengths.*

Bradley R. Miller. Porcelain Cell Addition Sequence, *1977, Dia. ca. 3 (maximum).*

Bradley R. Miller. Compression Form, *1976, 150 pieces, stoneware, glass, wood, ca. 4 × 7 × 7.*

Richard Notkin (b. Chicago, Ill., 1948). Curbing Free Enterprise, *1975, earthenware, with brass, hand-built and carved, underglaze rubbed away to reveal surface texture, clear glaze over all, 15 × 13 × 9.*

artists. Once, Jim Gale, another University of Washington graduate, produced a huge, ceramic beast with a saddle which Nininger "rode" at the opening of an exhibition wearing an originally designed costume that included ceramic parts made by Gale. Sometimes she appears in her productions as an object, such as in the wearable tea set titled *Gypsy Pilot Tea Set.* In her *Erak, Erak, They Eat Peanuts,* Nininger, dressed in a handmade elephant costume, passed out peanuts to the audience while yard-high, low-fired clay elephants surrounding an altar spouted real smoke through their trunks. Her work in clay is perfectly executed with airbrushing, underglazes, and beautifully combined pastel colors. The visual aspects of the performance pieces are more fully developed than the dramatic and literary parts.

Jim Gale's approach to his work can be summed up with the statement: "Working with art is one of the few ways that you can play all day and still be an adult." This artist, who sports a gold inlaid "shazam" lightning bolt in his upper left incisor, started his career in ceramics by making a series of hand-modeled ducks, their identities partially concealed with masks. One work, titled *To Tell the Truth,* was a parody on the popular television show. Later he made gigantic, highly crafted, hand-modeled ceramic monsters with carefully formed half-inch-thick walls. Based on historical and legendary models, these works are thoroughly gruesome and also humorous. Gale built one gigantic monster ten feet long for the Port Townsend playfield in Washington. While Gale has not followed the slip-cast mold trend at the university, his work, in its careful construction, its use of materials, and its narrative style, is consistent with some of the aims of this newer trend.

Dennis Evans, a young man with a chemistry degree and versatile artistic talents, while still at the University of Washington produced a series of wheelthrown *Genesis Plates,* each containing a hand-modeled "cosmos" depicting in meticulous detail the events of the Creation. This was an early use of airbrushed, dull, underglaze surfaces. A year later he produced a series of large, shallow ceramic bowls with surfaces in overall geometric designs formed with applique strips, usually in neutral, monochrome clay, but sometimes in black and white, and exhibiting three-dimensional optical effects. The next year, under the pseudonym "Ubu Waugh," he started a series of works that have developed in a complicated way to the present day. The first works in this series were purely sculptural, involving long, broken, hand-built forms of a pristine, white, porcelain clay body, wrapped carefully with straw and raffia "splints" and mounted on well-finished, wood bases. These minimal, austere works relate to human beings in a powerful and enigmatic way; it is as if the splinted porcelain forms are infused with life. From that point, Evans began making "musical instruments" of porcelain or from found objects that he encased in well-crafted boxes or translated into "ritual objects" for performances of his own musical compositions. He is interested in video and carefully documents all of his performances, incorporating video and sound cassettes into his pieces. His Duchampian view of art and the world have a mystical dimension not often met with in the ceramics world.

David Furman, who had studied landscape architecture and urban planning at the University of Oregon, eventually learned design and the basics of ceramics at the University of Oregon before enrolling in graduate school at the University of Washington. His concern for architectural space manifested itself in some charming, small, hand-built vignettes of unpeopled spaces, reflections of his sense of his own space—*My Living Room, My Kitchen, My Bathroom,* etc.—with brilliant, low-fired color. These works were developed more thoroughly after he joined the faculty at Pitzer College in California and superimposed his dog, Molly, into the spaces. About

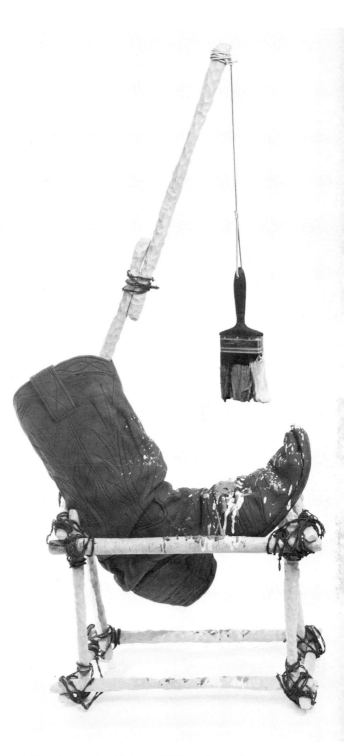

Dennis Voss (b. Gordon, Nebr., 1948). Open Range Corruption, *1977, earthenware with barbed wire, burned paintbrush, and leather cord, boot constructed with "screen" technique, 57½ × 27½ × 14. Henry Art Gallery, Univ. of Wash., Seattle.*

this development Furman says: "There was the implication of man and his manifestations, his imagery, his iconography. I think that I was trying to look at these spaces from a different vantage point and re-evaluate and reinterpret. . . . They're very tiny . . . and that makes you bigger and you transcend scale, and you're able to examine something in a way that isn't usually humanly possible. That comes into play now with these rooms (with Molly), but there's a different purpose in these pieces. . . . I'm using life that is reflective of me, perhaps. My relationship with my dog—she's important to me in my life, so it seems natural that she should become part of my art work because that's a part of my life, too. . . . Molly's my model."

Earlier, Furman had been much interested in food as imagery, turning out a series of elegant "celebrity" cakes, and another series of food-related objects with humorous punning titles. His loose handling of the clay and free application of the glazes were very much a part of the funk idiom. He is constantly experimenting in many media, including sculpture, graphics, painting, glass, and film.

John McCuistion, formerly Rudy Autio's student and presently on the faculty at the University of Puget Sound, prepared an environmental exhibition for the gallery at Indiana State University which involved the scattering of small extruded shapes in clay (fortified with perlite and fired at different temperatures and atmospheres) on the floor of the exhibition gallery. Viewers were invited to participate by rearranging the clay bits. McCuistion also has produced sculptural vases with interesting combinations of surface decorations, especially strong in their use of color.

Leaving Kentucky in 1974 for Bozeman, Montana "to escape droves of artists and the educational system" was Dennis Voss. Voss, who was reared among cowboys on a cattle ranch in Nebraska, is concerned with "putting the gesture of the West into my images: the top of a barroom table, a beef steak, a sling shot." He integrates certain feelings associated with his past into his objects. One of his works in clay is a large, three-dimensional assemblage with a cowboy boot leaning against a rickety chair on a baseboard—all in "fool-the-eye" style (he calls it "absurd realism"), one of the most recent directions in the medium, following the lead of painting. He is also interested in increasing the scale of objects. He would like to build a thirty-foot cowboy boot that would reflect the gestures of a cowboy on a bucking horse. It is possible that he may eventually work with earth and land pieces. His media interests are wide; one recent project was the production of a slide show titled *Running Away with the Steak* in which he and his personal feelings about steak and the actual steak become one. His interest in clay objects that look like leather was sparked by the objects of Marilyn Levine, although he had no idea of her techniques. In solving this problem, he developed in 1973 an important technique which he refers to as "the clay and plastic screen process," for building large objects with quarter-inch-thick walls, which involves plastic screen sandwiched between two, wet slabs of clay. This pliable slab can then be cut into shapes and manipulated as if it were leather. The slab is so thin that he is able to force-dry it with a hair dryer at any stage, thus controlling the results. This way, he can get a "super realism" effect, or allow a more claylike feeling. Voss suggests that the possibilities for this technique are endless. The screen, which shrinks with the clay and burns out in the firing, strengthens the clay for constructing large pieces. For instance, a 10' by 15' by ¼" slab could be made on the floor, lifted by four people, and hung like a drape, to be fired in a huge kiln. Or, the slab could be dropped over a prepared form.

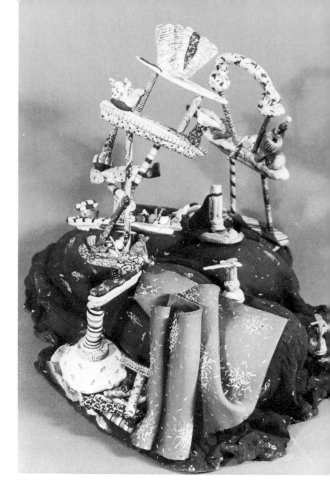

Alice Sundstrom (b. San Diego, Calif., 1951). Untitled Sculpture, 1977, white earthenware, hand-built, gouache surface and wood, 16 × 18 × 15.

Ken Little. Diorama, 1976, figure and painting: earthenware, hand-built, acrylic on canvas supported by wood frame with foam pad, 40 × 50 × 50.

Bradley R. Miller made unusual use of clay in partial fulfillment of his M.F.A. degree at the University of Oregon in 1977. In one experiment he made and fired clay rock forms, then tumbled them in a ball mill to simulate river wearing. In other experiments he developed two methods of pattern formation: compressing the plastic cells in the clay, and releasing the tensions from the clay during the firing. All of these experiments produced sensuously delightful objects, and the latter two, interesting information about the interlocking structure of clay, as well as appealing design possibilities.

John Rogers, former student of Ray Grimm at Portland State University has worked recently with small "desk sculptures" of porcelain. The preciousness of the objects is intensified and the phallic imagery disguised with rich abstract design in low-fired, bright colored glazes and lusters.

Richard T. Notkin, a graduate of the Robert Arneson department at the University of California at Davis, moved recently to Oregon. His own statement in a recent letter to the author gives a clear notion of his social concerns and convictions and the nature of the messages in his art: "In a suicidal world of unbridled, cancerous militarism, gluttonous waste of natural resources, strangulating pollution, and a greedy disregard for the survival of endangered species, artists have traditionally created, and should continue to create, amidst destruction."

A student at the University of Washington who was almost exclusively concerned with the formal aspects of ceramics was Anne Currier, who had studied in the Bauhaus milieu of Chicago. She brought to Seattle a clear concept of the kind of work she hoped to do and never deviated. Interesting works by Currier are her pristinely white sculptures composed of many interlocking forms resembling a puzzle. The works are of low-fired, white earthenware with clear and glossy commercial glazes. Some of these works are in combinations of black and white, which increases their elegance and sophistication. Currier says these were greatly influenced by Art Deco and the ideas of the Bauhaus.

Anne Veraldi's *Space Capsule* was executed at the University of Washington of delicately formed clay with a weird outer-space sound built in, reflecting the concerns with space of some artists in the seventies.

Harrison Jones, also of the University of Washington, created in clay and in multi-media objects that mourned the death of the earth, reflecting widespread and ardent interest in the environment and ecology in the seventies.

A Californian and a recent graduate of the University of Washington is Alice Sundstrom, whose work, produced within the milieu of the slip-cast assemblage, remains outside of the West Coast mainstream style. Her abstract forms are composed of small, oddly formed dabs of clay which are painted with brilliantly colored gouache and strung together on twine that is stretched in various configurations onto a freestanding frame of wood mounted on a large mass of painted clay. These sculptures are sometimes four feet tall.

Ken Little had experimented extensively with clay before joining the faculty at the University of Montana in 1974. His experimentation followed the attitudes of some of the painters and sculptors of the sixties in their reaction against the austerity of "minimalism" and its clinical "primary structures," but without the irreverence associated with the reaction of funk artists. During those years he was inspired by such artists as Robert Morris (after 1967) and the late Eva Hesse in their unorthodox use of materials in ambiguous presentation. He produced large, three-dimensional, slab-built objects with jutting parts and grease- and petroleum-finished surfaces. Soon he became more interested in the nonvisual aspects

William Gilbert (b. New Haven, Conn., 1950). Untitled Sculpture, 1976, earthenware and wood with bolts, coiled clay, salt glaze, 96 × 90 × 54.

Amanda Jaffe (b. Pasadena, Calif., 1953). Woman in the Sea, 1976, white clay and wire, slip-cast, airbrushed duncan underglazes, matte polymer, 26 × 20 × 1.

of clay and set up situations that were involved with such elements as the sound, the taste, and the weight of clay. Having always been interested in drawing, in the early seventies he began "sketching" in clay, producing objects of unfamiliar shape that he considered nonprecious, "spare parts," the results of an "everyday experience with clay." These "sketches" in clay were sometimes transferred in two-dimensional drawing to clay plates. At about the same time, he created quasi-environmental assemblages of fired parts. One such assemblage included hay—"hay and clay are complementary"—with a burning candle. He encouraged friends and students to "perform" with or on these pieces.

After arriving at the University of Montana, Little became captivated by the climate and the landscape and created forms that symbolized to him the seasons of the year. With sustained interest in the land and in the river, he began creating abstract and colorful expressionistic renderings of what he considers to be river images (or the "aura" of the river) with acrylic on canvas, as back drops for stylized, rigid, single forms (chunky stick figures) in clay of his dog, Billy, or other dogs or animals, or human forms. Eventually these developed into diorama-like scenes mounted either on elevated platforms in free space or as three-dimensional "room" spaces measuring eight feet in each direction. He expresses his awareness of the connections, as well as the potential alienations, between the "auras" or spirit of the land and the river and the living beings in this series, which is "Western art" in the most contemporary sense. Having come from Florida and the East Coast, Little is not part of the West Coast trend in ceramics, and, although Montana is somewhat isolated, he travels, lectures, and absorbs, returning to Montana and to his students inspired and with renewed enthusiasm.

Michael Lucero, working with figures, both human and nonhuman, produced a considerable body of sculpture at Humboldt State College before entering graduate school in 1977 at the University of Washington. These early works showed a potentially powerful aesthetic, partly achieved through a unique selection of materials and techniques far removed from much of the work in clay that was being or has since been produced on the West Coast. At the University of Washington he enlarged the figures, creating at one time distorted and "distressed" human figures of coil-built construction, which were suspended rather than mounted. Lucero's understanding of the critical value of using appropriate techniques for achieving aesthetic ends became apparent when he began constructing the forms with chicken wire "armatures" that were hung densely with small, hand-pressed and molded, fired clay "petals," colored with bright underglazes. The loose freedom of this construction, which replaced the rigidity of the coil-built figures, complemented their suspension in free space and helped create the feeling of softness and vulnerability of a living body. One of the earliest of these works, produced after six months of graduate school during a personally painful time for the artist—a time when he felt "hung up" or "up in the air"—was his *Golden Fleece,* a ram suspended in time and space, a symbol to him of the possible reoccurrence of creativity and of strength in relation to himself.

After *Golden Fleece* Lucero developed his technique into much larger, more elongated human figures, also suspended in space. These newer works hang in his studio, in a kind of environmental relationship, each also demanding its own space. A theme running through all of this work is the artist's devout humanism and his understanding of "the human condition" as well as evidence of his search for freedom through these images and the way they are handled. One powerfully evocative work is his *Jesus Figure* with its organic, fleshlike surfaces, achieved with the clay "petals."

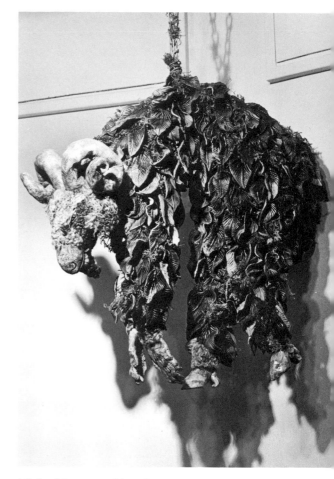

Michael Lucero. Golden Fleece, *1977, earthenware, hand-formed clay "petals" over wire armature, underglaze colors, H. 30× W. 30. Coll. of R. Joseph and Elaine Monsen, Seattle.*

Peter Fortune (b. Ludington, Mich., 1904). Rosey's Hotel *(front view), 1971, sculpture, earthenware, hand-built, H. 66½ (including base).*

Lucero invests these figures with a strong sense of mystery without the vagueness that so often accompanies ambiguity. He welcomes suggestions and interpretations of this work. About the tedious task of attaching hundreds of clay "petals" to each work, he considers his acceptance of this work, with its involved and careful craftsmanship, a valid statement about and by the artist. And, for the artist, it is a way of documenting his time and his commitment to the work. During this monotonous process he claims that he feels a certain freedom.

Two mature artists whose work in ceramics has only recently been recognized more widely are Washingtonians Peter Fortune of Everett and Clayton James of LaConner. Fortune, now in his seventies, retired from the merchant marine in 1959. He is a self-taught artist, with minimal study in night classes at the School of the Art Institute of Chicago in the early twenties and a few quarters work at Everett Community College from 1960 to 1962. His exploration in three-dimensional space and form in ceramics began in 1968. Fortune says of himself, "Please remember that I am not an artist, but an old man who fiddles with creative diversion, at most I could be called a painter." Although he has worked at painting and print-making and individual sculptures, his tour de force, a work 66" by 36" by 42", titled *A Full House, San Andreas* or *Rosey's Hotel*, sums up his naïve handling of the clay and glazes and his sophisticated understanding of the foibles of humankind. While the house reflects the architecture of the Victorian era, the activities of the people in and around the house are as timely today as they were in the late 1880s. The house, its surrounding fence, and its occupants are formed of fired, white clay and colored with bright, low-fired glazes. To indicate the difference between fantasy and reality he has developed a unique device: all of the uncolored, white parts represent fantasy, while the colored sections represent reality. This system also enables him to add white to his overall design. All of the rooms in the house are lighted with electricity, and the house and its surrounding fenced-in yard are dotted with vignettes depicting the activities of the occupants. Fortune and his wife appear in various guises in and about the house. The work shows not only Fortune's considerable artistic talent, but also his humor and compassion for the human condition. He is presently working on a large wall consisting of six-inch-deep modules, each depicting the subject matter of the Garden of Eden and all mounted against a wood background with the title *Adam and Eve Begun It*.

Clayton James, a noted Northwest sculptor-turned-ceramicist, has produced fifty-pound, monumental, coil-built pots fired with primitive techniques. His most recent work was a series of warrior masks in stoneware and earthenware, resembling masks of death. Darkened with smoky firing and burnished with oil and wax, these pieces could well have been dug up from an ancient burial site. It is interesting to read James's comments about his new experience with working in clay in view of the fact that he was already a recognized artist with a full career behind him before working in the new medium: "I have worked in many mediums over the years—painting, concrete, wood, etc.—but never in any of them have I felt so keenly that this 'reached further back in time' than in clay—the primitive, ritualistic—I like to call it the continuum of the cultural flow from the ancients. It could be that the material itself is so ancient—man has been picking up a wad of clay and pinching it into forms for so long a time."* "I think the work [in one of his exhibitions] shows this discovery—struggle, really—of taking the clay in hand and shaping it—the connection between the material and the primordial—by the act of the hand, the perfecting of the

* James to R. W. Campbell, n.d. (unpublished).

Clayton James (b. Belding, Mich., 1918). Warrior Head, *1974, earthenware, hand-built (coil method), unglazed, ca. H. 20.*

Peter Fortune. Rosey's Hotel *(side view).*

form. And, somehow, all those centuries of people doing the same thing in their own way are there talking to you—the continuum."*

Ray Ho, faculty member at the University of Puget Sound, is a ceramic artist who produces highly decorative, functional objects that are in heavy demand. These slab-built forms are decorated with dense, ornate designs on surfaces of low-key color. The designs, formed with applied stripes of clay are basically geometric and remind one of some of the heavily designed surfaces of Islamic work in ceramics.

Four young undergraduate students of John Takehara at Boise State College in the seventies are examples of young artists who are working both in vessel forms and in sculpture. Beth Garland-Ledden juxtaposes female-associated "lace" decoration with a symbolically bold male form to produce a Yin-Yang concept. She attributes her interest in working with "earth-produced materials"—animal bones and skins, feathers, plant fibers, and clay—to her family background: her great-grandmother was a Cherokee Indian.

Craig Sofaly has been working with realistic human forms in coffinlike boxes. He "sagger fires" the work, that is, he stuffs the coffin with burlap, straw, and charcoal, which, when fired in the kiln, leave deposits on the figure and create a reduced atmosphere for darkening affects. The resulting figures seem like organic forms in the process of decomposing.

Kerry Moosman makes vessels combining feathers, and sometimes, leather, with clay. He also makes large, coil-built, stoneware, ovoid forms with masklike faces emerging from the surfaces.

Terry Lutz throws most of his forms as functional vessels, but embellishes them by carving or painting with slip in natural trees or landscape designs.

In January 1978, Lukman Glasgow, a California ceramicist, replaced Jan de Vries as director of the Contemporary Crafts Gallery in Portland, Oregon. A year before coming to Portland, Glasgow did an interesting analysis of some recent work in clay in the text of *Illusionistic-Realism Defined in Contemporary Ceramic Sculpture*. In fulfilling his new duties as director of Contemporary Crafts, Glasgow's stated commitment is to exhibiting works that are "contemporary," reflecting the name of the gallery.

Conclusions

Any attempt to establish the provenance of recent trends in any field at a time when communication has become instant would be difficult. This is as true in ceramics for functional wares, where the options for change are limited and the changes subtle, as it is for ceramic sculpture, in which the possibilities for innovation are greater. Philosophies and techniques are shared through the network of artists both within and outside of the university and through the media. During the last several decades in the Northwest, however, the centers of dynamic and forward-moving activity in ceramics have obviously shifted within the region several times. Beginning in Oregon at the Oregon Ceramic Studio, several years before World War II, with support from the University of Oregon, the Portland Art Museum, the Arts and Crafts Society, and the public schools, the emphasis was on encouraging potters to develop their talents, as well as on educating school children and the public to the merits of works in clay. Victoria Avakian Ross at the University of Oregon and Lydia Herrick Hodge at the Oregon Ceramic Studio in Portland were most responsible for this lively ceramics

Ray Ho. Platter, 1970, stoneware, slab-built with applied clay decoration, 1¼ × 16 × 16.

Kerry Moosman. Bowl, 1975, stoneware, coil-built, metal-oxidized tin slips, horsehair, H. 19 × Dia. 22.

* James to James McKinnell, n.d. (unpublished).

scene. The dynamic thrust continued at the Studio but was over-lapped and eclipsed in the early fifties by events in Montana at the Archie Bray Foundation where the philosophies of Hamada, Leach, and Yanagi changed the attitudes of ceramicists in the entire Northwest area as well as the United States for all time. The production of tightly controlled, cast and hand-built wares gave way to that of sturdy, large-scale, functional objects of stoneware, usually fired in a reduction atmosphere for spontaneous effects. These newer objects were created with a freedom that had never been experienced before. Running concurrently with the promulgation of the Oriental way was the dramatic influence of Peter Voulkos' energy and innovation—energy shown especially in his gigantic, powerfully thrown vessels, with glazes and decorations derived from his extensive experimentation. Out of this period of great freedom, the universities of all the states came alive in the mid-1950s under the direction of new teaching faculty and with new ceramics curricula and the necessary equipment and materials. Robert James at the University of Oregon, Ray Grimm at Portland State University, and George Roberts at the University of Idaho have maintained for the past twenty years strong ceramics departments though with minimal emphasis on the technical and aesthetic approaches associated with the newer trends in ceramics of the sixties and seventies. Robert Sperry at the University of Washington set a powerful example for his ceramics department with his prolific production of gigantic abstract and semi-abstract sculptures and generously proportioned functional wares. In the early 1960s, as a result of Voulkos' clay revolution in Los Angeles in the mid- and late-1950s, expressionistically handled, process-oriented clay in gigantic, hand-built, stoneware vessels and sculptural constructions began to appear with bright, low-fired glazes and acrylic-painted surfaces. Rudy Autio, who had moved to the University of Montana, was especially representative of this trend. Several artists, working independently, but at the University of Washington, were responsible along with Autio for the dramatic change in emphasis from functional wares to sculptural concerns and on low-fired, brightly colored surfaces. Most intensely committed were Harold Myers, Patti Warashina, and Fred Bauer. Also working in this direction for a period of four years at Reed College in Portland was Erik Gronborg. The arrival of Howard Kottler at the University of Washington and the presence of other key figures have enabled the university to sustain its reputation for high-level energy and innovation in the Northwest ceramics field. Sperry and his students have worked predominately in functional wares, and Warashina's and Kottler's influence has been toward the area of innovative sculptural ceramic objects.

In the ceramic sculpture of the Northwest one can find examples of every major trend in the history of art of this century, including Cubism, the Bauhaus School and Constructivism, Art Nouveau, and Art Deco. There are abundant examples of Abstract Expressionism and some of Op and Pop art and Minimal art. One even comes across an occasional surface executed in the manner of color field painting. There is New Realism and performance or ritualistic art connected in some way with ceramics. A recent emphasis on the importance of the idea as art instead of the object as art has brought ceramics into the fold of Conceptualism. Just as the tempo of change from one trend to another in other media has speeded up dramatically in the sixties and seventies, so it has in ceramics. These changes in the Northwest have occurred most noticeably at the University of Washington during the past two decades.

Beginning with the rapid and innovative development in ceramics of the early fifties, there has been to the present day a strong tradition for the production of hand-built and wheelthrown, generously

David Nechak (b. Yosemite National Park, Calif., 1939). Rungless Ladder, 1970, white stoneware with cone 06, white slip fired to cone 05, H. 10, Dia. of base, 11.

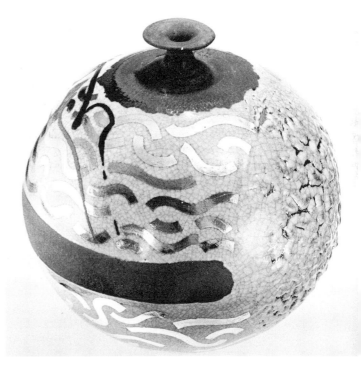

Robert Sperry. Vase, ca. 1975, stoneware, wheel-thrown, white glaze, chrome, iron, and cobalt oxides, gold luster, H. ca. 18.

proportioned, functional wares in the rich, earthy tones associated with stoneware temperatures and reduction atmospheres, as well as in the clear colors of oxidized surfaces. There has also been a tradition for these wares, especially plates and platters, to serve as "canvases" on which to paint pictures, sometimes landscapes, or flowers, or calligraphic symbols and abstract designs. Although in the best the form and the surface treatment are well integrated, often it is the richly decorated surface that is emphasized.

Robert Sperry, though he has worked in ceramic sculpture and in other media, has maintained a philosophical commitment throughout his career to "the pot," a commitment manifested in his work and in public statements. His influence has been strongly felt by many Northwest ceramicists who work as potters and potter-painters in mass and semi-mass production. In Sperry's own functional ceramics since about 1973, the forms are larger and the decoration more elegant and expansive than earlier. The latest work is a combination of great black and green brush strokes, and gold luster and black arabesques and rectangular and circular designs trailed or brushed on thick gray and white crawling and crackled glazes. He believes this recent work is a synthesis of all the major directions his work in functional pottery has taken during his long career. In arguing for the uniqueness and value of traditional, wheelthrown pottery, Sperry states that while the many varieties of ceramic sculpture being produced today would be just as successful aesthetically if formed of other materials, pottery can be produced only with clay and only on the wheel. Because of Sperry's sustained production and exhibition of high-quality functional ceramics ("the people's ware") and his willingness to be involved in national conferences and to have his statements published, he is one of the most widely recognized Northwest ceramicists.

George Roberts of Idaho and Robert James and Ray Grimm of Oregon, although they are all sculptors in one or more media, have also underlined the value of producing functional wares during their teaching careers. This is also true of Richard Fairbanks at Central Washington State College and of ceramics instructors in many colleges throughout the Northwest. Their own students as well as individual potters who have settled in the Northwest produce for an eager market. The philosophies of the Orient as well as of such eminent Eastern schools as Alfred are the inspiration for most of this work, which is well crafted and designed in many variations of a limited body of techniques and materials such as earthenware, stoneware, and porcelain clay bodies and slips and glazes colored with cobalt, copper, iron, nickel, rutile, chrome, and other oxides. Although the possibilities for variation in tableware are limited in form by considerations of function and in surface decoration by the presence of toxic chemicals in some glazes, few contemporary craftsmen are challenged to realize the full range of creative choices available to them. The resulting similarity in design among pots produced today leads to anonymity for the potter. If it is a giant struggle for the production potter to achieve individual recognition, he or she can at least be assured by the masses of functional wares sold each year in the shops and the dozens of summer fairs that, generally, the production potter is highly appreciated and revered by the people who live in the Northwest.

Wherever the center for new ideas or for dynamic energy in either sculptural or functional ceramics was at any given time, however, there has been a strong tradition for the use of clay as an art medium in myriad ways in all four Northwest states. And, although this "clay dynamic" seems to have been regional in character, it is likely that artists have worked as individuals, philosophically and aesthetically, and that there has never been a definable "school" of clay work in the Northwest states.

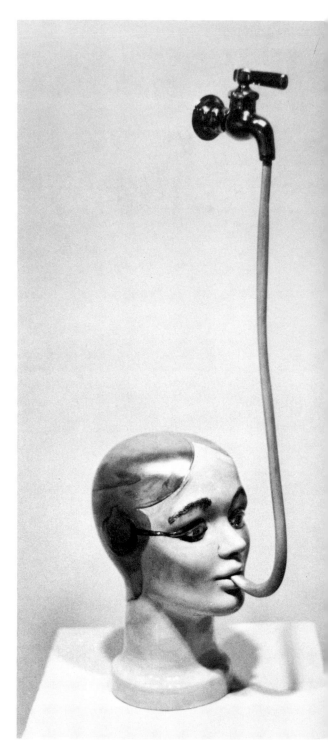

Lukman Glasgow (b. Richfield, Utah, 1935). Time Curve, *1976, earthenware, slip-cast and altered forms with modeled clay, lusters, 32 × 12 × 9.*

Bibliography

CATALOGS AND BOOKS

Adachi, Kenji, Richard E. Fuller, and Henry Trubner. *One Hundred Masterpieces from Japanese Collections.* Seattle: Seattle Art Museum, 1972.

American Crafts Council. *Craftsmen USA—1966.* New York: Museum of Contemporary Crafts of the American Crafts Council, 1966.

Applegate, Judith, and Elayne H. Varian. *Art Deco.* New York: Finch College Museum of Art, 1970.

———, and Janice Lovoos. *Making Pottery Without a Wheel.* New York: Van Nostrand Reinhold, 1965.

Beaujon, Edmond. *L'art du Potier Paul A. Bonifas.* Neuchâtel, Switz.: La Baconniere, 1961.

Berenson, Paulus. *Finding One's Way with Clay.* New York: Simon and Schuster, 1972.

Blasberg, Robert W. *George E. Ohr and His Biloxi Art Pottery.* Point Jarvis, N.Y.: J. W. Carpenter, 1973.

Britannica Encyclopedia of American Art, 1st ed., s.v. "Autio, Rudy," p. 52.

———, 1st ed., s.v. "Ball, F. Carlton," p. 54.

———, 1st ed., s.v. "Voulkos, Peter," p. 579.

Chicago, Judy, Garth Clark, Dextra Frankel, and Richard Shaw. *Overglaze Imagery Cone 019–016.* Fullerton, Calif.: Art Gallery, California State University, 1977.

Clark, Robert J. *The Arts and Crafts Movement in America, 1876–1916.* Princeton, N.J.: Princeton University Press, 1972.

Cochran, Malcolm. *Contemporary Clay: Ten Approaches.* Hanover, N.H.: Jaffe-Friede and Strauss Galleries, Dartmouth College, 1976.

Contemporary Crafts Gallery (formerly Oregon Ceramic Studio). Catalogs of the Annual Exhibition of Northwest Ceramics, Portland, Oregon. 1950–64.

Coplans, John. *Abstract Expressionist Ceramics.* Irvine, Calif.: Division of Fine Arts, University of California, 1966.

Dockstader, Frederick J., Robert Koch, Daniel Rhodes, and Marvin D. Schwartz. *Forms from the Earth: 1,000 Years of Pottery in America.* New York: Museum of Contemporary Crafts of the American Crafts Council, 1962.

Everson Museum of Art (formerly the Syracuse Museum of Fine Arts). Catalogs of the Ceramic National Exhibition, Syracuse, New York. Annual: 1932–51, biennial: 1953–72.

Foley, Suzanne. *A Decade of Ceramic Art, 1962–1972.* San Francisco: San Francisco Museum of Art, 1972.

———. *Robert Hudson/Richard Shaw: Work in Porcelain.* San Francisco: San Francisco Museum of Art, 1973.

Glasgow, Lukman, and Elaine Levin. *Illusionistic Realism Defined in Contemporary Ceramic Sculpture.* Laguna Beach, Calif.: Laguna Beach Museum of Art, 1977.

Gropius, Walter. *Scope of Total Architecture.* New York: Macmillan, 1962.

Hall, Julie. *Tradition and Change.* New York: E. P. Dutton, 1977.

Henry Art Gallery, University of Washington. Catalogs of the Northwest Crafts Exhibition, Seattle, Washington. Annual: 1953–65, biennial: 1967–present.

———, and the Center for Asian Arts, University of Washington. *Hamada's Ceramics.* Seattle, 1963.

Illustrated Directory: Architectural Craftsmen of the Northwest, comp. Ann Todd. Seattle: American Crafts Council.

Leach, Bernard. *A Potters Book.* Holly-by-the-Sea, Fla.: Translantic Arts, Inc., 1967.

Miller, Bradley R. *Close Packing and Cracking.* Eugene, Ore.: University of Oregon Art Museum, 1977.

Mutsuo Yanagihara. Seattle: Henry Art Gallery, University of Washington, 1967.

Nelson, Glenn C. *Ceramics: Potter's Handbook.* New York: Holt, Rinehart and Winston, 1960.

Nordness, Lee. *Objects: USA.* New York: The Viking Press, 1970.

Northwest Designer-Craftsmen. Seattle: Northwest Designer-Craftsmen, 1976.

Prokopoff, Stephen, and Suzanne Foley. *Robert Arneson.* Chicago: Museum of Contemporary Art, 1974.

Ratcliff, Carter. *Britannica Encyclopedia of American Art,* 1st ed., s.v. "Voulkos, Peter," p. 579.

Rhodes, Daniel. *Clays and Glazes for the Potter.* Philadelphia and New York: Chilton Company, 1957, 1973.

Richards, Mary Caroline. *Centering in Pottery, Poetry, and the Person.* Middletown, Conn.: Wesleyan University Press, 1962.

Rose, Barbara. *American Art since 1900: A Critical History.* New York: Praeger, 1967.

Scheidig, Walther. *Weimar Crafts of the Bauhaus.* New York: Van Nostrand Reinhold, 1967.

Seattle Centennial Ceramic Exhibition. Seattle: Henry Art Gallery, University of Washington, 1952.

Selz, Peter. *Funk.* Berkeley, Calif.: University Art Museum, University of California, 1967.

———, and Mildred Constantine. *Art Nouveau: Art and Design at the Turn of the Century.* New York: Museum of Modern Art, 1959.

Slivka, Rose. *Peter Voulkos: A Dialogue with Clay.* New York: New York Graphics Society in association with the American Crafts Council, 1978.

Smith, Paul J. *Clayworks: 20 Americans.* New York: Museum of Contemporary

Crafts of the American Crafts Council, 1971.

Stockheim-Schwartz, Judy. *Patti Warashina.* El Cajon, Calif.: Grossmont College Gallery, 1975.

Wildenhain, Marguerite. *Pottery: Form and Expression.* New York: American Craftsmen's Council, 1959.

Yanagi, Soetsu. *The Responsibility of the Craftsman* and *The Mystery of Beauty.* Helena, Mont.: Peter Meloy, 1952. (From a lecture by Soetsu Yanagi at the Archie Bray Foundation.) Reprinted 1966 by the Archie Bray Foundation.

PERIODICALS

Adams, Alice. "Stoneware at America House." *Craft Horizons* 22(November 1962):43. (Reference to work by Robert Sperry).

"American Ceramics." *Design Quarterly,* nos. 42 and 43(1958).

Barth, Catherine. "Bizen." *Ceramics Monthly* 23, no. 10(December 1975):27–29.

Callahan, Kenneth. "Pacific Northwest." *Art News* 45, no. 5(July 1946):22–27, 53–55. (References to Paul Bonifas, Lydia Herrick Hodge, and Eugenie Worman, p. 54).

Canavier, Elena Karina. "Kohler Conference: An Art/Industry Alliance." *Ceramics Monthly* 21(November 1973):27. (Rudy Autio's *Two Figures and Horse* reproduced).

Cohen, Harriet. "Craftsmen USA'66/Part One, North Central." *Craft Horizons* 26, no. 2(March/April 1966):28–31, 51–53. (References to Patti Warashina and Fred Bauer, pp. 31, 52).

"The Collector." *Craft Horizons* 34, no. 5(October 1974):32–37. (Reference to the collection of R. Joseph and Elaine Monsen, p. 32).

"Contemporary Crafts Gallery, Portland, Oregon, Exhibition." *Craft Horizons* 36(August 1976):53.

Coplans, John. "Out of Clay, West Coast Ceramic Sculpture Emerges as a Strong Regional Trend." *Art in America* 6(November 1963):40–43.

"Craft World." "Supermen Throw Supermud." *Craft Horizons* 37(February 1977):8.

"Craftsman's World." *Craft Horizons* 12 no. 6(December 1952):47. (Reference to Archie Bray Foundation Ceramics at America House).

———. *Craft Horizons* 13, no. 4(July/August 1953):49. (Reference to work by Peter Voulkos).

———. *Craft Horizons* 14, no. 5(September/October 1954):43. (Refer-

ence to an exhibition of work by Peter Voulkos at America House).

_____. *Craft Horizons* 14, no. 6(November/December 1954):42–43. (Reference to an exhibition of stoneware by Peter Voulkos at America House).

"Craftsman's World: Exhibitions." *Craft Horizons* 12, no. 5(September/October 1952):46. (Reference to Archie Bray Foundation ceramics).

_____. *Craft Horizons* 13, no. 2(April 1953):43. (Reference to work by Peter Voulkos).

_____. *Craft Horizons* 13, no. 3(June 1953):47. (Reference to Northwest Craftsmen's Exhibition and the sixth annual Festival of Contemporary Arts).

Daniel, Greta. "Contemporary Craftsmen of the Far West." *Craft Horizons* 21, no. 6(November/December 1961):10–17.

DePew, Dave. "The Archie Bray Foundation." *Ceramics Monthly* 20(May 1972):18–23.

"Designer Craftsmen U.S.A. 1953." *Craft Horizons* 13, no. 6(November/December 1953):17. (Reference to work by Peter Voulkos).

Ferguson, Ken, interviewed by Charlotte Sewalt. *Ceramics Monthly* 26, no. 2(February 1978):25–31.

Griffin, Rachael. "Earth and Air Find Their Magic in the Ceramics of Ken Shores." *Craft Horizons* 30(August 1970):26–28. Reprinted in *Oregon Rainbow,* 1, no. 1(Spring 1976):28–32.

Gronborg, Erik. "Contemporary Ceramics, the Monsen Collection." *The Oregonian* 26(March 1967).

_____. "The New Generation of Ceramic Artists." *Craft Horizons* 24, no. 1(January/February 1969):26–29.

Harrington, LaMar. "Letter from Seattle." *Craft Horizons* 23, no. 4(July/August 1963):39. (Reference to work by Rudy Autio).

_____. "Letter from Seattle." *Craft Horizons* 24, no. 5(September 1964):53. (Reference to work by Fred Bauer and Patti Warashina).

_____. "Letter from Seattle." *Craft Horizons* 26, no. 1(January/February 1966):45–47. (Reference to work by Robert Sperry, p. 47).

_____. "Letter from Seattle." *Craft Horizons* 27, no. 2(March/April 1967):49. (Reference to work by Howard Kottler).

Hayman, Sally. "Northwest Today." *Seattle Post-Intelligencer* (26 November 1967):15. (Reference to work by Ron Gasowski).

"Illusionistic Realism." *Ceramics Monthly* 25, no. 7(September 1977):59–63. (Reference to controversy over work by Howard Kottler exhibited in show. See issues following for Letters to the Editor that

have continued in response to this article.)

Isaacs, Walter. "Paul Bonifas, Potter from Switzerland." *Design* 49(September 1947):24.

Jones, Catherine. "Letter from Portland." *Craft Horizons* 27, no. 3(May/June 1967):65. (Reference to work by Howard Kottler).

Kasal, Robert. "Letter from Portland." *Craft Horizons* 26, no. 6(November/December 1966):54. (Reference to work by Kenneth Shores).

Kelly, Claire C. "Sense and Sensuality in Northwest Art." *Artweek* (23 October 1976):5.

Levin, Elaine. "Comment Non-traditional Clay." *Ceramics Monthly* 26, no. 2(February 1978):19, 21, 70.

_____. "Lukman Glasgow." *Ceramics Monthly* 26, no. 3(March 1978):45–51.

Licka, C. E. "A Prima Facie Clay Sampler: A Case for Popular Ceramics, Part 1." *Currant* (August/September 1975):8–13, 50–53.

_____. "A Prima Facie Clay Sampler: A Case for Popular Ceramics, Part 2." *Currant* (October/November 1975).

Lippard, Lucy. "Northwest Passage." *Art in America* (July/August 1976):59–63. (References to work by Dennis Evans and Joyce Moty, p. 62).

Maillard, Dominique. "The International Exposition of Ceramics at Cannes." *Craft Horizons* 15, no. 5(September/October 1955):10–15.

Meisel, Alan. "Letter from San Francisco." *Craft Horizons* 27, no. 3(May/June 1967):62–63. (Reference to work by Erik Gronborg, p. 63).

"M.F.A. Exhibition at Puget Sound." *Ceramics Monthly* 25, no. 7(September 1977):30.

Normark, Don. "Letter from Seattle." *Craft Horizons* 21, no. 2(March/April 1961):55. (Reference to work by Harold Myers).

_____. "Exhibitions in Seattle." *Craft Horizons* 21, no. 4(July/August 1961):44. (Reference to work by Robert Sperry).

_____. "Ceramics and Robert Sperry." *Craft Horizons* 22, no. 1(January/February 1962):32–35.

"Patti Warashina." *Ceramics Monthly* 24, no. 5(May 1976):28–29.

Pyron, Bernard. "The Tao & Dada of Recent American Ceramic Art." *Artforum* 11, no. 9(March 1964):41–42.

Robbins, Tom. "Has Northwestern Art Gone to Pot?" *Seattle Times* (4 March 1963).

_____. "Northwest Today." *Seattle Post-Intelligencer* (16 October 1966). (References to work by Warren Maruhashi on cover and pp. 3, 5.)

Sawyer, Kenneth. "U.S. Ceramics at the Third International Exhibition of Contemporary Ceramics in Prague." *Craft Horizons* 22, no. 3(May/June 1962):58–59.

Schwartz, Fred. "Exhibit at Left Bank Gal-

lery." *Craft Horizons* 28, no. 2(March/April 1968):42. (References to work by Fred Bauer and Patti Warashina).

Slivka, Rose. "The New Ceramic Presence." *Craft Horizons* 21, no. 6(November/December 1961):30–37.

_____. "The American Craftsman/1964." *Craft Horizons* 24, no. 3(May/June 1964):32.

Soldner, Paul. "Craftsmen USA'66/Part Two, Northwest Region." *Craft Horizons* 26, no. 3(June 1966):72–73, 108.

_____, interview with Peter Voulkos. "Ceramics West Coast." *Craft Horizons* 26, no. 3(June 1966):25–28, 97.

Stevenson, Branson G. "Craftsman's World, Clays and Glazes of Montana." *Craft Horizons* 13(February 1953):42–43.

"The Super Mud Conference." *Ceramics Monthly* 25(January 1977):20–25. (Warren MacKenzie interviewed by Peter Freund).

Tucciarone, W. "LaVerdiere, Demonstration of His Coil-Building Method." *Ceramics Monthly* 18(September 1970):14–17.

Voorhees, John. "Exciting Things Happen in Show at Manolides." *Seattle Times* (21 April 1970):A16.

Yaw Gallery, Birmingham, Michigan Exhibition." *Craft Horizons* 36, no. 5(October 1976):54. (Reference to work by Howard Kottler).

MISCELLANEOUS

American Craftsmen's Council. "1957 Asilomar." Paper delivered at the First Annual Conference of American Craftsmen, June 1957, at Asilomar, Calif.: University of Washington, School of Art Library.

_____. "Dimensions in Design." Paper delivered at the Second Annual Conference of American Craftsmen, June 1958, at Lake Geneva, N.Y. University of Washington, School of Art Library.

_____. "Research and the Crafts." Paper delivered at the Fourth National Conference of the American Craftsmen's Council, August 1961, University of Washington, Seattle. University of Washington, School of Art Library.

Bach, Frank. *Clay Sculpture—Voulkos.* 1958. Film, color, silent, 10 min., 16 mm. Filmed at University of Montana Television Studio.

Sperry, Robert. *Village Potters of Onda.* 1965. Film, b/w, silent, 27 min., 16 mm. University of Washington Audio Visual Film Library.

_____. "Is Pottery an Anachronism in the Twentieth Century?" Paper delivered at the Washington Art Association Meeting, 1956. University of Washington, School of Art Library.

Index

Numbers in **bold face** refer to the numbered illustrations in the color section following page 8. Page numbers in *italic* refer to black-and-white illustrations.

PHOTOGRAPH CREDITS

Color (caption numbers)
Howard R. Giske: 5, 6, 13
Al Monner: 12
Johsel Namkung: 1, 2, 9, 10, 14
Richard R. Policar: 4, 8
Sjef Wildschut: 7

Black-and-White (page numbers)
Courtesy American Crafts Council, Research and Education Division: 70 top, 72 top; (photo by Rudy Autio) 67 right, 68 top, 70 top; (photo by Don Normark) 63 left; and Smithsonian Institution: 68 bottom
Kari Berger: 104 top right, 106 top right
Ferdinand Boesch: 94 bottom
Coleen Chartier: 110 top left, 111
David Christian: 108 bottom
Courtesy Contemporary Crafts Gallery: 124; (photo by Margaret Murray Gordon) 20, 66, 82 top left
Julie Coryell: 58 top left
Anne Currier: 7
Jo David: 112 top right
Jini Dellaccio: 122 top
Dudley, Hardin, and Yang, Inc.: 5, 62 top, 86 right
Courtesy Everson Museum (photo by Robert Lorenz): 1, 23 bottom, 26 top
Forde Photographers: 72 bottom
Howard R. Giske: 75 top, 89
Margaret Murray Gordon: 16, 19 top, 26 bottom left, 27 bottom
Elizabeth Green: 49
Vern Green: 61, 63 right
Wes Guderian: 44 bottom
Don Halloran: 102 top left
Goodwin Harding: 58 top right
Howard Huff: 54 bottom
Hans Jorgensen: 56 bottom, 82 bottom, 83
Manson Kennedy: 54 top, 55 bottom
Robert P. Lowing: 76 top right, 112 top left
Steve Meltzer: 82 top right
Courtesy Montana State University: 23 top
M. Moore: 115 bottom
Roy Morris: 117
Johsel Namkung: 8, 47, 53 bottom, 55 top, 106 top left, 114 bottom
Don Normark: 51 top and bottom
Photo Art Commercial Studios: 5, 15 bottom
Courtesy Polly Friedlander Gallery: 57 bottom right
Mary Randlett: 3, 22 top, 27 top, 29 bottom, 52 top, 53 top, 58 bottom, 59, 60, 71 top, 85, 90 bottom right, 91, 98 top, 104 bottom, 109, 110 top right and bottom, 120 top
Walter Rosenblum: 62 center
Courtesy Seattle Art Museum (photo by Paul Macapia): 18
William Traver: 123 top
Courtesy University of Washington, Archives and Manuscripts Div., Suzzallo Library, 30; Instructional Media Services: 2, 17, 19 bottom left and right, 21 top and bottom, 26 bottom right, 28, 29 top, 31, 32, 36, 37, 38 top, 40 bottom, 41 top and bottom, 42, 44 top, 45 top, 46 bottom, 50, 52 bottom, 56 top, 62 bottom, 64 all, 67 bottom left, 71 bottom, 73, 74 right, 76 top left, 84 all, 90 top and bottom left, 92 top and bottom, 94 top, 96, 97 all, 98 bottom, 99, 100 top and bottom, 101, 102 top left and bottom, 103, 106 bottom, 107, 113, 114 top, 115 top
David Weller: 120 bottom, 121 bottom
Patty Williams: 9, 105